ATLAS OF HUMAN ANATOMY

FOR THE ARTIST

ATLAS OF HUMAN ANATOMY

FOR THE ARTIST

STEPHEN ROGERS PECK

OXFORD UNIVERSITY PRESS
Oxford New York

OXFORD UNIVERSITY PRESS
Oxford London Glasgow
New York Toronto Melbourne
Nairobi Dar es Salaam Cape Town
Kuala Lumpur Singapore Hong Kong Tokyo
Delhi Bombay Calcutta Madras Karachi

and associate companies in
Beirut Berlin Ibadan Mexico City

Library of Congress Cataloging in Publication Data

Peck, Stephen Rogers, 1912-
 Atlas of human anatomy for the artist.

 Originally published: 1951.
 Includes index.
 1. Anatomy, Artistic. I. Title.
NC760.P35 1982 743'.49 81-16848
ISBN 0-19-500052-8 (cloth)
ISBN 0-19-503095-8 (pbk.)

30 29 28 27 26 25 24 23

Printed in the United States of America
on acid-free paper

To J. E. P.

Human form has long challenged the artist's creative powers. Its irresistible force of communication places it among the foremost instruments of graphic expression. Its versatility so captures the imagination that, now and again, human form has emerged as the theme itself. It is natural that the artist should investigate human structure in order to express its form. Yet access to the dissecting room is not always easy, and not always profitable. In any case the facts require translation, for the artist will be exploring the æsthetics of anatomy. I think of this as relating structural design to sensuous design. The one must be learned, the other perceived. This is the substance of what is called artistic anatomy. It is the dual aim here to present the separate structures and to create a working awareness of their integration.

This book is not a treatise on drawing—in the sense of cultivating quality and style. Nor does it touch upon the fundamentals of figure drawing—line, form, action, and so on. Important as they are, they lie beyond the scope of an anatomy book. Quite simply, this is a manual for the student who feels the need of exploring and memorizing human design.

One question is apt to arise at the very outset: just how well versed in anatomy must the artist be? And although beginning students are surely entitled to ask the question, I find it difficult to answer. A man's art is his personal domain. It is a matter not of professional requirements, but of what one artist's ideas require. This atlas is, of course, a condensation of facts, and a trans-lation to the idiom of the artist. In view of this, the beginner should perhaps set out to learn everything he can. Whatever seems in his experience to be useless debris will be dropped soon enough by the wayside. But a word of caution to the zealous student. Anatomy is complex. Its very complexities are fascinating, but they are likely to lead the way to unreasonable evaluations. The student should not assume that it is necessary to be correct at all costs in these matters of bone and muscle. In one sense, a human body is the sum of its parts. But this premise can both help and hinder. It can hinder when we attend to the parts and ignore the sum. It is true the student must work at first to be correct, but he should never forget that there is little virtue in sheer correctness. Ultimately, he should propose—right or wrong—to be convincing. He should acquire such mastery of structure that he no longer depends on the accuracy of his eye or the patience of his model. He will want to gain, in his own right, such command of human forms and contours that his creation will become identified not with his anatomy charts, but with *him*. I believe, in fact, it is those aberrations of the anatomical truth that so often make a piece of work personal and exciting.

I hope the reader may find here both knowledge and a point of view. In these pages I have tried to put him in closer touch with a masterful design. May his penetration of that design enlarge his capacity for response to the world about him.

New York City
1 *January* 1951

S. R. P.

ACKNOWLEDGMENTS

The drawings in this atlas sprang from more than a covenant between myself and a chestful of anatomical oddments. There were live models, too, and the atlas came to be thought of as 'our' book. I regret that their identities must be withheld. But let those names be conspicuous by their absence. If this work of ours can prove fruitful to students of the figure, we shall all share the deepest satisfaction. Less direct but even more vital were the contributions of a multitude of art students. Their questions have been my point of departure, their efforts my proving ground. And their spirited concern with anatomy not only induced me to begin this book but sustained me throughout its many years of production.

To my friend Darwin L. Platt, osteologist, goes much credit for the furnishing of carefully selected and skillfully prepared bone material. The American Museum of Natural History helpfully provided access to special museum facilities. Photographs of racial types, physiques, et cetera, came from a variety of sources. Permission for their reprint here is gratefully acknowledged, and credits accompany the respective cuts. Photographer John Seymour Erwin made the camera studies that appear on pages 181-9, 198-200, 207, and 227-35. For permission to reprint certain passages of quoted material, I wish to thank the following publishers: Pantheon Books, Inc., for translations from Tintoretto, Alberti, and Falconet, as com-piled in *Artists on Art* by Goldwater and Treves; Harper and Brothers, for a passage from *Ingres* by Walter Pach; and the Oxford University Press, for a quotation from Michelangelo as translated by A. F. G. Bell from Francisco de Hollanda in *Four Dialogues on Painting*. A material assistance was given by the critical readers of the manuscript. I am grateful for the advice that stemmed from their special fields of experience. It is a distinguished list: Professor Ture Bengtz (Museum School of Fine Arts, Boston); Dr. George A. Bennett, Professor of Anatomy (Daniel Baugh Institute of Anatomy); Professor Russell T. Hyde (College of Fine Arts, Carnegie Institute of Technology); Dr. Dorothy Z. Kraemer (College of Physicians and Surgeons, Columbia University); Mr. Luigi Lucioni, artist; and Professor Barse Miller (Chairman of the Art Department, Queens College). Not the least of my indebtedness is to the Oxford University Press. The patience of my publisher greatly eased the gestation of something over one decade!

Finally, I pay tribute to the memory of Henry W. Stiles, under whose guidance I made my first explorations with the scalpel. It is a rare experience to come into the orbit of one whose prodigious knowledge is obscured by a tender heart—an anatomist for whom the cadaver is yet an individual rendering his last service to mankind.

CONTENTS

*And who is so barbarous as not to under-
stand that the foot of a man is nobler than
his shoe, and his skin nobler than that of
the sheep with which he is clothed, and not
to be able to estimate the worth and degree
of each thing accordingly?*

—MICHELANGELO

THE LANGUAGE OF ANATOMY

The human body is a sort of geographical terrain upon which the anatomist, like a surveyor, must be prepared to take his bearings. It will help us to be brief in our discussion if first we acquire a suitable vocabulary. Descriptive terms given in the following pages are in common use, and they will suffice as a verbal springboard from which we may readily plunge into any section of this book. A key to the pronunciation of unfamiliar terms encountered here and elsewhere will be found on pages 261–3

THE LANGUAGE OF ANATOMY

PERTAINING TO POSITION

Longitudinal	Ref. to long axis
Transverse	At right angles to long axis
Vertical	Ref. to long axis in erect position
Horizontal	At right angles to vertical
Oblique	Slanting
Median	Midway
Midline	Divides body into right and left sides
Medial	Nearer to midline (or center plane)
Lateral	Further from midline (or center plane)
Anterior	Front
Posterior	Rear
Superior	Upper; nearer to crown of head
Inferior	Lower; further from crown of head
Deep	Further from surface } ref. to solid form
Superficial	Nearer to surface
Internal	Inside } ref. to wall of cavity, hollow form
External	Outside
Proximal	Nearer to root of limb
Distal	Further from root of limb
Palmar	Ref. to palm-side of hand
Plantar	Ref. to sole of foot
Dorsal	Ref. to back; also, back of hand and top of foot
Supine	Forearm and hand, turned palm-side upward
Prone	Forearm and hand, turned palm-side downward
Inverted	Turned inward (as foot at ankle joint)
Everted	Turned outward (as foot at ankle joint; also lower lip)
Intermediate	Between other structures
Interosseous	Between bones (as membranes and muscles)

PERTAINING TO BONE

Bone	Inflexible structures composing the skeleton
Cartilage	Substance from which bone ossifies; gristle
Joint	} Connection between bones
Articulation	
Suture	Interlocking of teeth-like edges
Head	Enlarged round end of a long bone; knob
Neck	Constriction of a bone near its head
Body	Broadest or longest mass of a bone
Shaft	Body of a long bone
Symphysis	Union of right and left sides in midline
Eminence	Low convexity (just perceptible)

Protuberance⎱
Tubercle⎰ Bump (can be felt under finger)
Tuberosity Large and conspicuous bump
Process Projection (can be grasped with fingers)
Spine Pointed projection or sharp ridge
Crest Ridge or border
Condyle Polished articular surface (usually a knob)
Epicondyle Elevation near a condyle
Trochlea Spool-shaped articular surface
Ramus Plate-like branch of a bone
Facet Small articular area; often a pit
Fossa Shallow depression
Foramen Hole; perforation

PERTAINING TO FLESH

Ligament Fibrous tissue binding bones together or lashing tendons or
 muscles in place
Muscle Contractile organ capable of producing movement
Belly Fleshy part of a muscle
Head Portion of a muscle having a separate attachment
Tendon Fibrous tissue securing a muscle to its attachment
Aponeurosis Expanded tendon for attachment of a flat muscle
Fascia Fibrous envelopment of muscular structures
Sheath Protective covering
Serration One of the notches at a saw-like edge
Digitation Finger-like division of muscle fibers
⎰ Origin Relatively fixed point of a muscle attachment
⎱ Insertion Relatively movable point of a muscle attachment
Action Movement accomplished by a muscle
⎰ Flexor Causes bending or angulation
⎱ Extensor Straightens
⎰ Levator Raises
⎱ Depressor Lowers
⎰ Abductor Draws away from the midline
⎱ Adductor Draws toward the midline
Erector Draws upright
Tensor Draws tight
Rotator Causes to revolve
⎰ Supinator Turns palm of hand upward
⎱ Pronator Turns palm of hand downward
Corrugator Draws (skin) into wrinkles
Sphincter Regulates the closing of an aperture

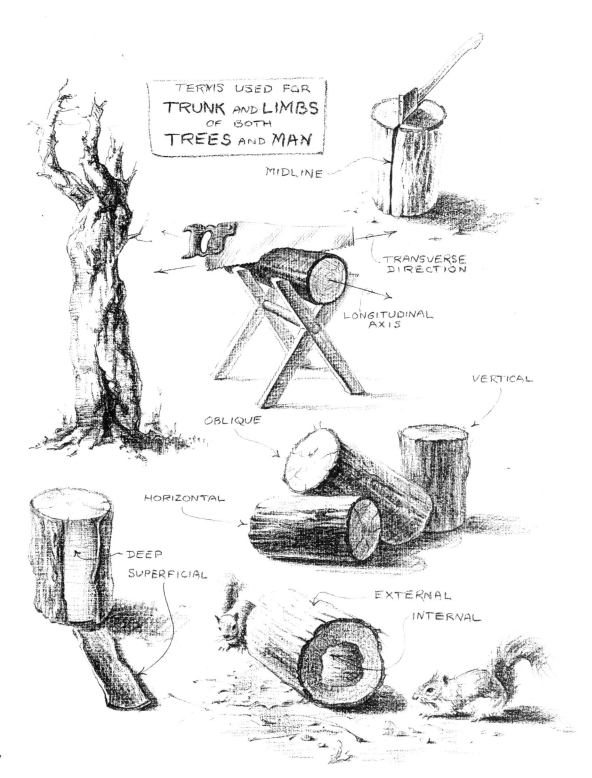

TERMS USED FOR
TRUNK AND LIMBS
OF BOTH
TREES AND MAN

MIDLINE

TRANSVERSE DIRECTION

LONGITUDINAL AXIS

VERTICAL

OBLIQUE

HORIZONTAL

DEEP
SUPERFICIAL

EXTERNAL
INTERNAL

xiv

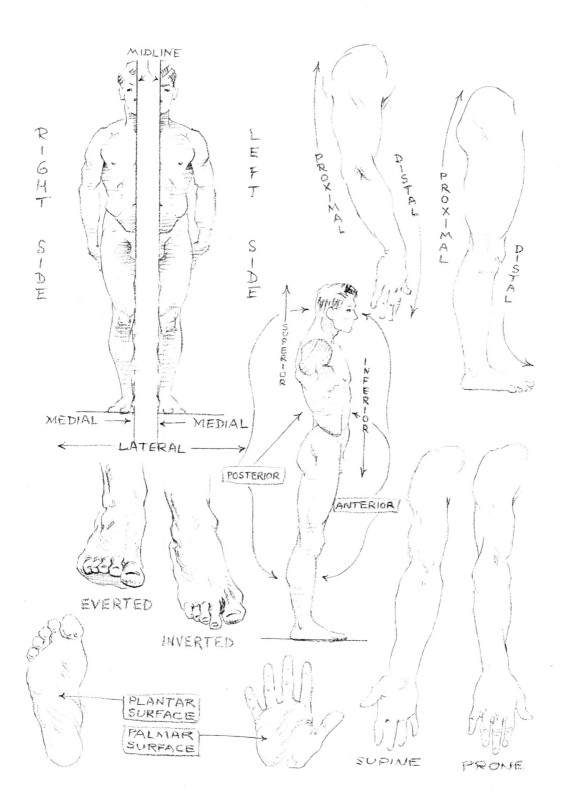

MIDLINE

RIGHT SIDE

LEFT SIDE

PROXIMAL

DISTAL

PROXIMAL

DISTAL

SUPERIOR

INFERIOR

MEDIAL → ← MEDIAL

← LATERAL →

POSTERIOR

ANTERIOR

EVERTED

INVERTED

PLANTAR SURFACE

PALMAR SURFACE

SUPINE

PRONE

Part I

BONES

If beauty resides in fitness to any extent, what can be more beautiful than this skeleton or the perfection with which means and ends are reciprocally adapted to each other.

—Eakins

The SKELETON

Probably few beginners have entered the Life Class with any real appreciation of skeletal structure. Ordinarily, it must be cultivated. The tyro is inclined to dispose quickly of bone, in favor of flesh. He insists that what he observes in the live model is evidence of muscle, tendon, and fat—not of a skeleton! The upholstery, he forgets, cannot by itself have form but takes its broad lines from the frame over which it stretches. Not only is a skeleton the anchorage for flesh, but also, at so many points, it is conspicuously present at the surface. It is the primary factor in proportion, and a means of great distinction between the sexes. And what is more, dry bones are objects of masterful design. Their study should bring profound respect as well as enlightenment.

The plate-like bones of head and trunk serve primarily as protective enclosures for vital organs. Like the scaffolding of a house, this much of the skeleton determines shape. We can readily comprehend the sturdy buttresses of hipbones, the keystone base for a stately spinal column, the vaulted gallery of a rib cage, the cupola-skull with its balcony of cheekbones. The live head, in fact, is little more than a skull adorned with ears, nose, and eyeballs. The upper trunk is recognizably a rib cage to which we add only its mantle of shoulder bones and muscles and so produce a pit under the arm. Again, the shape of the lower trunk is commanded by a bony pelvis. But this lies nearly obscured by buttocks and the enormous roots of thighs. We cannot see the evidence of pelvis at first—how it determines shape. We learn to see it. So all this is the house we live in, organized along an upright central axis. It is called the *axial skeleton.*[1]

If the head and trunk give us architecture, the arm and leg are matters of engineering. Here are the long bones of the *appendicular skeleton,* simple levers for transmitting power. They turn and bend with great freedom to adjust us to our environment. The joints of long bones will contribute more or less directly to specific surface forms, but a shaft usually lies deep in its harness of muscle. It is particularly important here for us to realize that though muscles may hide the bone, their directions are completely at the mercy of the bone. That is why a fleshy thigh slants in to the knee and why it arches forward. Remove the bone, and a thigh would have little more shape than a puddle of water.

Substantial and dynamic as is this human engineering, its presence at the surface is betrayed only to the penetrating eye. Ignoring what cannot be seen, the student runs great risk. His first objective should be a conviction of the critical importance of skeletal structure.

[1] Hipbones cannot be ignored in considering either trunk or lower extremity. The anatomist would not assign them to the axial skeleton. But artists find it more useful to think of the full pelvis as a fixed unit of the trunk. (See p. 60, *Pelvis.*)

REGIONAL CLASSIFICATION OF BONES

[Names of bones are in italics]
[Parentheses indicate common names or meanings]

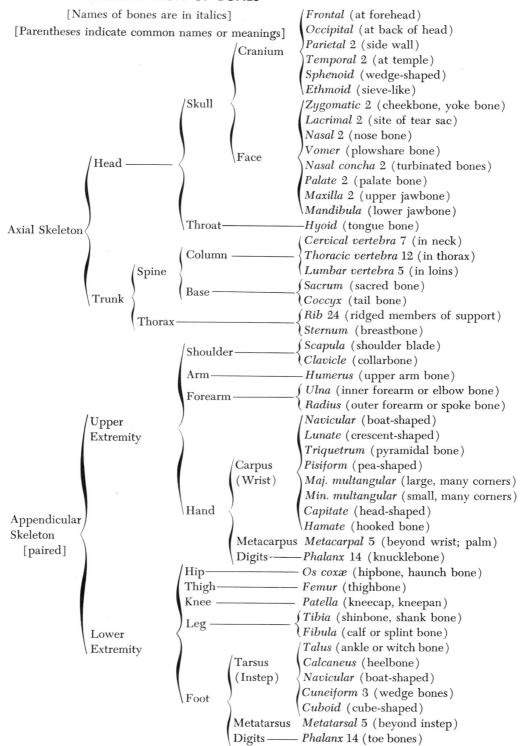

Axial Skeleton

Head
- Skull
 - Cranium
 - *Frontal* (at forehead)
 - *Occipital* (at back of head)
 - *Parietal* 2 (side wall)
 - *Temporal* 2 (at temple)
 - *Sphenoid* (wedge-shaped)
 - *Ethmoid* (sieve-like)
 - Face
 - *Zygomatic* 2 (cheekbone, yoke bone)
 - *Lacrimal* 2 (site of tear sac)
 - *Nasal* 2 (nose bone)
 - *Vomer* (plowshare bone)
 - *Nasal concha* 2 (turbinated bones)
 - *Palate* 2 (palate bone)
 - *Maxilla* 2 (upper jawbone)
 - *Mandibula* (lower jawbone)
- Throat
 - *Hyoid* (tongue bone)

Trunk
- Spine
 - Column
 - *Cervical vertebra* 7 (in neck)
 - *Thoracic vertebra* 12 (in thorax)
 - *Lumbar vertebra* 5 (in loins)
 - Base
 - *Sacrum* (sacred bone)
 - *Coccyx* (tail bone)
- Thorax
 - *Rib* 24 (ridged members of support)
 - *Sternum* (breastbone)

Appendicular Skeleton [paired]

Upper Extremity
- Shoulder
 - *Scapula* (shoulder blade)
 - *Clavicle* (collarbone)
- Arm
 - *Humerus* (upper arm bone)
- Forearm
 - *Ulna* (inner forearm or elbow bone)
 - *Radius* (outer forearm or spoke bone)
- Hand
 - Carpus (Wrist)
 - *Navicular* (boat-shaped)
 - *Lunate* (crescent-shaped)
 - *Triquetrum* (pyramidal bone)
 - *Pisiform* (pea-shaped)
 - *Maj. multangular* (large, many corners)
 - *Min. multangular* (small, many corners)
 - *Capitate* (head-shaped)
 - *Hamate* (hooked bone)
 - Metacarpus *Metacarpal* 5 (beyond wrist; palm)
 - Digits *Phalanx* 14 (knucklebone)

Lower Extremity
- Hip *Os coxæ* (hipbone, haunch bone)
- Thigh *Femur* (thighbone)
- Knee *Patella* (kneecap, kneepan)
- Leg
 - *Tibia* (shinbone, shank bone)
 - *Fibula* (calf or splint bone)
- Foot
 - Tarsus (Instep)
 - *Talus* (ankle or witch bone)
 - *Calcaneus* (heelbone)
 - *Navicular* (boat-shaped)
 - *Cuneiform* 3 (wedge bones)
 - *Cuboid* (cube-shaped)
 - Metatarsus *Metatarsal* 5 (beyond instep)
 - Digits *Phalanx* 14 (toe bones)

3

JOINTS

Bones unite with one another in various ways. Certain of these unions are 'locked' joints; some manifest only a passive movement; and others are so devised that their parts may glide with great freedom upon each other.

IMMOVABLE JOINTS

SUTURE: an interlocking of bones along their saw-tooth edges.

> e.g. *joints of cranium*
> > (cranial sutures)

CARTILAGE: adhesion by means of cartilage or gristle (substance from which bone ossifies).

> e.g. *joints of breastbone with first ribs*
> > (first sterno-costal)

SLIGHTLY MOVABLE JOINTS

FIBRO-CARTILAGE: provides a spongy cushion between bones.

> e.g. *joints of spine*
> > (inter-vertebral discs)

FREELY MOVABLE JOINTS

(Synovial[1] or 'lubricated')

PLANE: bones glide face to face, limited by their retaining ligaments.

> e.g. *joints of wrist and ankle bones*
> > (inter-carpal and -tarsal)

HINGE: movement about a transverse axis only, as in the lid of a box.

> e.g. *elbow joint*
> > (humero-ulnar)

[1] So called because of the presence of *synovia*, an oily lubricant.

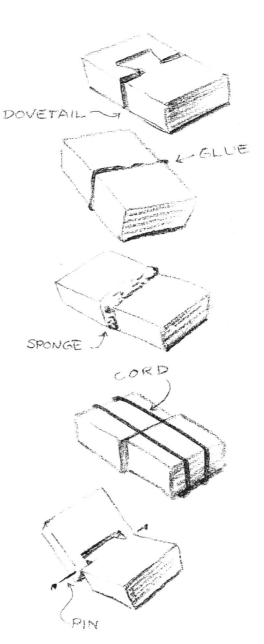

DOVETAIL

GLUE

SPONGE

CORD

PIN

4

SADDLE: increases the extent of the hinge joint by adding an axis of movement perpendicular to the transverse axis.

e.g. *joint of thumb with adjoining wristbone*
(carpo-metacarpal I)

CONDYLOID[2]: increases the extent of the saddle joint by permitting circular movement that will describe the side of a cone.

e.g. *joints of first row of knuckles, except thumb*
(metacarpo-phalangeal II-v)

PIVOT: a cylindrical form moving within a complete or partial ring, or such a ring moving about the cylinder. Only a vertical axis is present, as in the hinge of a gate.

e.g. *joints of forearm bones*
(radio-ulnar)

BALL-AND-SOCKET: provides the freest possible movement by means of a spherical head set within a cup-like cavity. This joint adds to the wide play of the condyloid joint the vertical axis of pivot rotation.

e.g. *hip joint*
(at the acetabulum)

ELLIPSOID: a modified ball-and-socket in which the uniting surfaces are ellipsoidal rather than spherical. Vertical rotation is impossible.

e.g. *joint of forearm with wrist*
(radio-carpal)

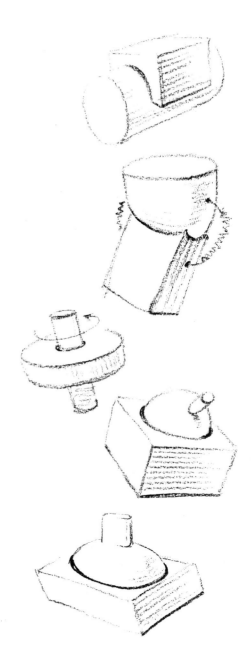

[2] The Condyloid type of joint is structurally like the ball type, except that muscles and ligaments do not allow rotation.

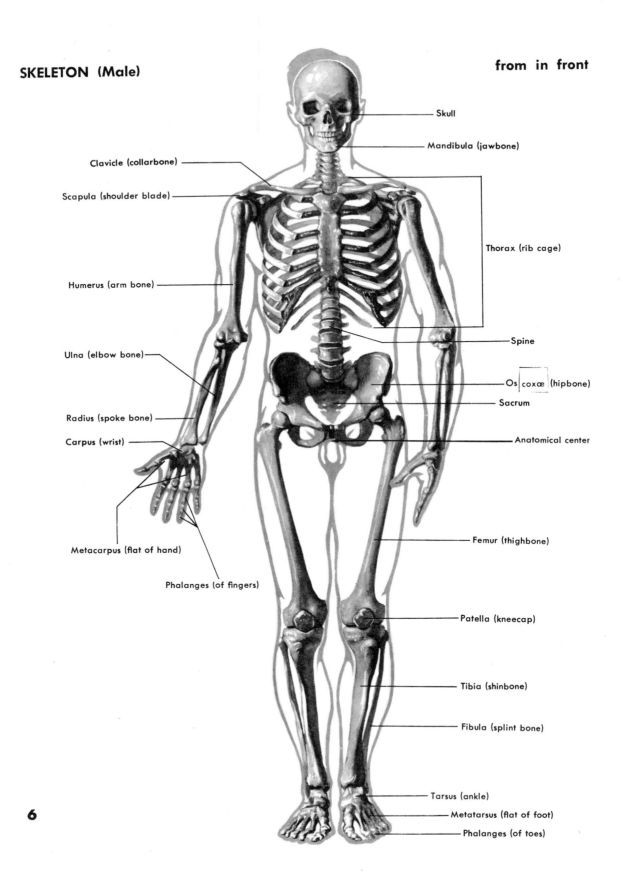

Skull

Mandibula (jawbone)

Clavicle (collarbone)

Scapula (shoulder blade)

Thorax (rib cage)

Humerus (arm bone)

Spine

Ulna (elbow bone)

Os|coxæ|(hipbone)

Sacrum

Radius (spoke bone)

Carpus (wrist)

Anatomical center

Metacarpus (flat of hand)

Femur (thighbone)

Phalanges (of fingers)

Patella (kneecap)

Tibia (shinbone)

Fibula (splint bone)

Tarsus (ankle)

6

Metatarsus (flat of foot)

Phalanges (of toes)

SKELETON (Male)

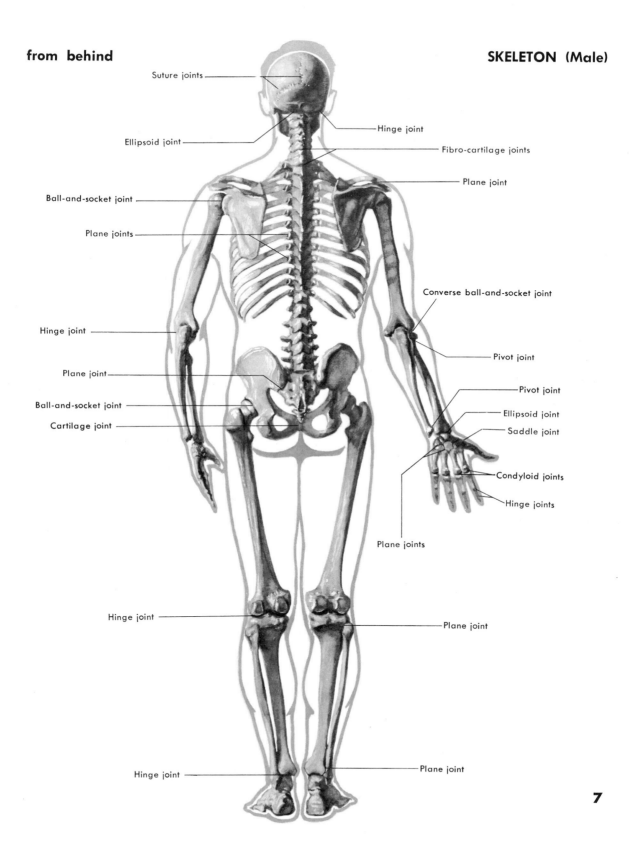

Suture joints

Hinge joint

Ellipsoid joint

Fibro-cartilage joints

Plane joint

Ball-and-socket joint

Plane joints

Converse ball-and-socket joint

Hinge joint

Pivot joint

Plane joint

Pivot joint

Ball-and-socket joint

Ellipsoid joint

Cartilage joint

Saddle joint

Condyloid joints

Hinge joints

Plane joints

Hinge joint

Plane joint

Hinge joint

Plane joint

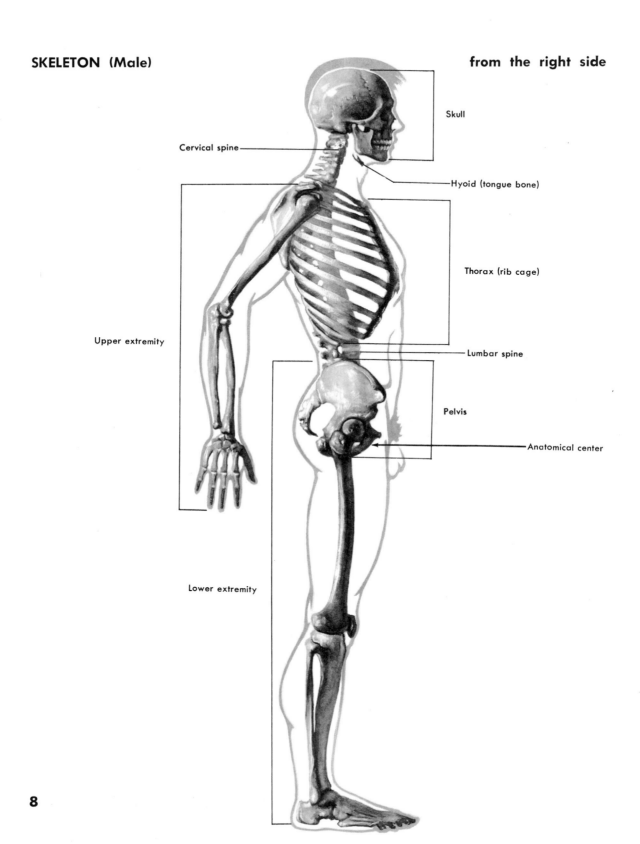

Skull

Cervical spine

Hyoid (tongue bone)

Thorax (rib cage)

Upper extremity

Lumbar spine

Pelvis

Anatomical center

Lower extremity

9

The SKULL

The term 'skull' designates a group of 22 plate-like bones that compose the framework of the head.[1] The average skull is 8½ inches high, higher than long (7½ inches), and longer than wide (6 inches). Skull height is the generally accepted unit for comparative measurements throughout much of the body.

CRANIUM

Skull segments (except lower jaw) interlock in a system of suture joints. Eight of these segments encase the brain. This protective shell, resembling an egg (large end behind), is called the cranium. Just as the egg is circular in transverse section and oval in longitudinal section, so is the cranium. Cranial bones consist of: 1 *frontal*, 1 *occipital*, 2 *parietals*, 2 *temporals*, 1 *sphenoid*, and 1 *ethmoid*. The ethmoid is of no structural importance and will be omitted here.

The FRONTAL, as its name suggests, is the broad bone of the forehead and forward roof of the skull. Rising gently at either side, from the smooth upper surface, are the *frontal eminences*. The forehead in life is the result of these two lateral swellings with their muscular jackets, blending more or less into one general swelling. Below the forehead, a more complex brow region consists of the delicate upper rims at the out-side of the orbits (eye sockets), and heavy bars, the *superciliary crests* (brow ridges), above the inner ends of the orbits. Both orbital rims and brow ridges are oblique in such a way as to describe a stretched-out letter M above the eyes. Orbital rims droop to the outside, each one terminating in a *zygomatic process* to join the zygomatic bone (cheekbone) in the face.[2] Being thinner, these orbital rims appear to be mortised into the coarser mass of brow ridges. The ridges very nearly merge above the root of the nose, being separated only by a small depression called the *glabella*. Brow form may be bold in the male skull, usually slight in females.

The OCCIPITAL [L. *ob*, against, + *caput*, head] is at the back of the head and may be seen to protrude somewhat. Its undersurface rests upon the spinal column at two knob-like *occipital condyles* (ellipsoid joint). These permit rocking movements of the head, as when we nod a 'yes.' The *occipital crest* in the median line terminates behind at the *occipital protuberance*, springboard for the fleshy contour of the neck.

The PARIETALS [L. *paries*, a wall] lie between frontal and occipital bones. They form the upper side walls and rear vaulted

[1] For relation of the Hyoid (tongue bone), see pp. 18, 99, 101.
[2] Cf. p. 14.

roof of the skull, uniting with each other in the midline much as the slanting sides of a gabled roof meet at the ridge pole. The point of greatest convexity in each bone is called the *parietal eminence*.

The TEMPORALS [L. *tempora,* the temples] form the lower side walls of the cranium in the region of the ears. Projecting forward from each bone is the slender root of the *zygomatic arch* to join the zygomatic bone (cheekbone)[3] in front. A smooth hollow beneath the root of the arch receives the head of the jawbone; and directly behind, the 'ear hole' (*auditory meatus*) shows a circular rim for attachment of the fleshy ear. Bulging downward to the rear of this 'ear hole' is the large *mastoid process,* and below the hole is a slender spur called the *styloid process.* The curved and jagged edge of the bony plate above the ear unites with sphenoid and parietal bones.

The SPHENOID [G. *sphene,* wedge], a single bone, straddles the undersurface of the cranium. It appears in both side walls between temporal and frontal bones at the regions known as the temples. For the artist's consideration, this bone at the temples may be said only to fill the gaps between temporal and frontal bones.

CRANIAL SUTURES

Each bone described above has ragged edges that allow it to fit tightly into the companion edges of adjacent bones. These meandering lines of union are the *cranial sutures.* In effect, they resemble the snug fit of Norway into Sweden. Three principal sutures are those bounding the parietal bones and appear from above to suggest the letter H. Frequently, in later life, an 'H' suture is raised enough to show as a blunt ridge; or it may just as often be traced as a very shallow furrow. Evidence of cranial sutures may be disclosed in the flesh by extensive baldness or by tonsure (head-shaving).

TEMPORAL LINE AND FOSSA

Arising from the outer end of the brow ridge and arching backward over the cranium is the *temporal line.* Here the distinction is seen between side wall and roof of the skull. The hollow of the side wall is called the *temporal fossa.* In life, it is filled by a jaw muscle (temporalis).

[3] Cf. p. 16.

FACE

The facial region of the skull hangs like a mask from beneath the small forward end of the ovoid cranium. There are 14 bones, including the movable lower jaw. Unlike bones of the case-like cranium, these are most irregular in shape and serve as a scaffolding for an intricate arrangement of facial muscles and sense organs. Facial bones consist of: 2 *zygomatics,* 2 *lacrimals,* 2 *nasals,* 1 *vomer,* 2 *nasal conchæ,* 2 *palates,* 2 *maxillæ, and* 1 *mandibula.* Except for the mandibula (lower jaw), they unite in suture joints. The lacrimals, vomer, nasal conchæ, and palate bones are of no structural importance and will be omitted here.

The ZYGOMATIC BONES [G. *zygoma,* yoke], or cheekbones, are prominent angular plates that fasten wing-like to the upper jaw and create a 'balcony' above the lower jaw. Three spurs are seen to leave the plate for separate destinations. One spur rises to the zygomatic process of the brow and gives the orbit its outer rim.[4] Another darts toward the nose and so contributes to the lower rim. A third spur reaches back to 'shake hands' with the forward-springing arm of the temporal bone. The slender *zygomatic arch* thus formed, a span from cheek to ear, suggests the bow of eyeglasses.[5]

The NASAL BONES [L. *nasus,* nose] project from beneath the wedge between the orbits. They are less than an inch in length and create a slanting roof (bridge) for the cavity of the nose.

The MAXILLÆ [L. jawbones], while they constitute the chief body of the upper jaw and give root to its teeth, also enter into the formation of the cheeks laterally and the wall of the nose above. Each maxilla sinks inward below the orbit, producing the *canine fossa* (filled with cheek muscles). In front, the two maxillæ join at the base of the inverted-heart-shaped nasal cavity in a pointed spur, the *nasal spine.* The *dental arch* in which the upper teeth are socketed is the margin of a bony plate, the *hard palate* (roof of the mouth).

The MANDIBULA [L. *mandere,* to chew] is the lower jawbone. In its forward reach, it underlies the maxillæ and is there called

[4] See Frontal bone, p. 10.
[5] Cf. pp. 11, 16, 18.

12

the *body*. The lower teeth take root in the *dental arch*, which traverses the upper border of the body. A projection at the chin is the *mental protuberance* [L. *mentum*, chin]. The *mental tubercles* are small lumps at either side of the midline and give squareness to the chin (said to be most distinct in males). Farther back at each side of the jaw, a broad, thin blade, the *ramus*, springs upward from the body. The rear 'corner' of the jaw, so produced, is called the *angle of the mandibula*. The angle is described by the lower border of the body and the rear border of the ramus, and ap-

proximates 120 degrees. This appears as the angle of four o'clock on the right side, eight o'clock on the left.[6] The ramus passes deep to the zygomatic arch.[7] There it divides into a forward *coronoid process* (for attachment of the temporalis muscle of mastication) and a rear *condyloid process* (for articulation with the skull). The latter process enters its socket in the temporal bone at the front of the 'ear hole' (hinge joint).

[6] The lower jaw is nearly horizontal at birth, its angle becoming more acute as maturity is approached.
[7] Cf. p. 16.

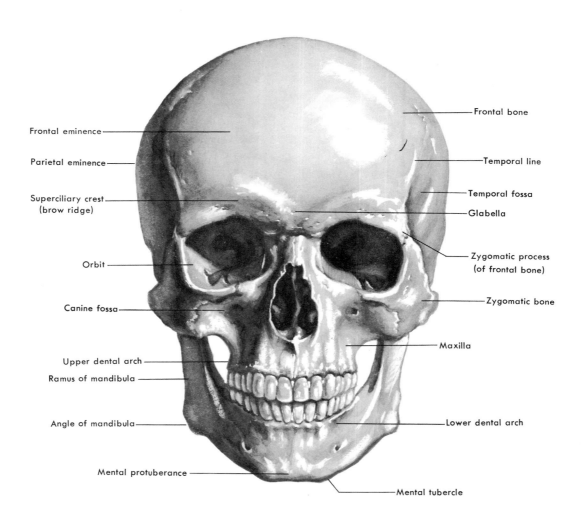

Frontal eminence

Parietal eminence

Superciliary crest
(brow ridge)

Orbit

Canine fossa

Upper dental arch

Ramus of mandibula

Angle of mandibula

Mental protuberance

Frontal bone

Temporal line

Temporal fossa

Glabella

Zygomatic process
(of frontal bone)

Zygomatic bone

Maxilla

Lower dental arch

Mental tubercle

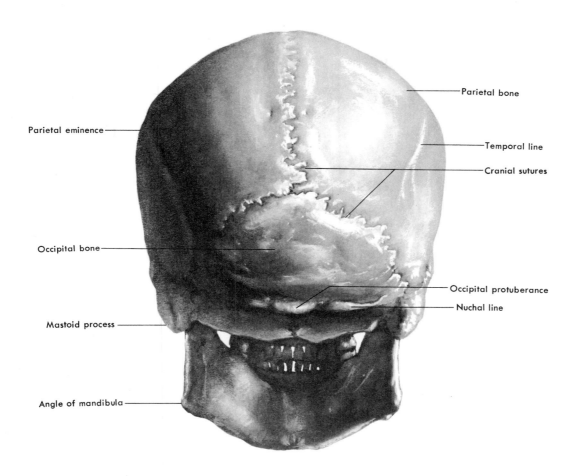

Parietal bone

Parietal eminence

Temporal line

Cranial sutures

Occipital bone

Occipital protuberance

Mastoid process

Nuchal line

Angle of mandibula

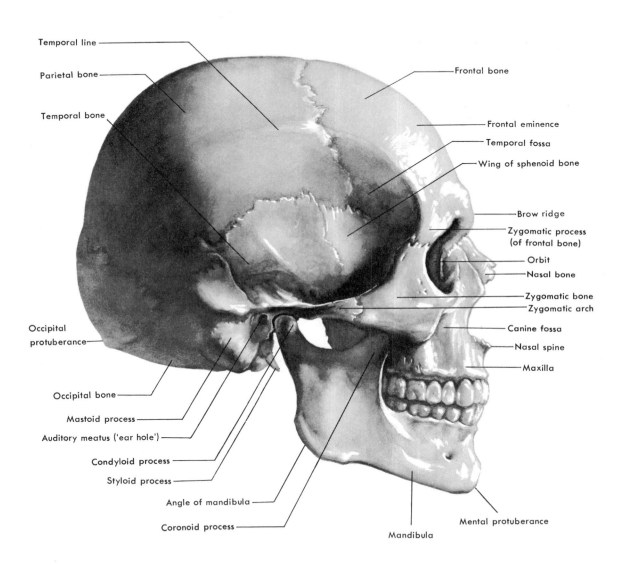

Temporal line

Parietal bone

Temporal bone

Frontal bone

Frontal eminence

Temporal fossa

Wing of sphenoid bone

Brow ridge

Zygomatic process
(of frontal bone)

Orbit

Nasal bone

Zygomatic bone

Zygomatic arch

Canine fossa

Nasal spine

Maxilla

Occipital
protuberance

Occipital bone

Mastoid process

Auditory meatus ('ear hole')

Condyloid process

Styloid process

Angle of mandibula

Coronoid process

Mental protuberance

Mandibula

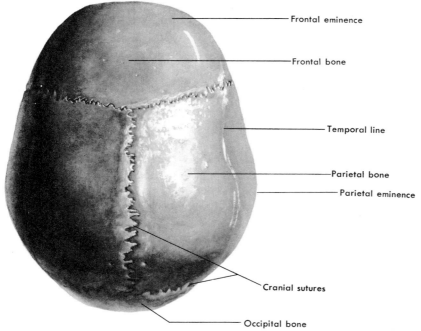

Frontal eminence

Frontal bone

Temporal line

Parietal bone

Parietal eminence

Cranial sutures

Occipital bone

from above

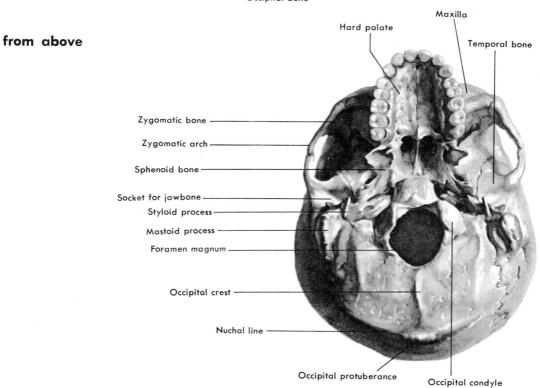

Hard palate

Maxilla

Temporal bone

Zygomatic bone

Zygomatic arch

Sphenoid bone

Socket for jawbone

Styloid process

Mastoid process

Foramen magnum

Occipital crest

Nuchal line

Occipital protuberance

Occipital condyle

from below

RELATION OF SKULL TO SURFACE FEATURES

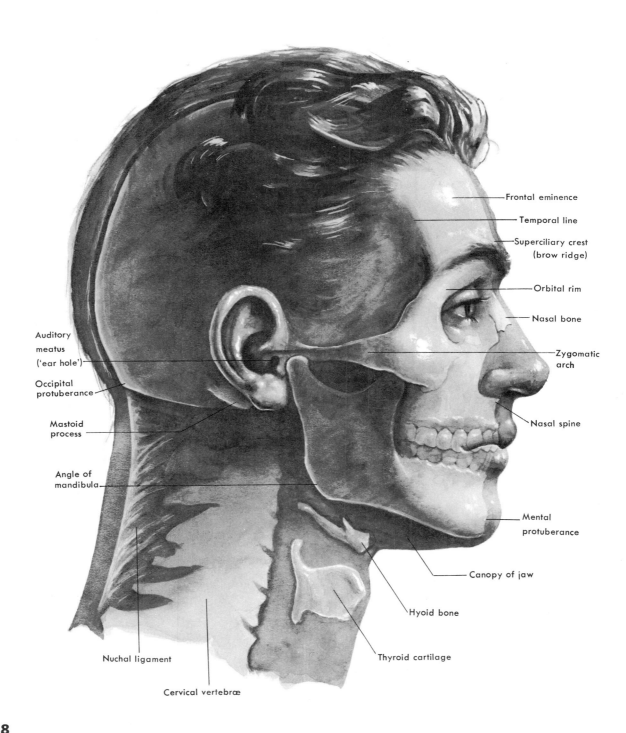

Frontal eminence

Temporal line

Superciliary crest
(brow ridge)

Orbital rim

Nasal bone

Zygomatic
arch

Auditory
meatus
('ear hole')

Occipital
protuberance

Mastoid
process

Nasal spine

Angle of
mandibula

Mental
protuberance

Canopy of jaw

Hyoid bone

Nuchal ligament

Thyroid cartilage

Cervical vertebræ

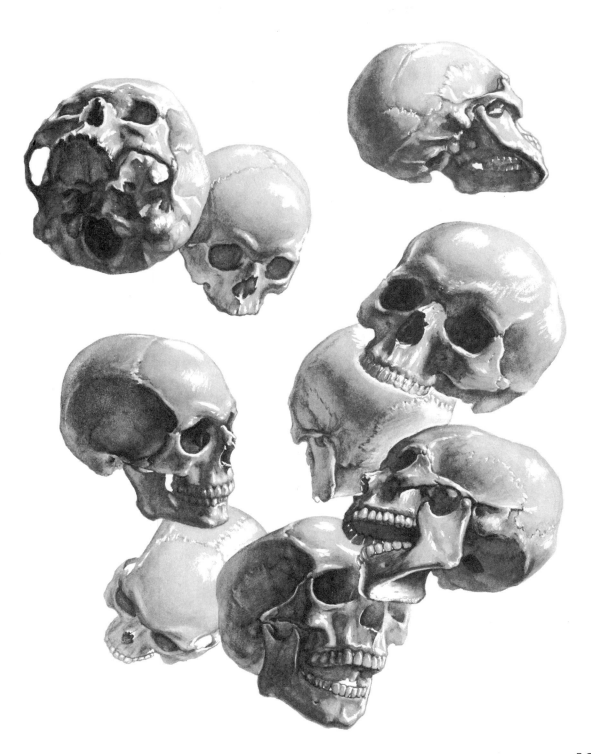

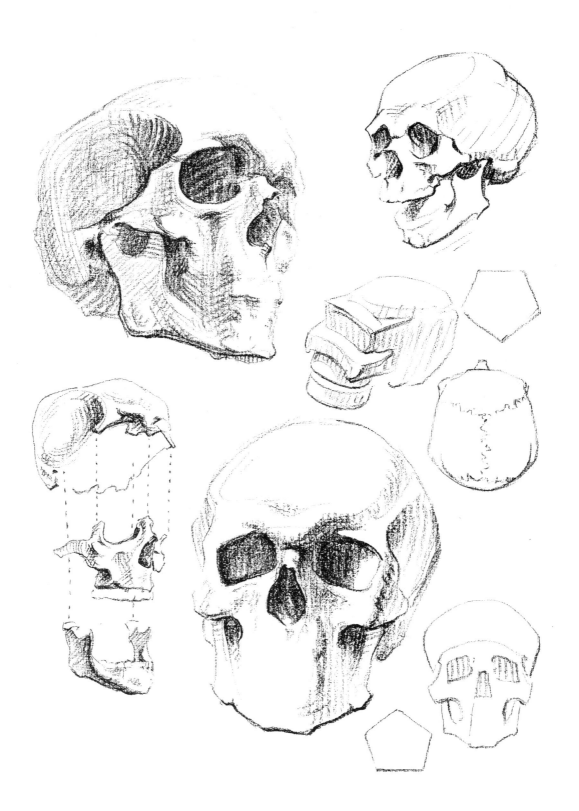

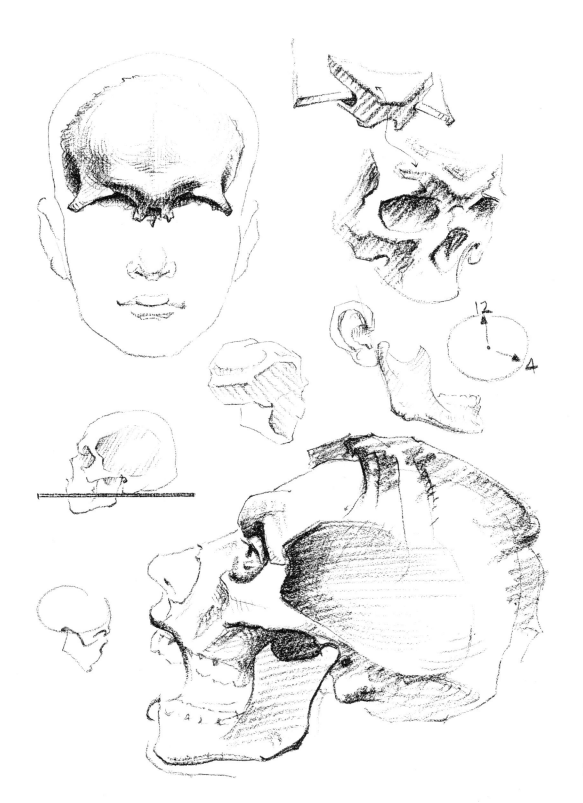

The SPINE, backbone

The skeletal axis is a curved and tapered column traversing the entire midline of the back, from fork to head. As it is required to sustain much weight and yet make allowance for contents of thorax and abdomen, precision of balance is imperative. This is effected by means of (1) a firm root in the pelvis, (2) variation in size of segments according to their loads, and (3) an ingenious four-arch curve. The spine is divisible into an immovable foundation below, consisting of the SACRUM and COCCYX, and a movable segmented shaft above, composed of VERTEBRÆ.

SACRUM AND COCCYX

The SACRUM [L. sacred bone] is a spade-shaped bone, bent convexly backward and wedged between the two iliac bones of the pelvis.[1] Securely planted upon its *base* above are the vertebræ; attached to the lower tip or *apex*, and terminating the spine below, is the COCCYX [G. *kokkux*, cuckoo] or tail bone. An important landmark of the back in life is the *sacral triangle*. It is bounded above by two dimple-like depressions at the posterior iliac spines,[2] and below by the cleft between the buttocks.

VERTEBRÆ

There are 24 vertebræ [L. *vertere*, to turn] named according to location. The 5 LUMBAR VERTEBRÆ [L. *lumbus*, loin] are largest of all, supporting the weight of thorax, arms, and head. They are especially capable of forward bending. No rotation is possible, and other movements are limited.

In the upper back, 12 THORACIC VERTEBRÆ give rise to as many pairs of ribs. This region is least flexible due to restraint imposed by the rib cage and the long spinous processes (see opp. page). It is capable of all movements, but only to a slight degree. The 7 CERVICAL VERTEBRÆ [L. *cervix*, neck] are relatively light, acting only as a pedestal for the skull. They are most flexible of all the vertebræ: capable of backward, forward, and lateral bending, as well as rotation. The uppermost member of the cervical family is the ATLAS (Cervical I), so called because it holds aloft the globe-like head. Its construction enables the head to rock backward and forward, as well as laterally. Beneath is the AXIS (Cervical II), which provides a rotary articulation with the Atlas, making possible swivel movements of the head. The upper six vertebræ lie deep from the surface under the *nuchal ligament* [*nucha*=nape of neck], a sort of check-rein from the cervical spine to the occipital crest and protuberance of the cranium.[3] Cervical VII reaches the surface to become conspicuous in life as the VERTEBRA PROMINENS.

The spinal column presents, in the rear, three longitudinal rows of spurs. The high center row (spinous processes) alone is evident at the surface, especially at the mid-region of the back. Its companion rows lie at either side, separated from it by the 'spinal gutters' in which are entrenched the long muscles acting on the spine.

[1] Cf. pp. 61-3.
[2] Ibid.
[3] Cf. p. 18.

A TYPICAL VERTEBRA

The form of a typical vertebra consists of a body, an arch, and a number of prongs associated with the arch. The *body* is the large central mass. It yields broad upper and lower surfaces for articulation (fibro-cartilage) with the bodies of adjoining vertebræ. Projecting backward in two roots from this body is the *vertebral arch,* surrounding the opening for the spinal cord. This arch gives rise to (1) two pairs of articular processes (above and below), (2) a pair of transverse processes, and (3) a spinous process. The *articular processes* unite with their companion articular facets of adjoining vertebræ (plane joints). To-gether with the spinous processes, they engage in a backward, mechanical locking operation. This helps to carry the spine upright and prevent injury to the contents of the chest by backward bending. The *transverse processes* are deep and serve as muscular attachments. The *spinous process* of each vertebra, except Cervicals I-VI, may be seen or felt at the surface. A cervical process fans like a lobster's tail; a thoracic process is a long spike; a lumbar process resembles the blade of an axe. But these are traits of the dry skeleton, not observed in a live subject. Thoracic vertebræ are distinguished by their facets for articulation with the ribs (plane joints).

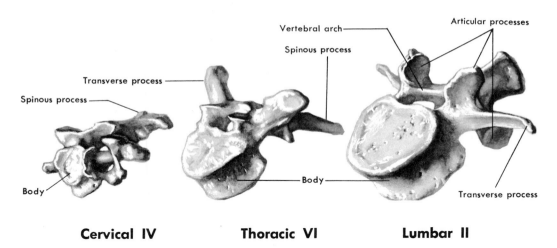

Cervical IV **Thoracic VI** **Lumbar II**

INTER-VERTEBRAL DISCS are thick cushions of fibro-cartilage, inserted between the bodies of adjoining vertebræ. They afford a resilience appreciable only in the collective movements of many vertebræ.

SPINAL CURVATURE:
THE FOUR-ARCH CURVE

It will be seen, in the side view, that the spine arches convexly forward in the neck and loins, and backward in the thorax and pelvis. The backward convexities are essential for the maintenance of chest and pelvic cavities required by vital structures. The forward convexities are compensatory. If we evaluate the curves in terms of speed, this serpentine profile is found to be accelerated downward: a slow (nearly straight) cervical curve, a very fast sacral curve. Longest of the spinal curves is that of the thorax.

SPINE

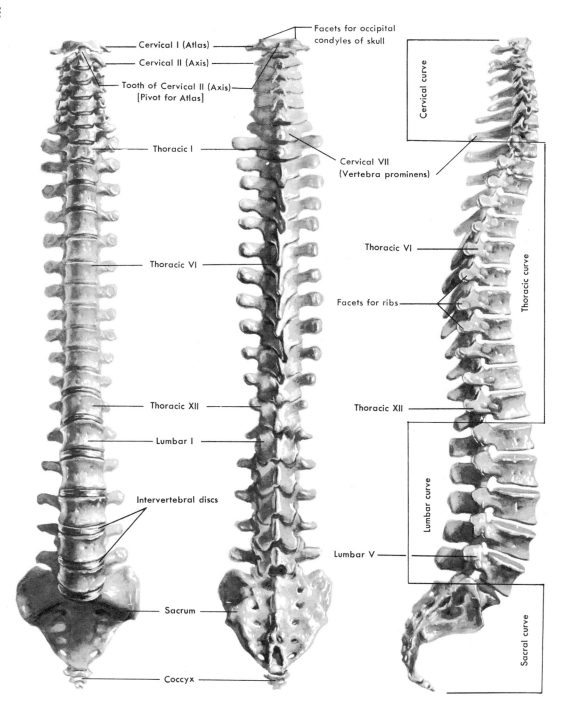

Cervical I (Atlas)

Cervical II (Axis)

Tooth of Cervical II (Axis)
[Pivot for Atlas]

Facets for occipital
condyles of skull

Thoracic I

Cervical VII
(Vertebra prominens)

Thoracic VI

Thoracic VI

Facets for ribs

Thoracic XII

Thoracic XII

Lumbar I

Intervertebral discs

Lumbar V

Sacrum

Coccyx

Cervical curve

Thoracic curve

Lumbar curve

Sacral curve

from in front **from behind** **from the right side**

from in front

from behind

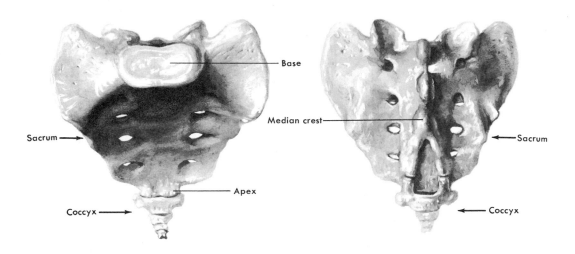

Base

Median crest

Sacrum

Sacrum

Apex

Coccyx

Coccyx

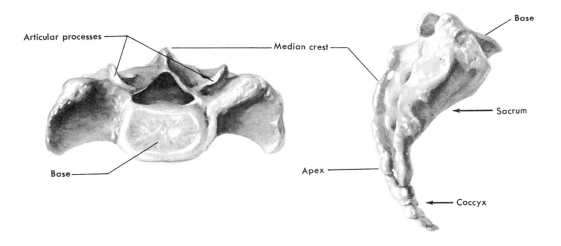

Articular processes

Median crest

Base

Base

Sacrum

Apex

Coccyx

from above

from the right side

Springing forward from the twelve thoracic vertebræ of the spine is the thorax [G. a cuirass], a slatted protective cage for the contents of the chest cavity and an anchorage for external trunk muscles. In general shape this cage resembles an egg, small end above. But the ovoid form is slightly compressed from front to rear, causing it to be wider than it is deep. In height, it is half again that of the skull. There is a large aperture below, whose front margin arches upward to the *pit of the stomach* (see below: *xiphoid process*). This rim, known as the *thoracic arch,* is a conspicuous surface feature of the torso. The angle formed by right and left sides of the arch may reach 90 degrees (right angle) in well-developed subjects. The small aperture above is kidney-shaped and corresponds in size to the neck, which emerges from it. In the front center wall of the chest are the STERNUM and its strap-like COSTAL CARTILAGES [L. *costis*, rib]; at the rear is the column of THORACIC VERTEBRÆ. The remainder of the thorax is composed of RIBS, derived behind from facets in the thoracic vertebræ and making their cartilage attachments in front to the sternum. Any movement among parts of the thorax is imperceptible. But as a unit, the thorax may rise forward and drop backward as in respiration; or it may be subject to slight expansion and compression caused by bending backward, forward, or sideward, and by respiration.

STERNUM

The sternum [G. *sternon*, the breast], or breastbone, gathers up the ribs in the midline. It is from 6 to 8 inches in length, thrust like a dagger downward and outward at the middle of the chest. Its parts are named accordingly: *manubrium* [L. handle]; *body*; and *xiphoid process* [G. *xiphos,* sword].

The *manubrium* is a flat plate whose upper margin displays three indented surfaces. Those on either side receive the clavicles (collarbones). The middle depression is called the *jugular notch,* accentuated by the presence of clavicles. It supplies the floor for a significant surface landmark, the *pit of the neck.* The lower margin of the manubrium is dented on either side to receive the cartilage of the first rib.

The *body* is twice the length of the manubrium, with which it forms a slight forward angle. The union may be cartilaginous or bony. Both manubrium and body furnish, along their outer borders, points of attachment for rib cartilages.

The *xiphoid process* may be either bone or cartilage. It is about as large as the last segment of the thumb, and it lies suspended from the body of the sternum at the pit of the stomach. The xiphoid's claim to attention is the fact of its position as the apex of the thoracic arch.

RIBS

The greater part of the thoracic cage is formed by 12 pairs of ribs. These are flat, twisted blades curving about from the thoracic vertebræ behind and swinging obliquely downward to the front. Most of the ribs produce a costal cartilage for attachment to the sternum. The

obliquity of direction is greatest in the lower thorax. Length decreases from the eighth ribs both above and below. Spaces between ribs are called *intercostal spaces* (the first space lies between first and second ribs).

The particular method of sternal attachment is denoted by classification of the ribs. The upper seven pairs are TRUE RIBS because they establish a direct contact with the sternum by individual cartilages. The lower five pairs are FALSE RIBS. Ribs VIII, IX, and X each have a strap of cartilage, which fastens to the strap above it. The resulting cartilaginous rim, at the lower front edge of the cage, has been described as the *thoracic arch*. Ribs XI and XII, called FLOATING RIBS, are without cartilage and have no sternal attachment whatever. They lie more or less concealed within the wall of the back. Evidence of individual ribs in the healthy subject is best seen at the lower end

of the rib cage, especially to the rear. Superficial rib-like swellings high at the sides are, in reality, bundles of muscle fiber which arise from the ribs.[1]

A TYPICAL RIB

Each rib articulates at its *head* with facets in the vertebral column (plane joints).[2] The constriction next to the head is the *neck,* and beyond the neck is a *tubercle* making contact with the transverse process of its corresponding vertebra. The remainder of the rib, flat and blade-like, is called the *body*. At first, the rib runs laterally and somewhat backward; but at a short distance beyond its tubercle it takes a sharp turn forward. This *angle* of the rib is a special distinction of Man. Unlike most animals, he may lie upon his broad, flat back with ease.

[1] Cf. pp. 102, 106: *serratus* and *external oblique* muscles.
[2] Cf. pp. 23, 24.

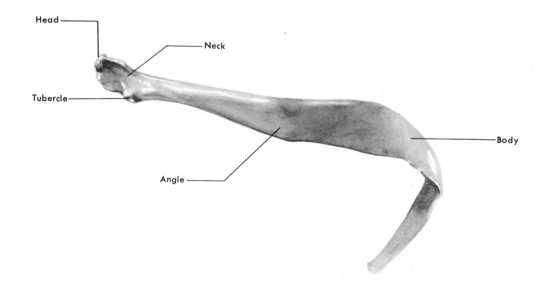

Head — Neck — Tubercle — Angle — Body

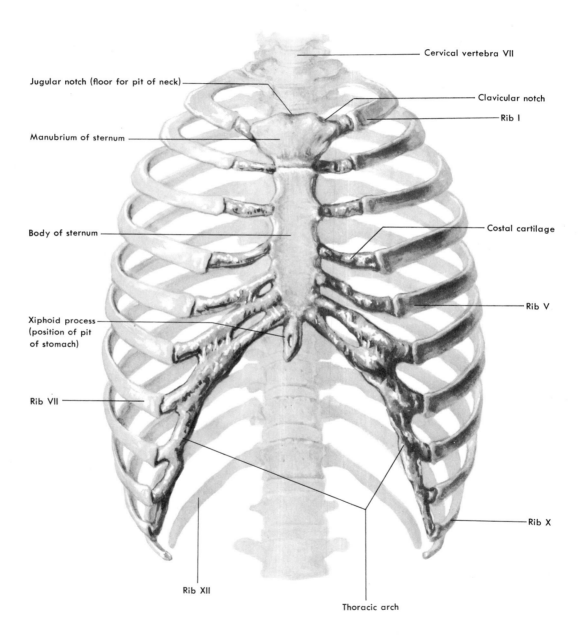

Cervical vertebra VII

Jugular notch (floor for pit of neck)

Clavicular notch

Rib I

Manubrium of sternum

Body of sternum

Costal cartilage

Rib V

Xiphoid process
(position of pit
of stomach)

Rib VII

Rib X

Rib XII

Thoracic arch

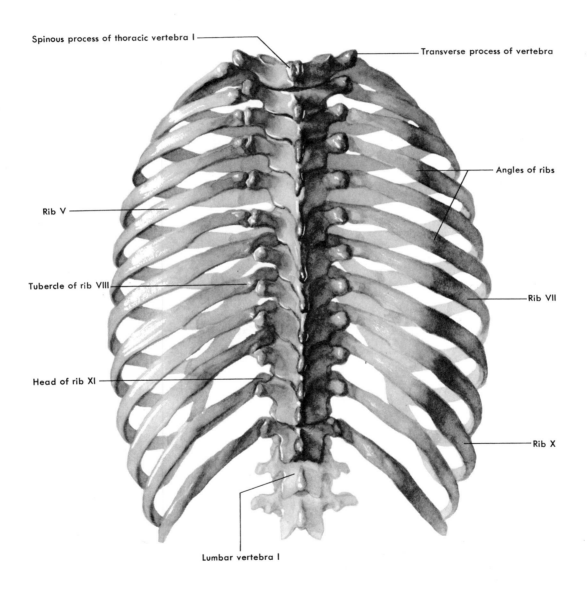

Spinous process of thoracic vertebra I

Transverse process of vertebra

Angles of ribs

Rib V

Tubercle of rib VIII

Rib VII

Head of rib XI

Rib X

Lumbar vertebra I

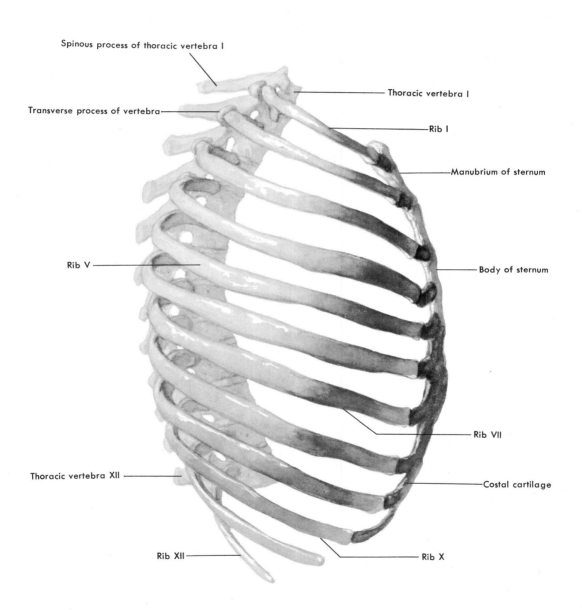

Spinous process of thoracic vertebra I

Thoracic vertebra I

Transverse process of vertebra

Rib I

Manubrium of sternum

Rib V

Body of sternum

Rib VII

Thoracic vertebra XII

Costal cartilage

Rib XII

Rib X

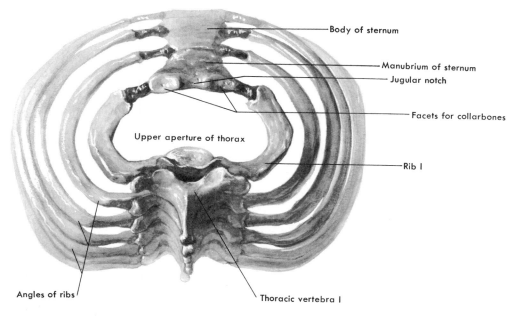

Body of sternum

Manubrium of sternum

Jugular notch

Facets for collarbones

Upper aperture of thorax

Rib I

Angles of ribs

Thoracic vertebra I

from above

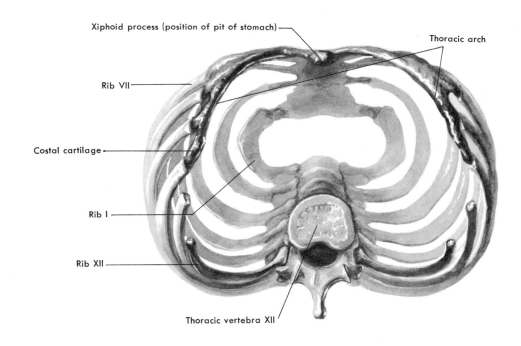

Xiphoid process (position of pit of stomach)

Thoracic arch

Rib VII

Costal cartilage

Rib I

Rib XII

Thoracic vertebra XII

from below

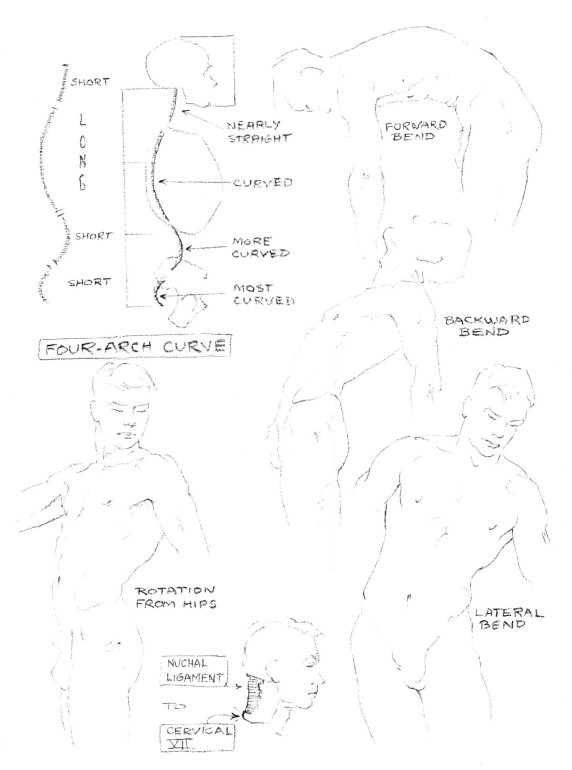

SHORT

L
O
N
G

SHORT

SHORT

NEARLY
STRAIGHT

CURVED

MORE
CURVED

MOST
CURVED

FOUR-ARCH CURVE

FORWARD
BEND

BACKWARD
BEND

LATERAL
BEND

ROTATION
FROM HIPS

NUCHAL
LIGAMENT

TO

CERVICAL
VII

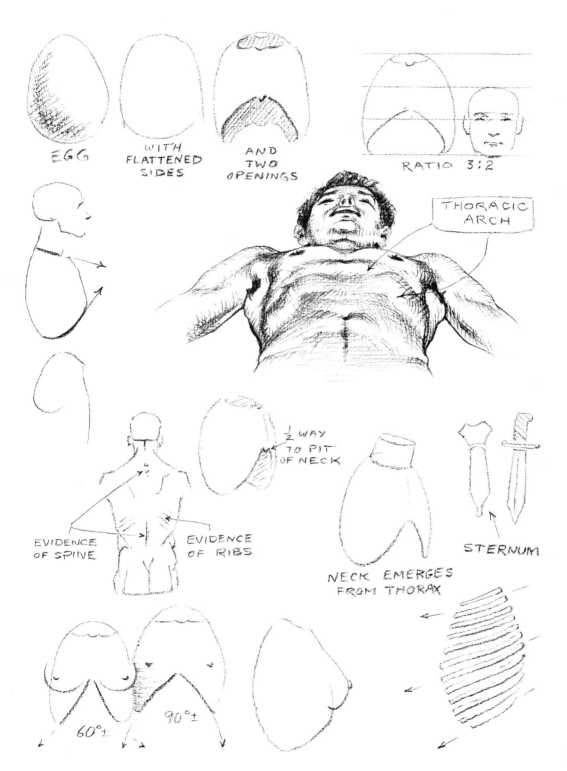

EGG

WITH
FLATTENED
SIDES

AND
TWO
OPENINGS

RATIO 3:2

THORACIC
ARCH

½ WAY
TO PIT
OF NECK

EVIDENCE
OF SPINE

EVIDENCE
OF RIBS

NECK EMERGES
FROM THORAX

STERNUM

60°±

90°±

33

The SCAPULA, shoulder blade

The trowel-like bony plate, conspicuous at either side in the upper back, is called the scapula [G. *scapane*, a digging tool]. It extends, when the arm is at the side, from the second to between the seventh and eighth ribs. This closely parallels the position of the sternum in front. The average vertical length is about 6½ inches, and this same span is found between right and left scapulæ at their lower tips. The scapula furnishes a socket for the bone of the upper arm. It has axial attachment only by way of the collarbone, with which it joins to form the shoulder girdle. Movement consists of gliding and wheeling upon the ribs. Structurally, the scapula is divisible into a body, a spine, and a process.

The BODY is thin, triangular, and bent forward to fit the thorax. The sides of the body are called margins: (1) the *upper margin*, above; (2) the *vertebral margin*, facing the spine; and (3) the *axillary margin*,[1] facing the arm. The angles are called: (1) *medial*; (2) *lateral*; and (3) *lower*. The lateral angle is enlarged and more often called the *head*. It has a hollowed surface, the *glenoid fossa*, which receives the bone of the upper arm (ball-and-socket joint).[2] Surface muscles obscure the scapular body, but evidence of the vertebral margin and lower angle may be present in the live subject.

The SPINE is a high crest on the back of the scapular body, situated on a line with the glenoid fossa. It rises from the vertebral margin, ascends laterally, and arches over and beyond the head. It expands and projects outward as a partial roof over the socket of the arm and is there called the *acromion process*. Depressed surfaces are created above and below by the ascending spine: the *supraspinous fossa* and *infraspinous fossa*, respectively. Superficially, the spine is in evidence throughout, but usually as a shallow groove separating the muscular forms above and below.

The CORACOID PROCESS [G. *korax*, crow: resemblance to beak] arises from the top of the lateral angle (head); it protrudes forward and laterally, like a curled finger pointing to the bone of the upper arm. In the live subject, it lies close to the triangular hollow (infraclavicular fossa) below the collarbone.

ELEVATION OF THE ARM

A sideward lifting of the arm is assisted by wheeling of the scapula, so that its acromion is drawn upward and medially while the lower angle is drawn upward and laterally. But scapular and arm movements are not entirely synchronized. Wheeling of the scapula lags behind elevation of the humerus until the arm rises above the horizontal. Here arm movement diminishes quickly, and further elevation is promoted chiefly by play of the scapula. It is the story of the tortoise and the hare. Although the sluggish tortoise (scapula) seems ill-matched against a bounding hare (humerus), he overtakes the swift but foolish creature and wins the race.

[1] *Axilla* [L. armpit].
[2] Cf. p. 37.

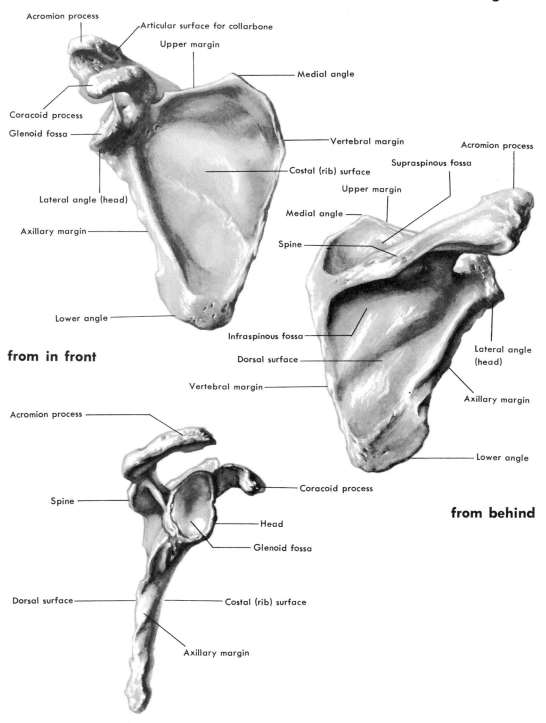

Acromion process
Articular surface for collarbone
Upper margin
Medial angle
Coracoid process
Glenoid fossa
Vertebral margin
Costal (rib) surface
Supraspinous fossa
Acromion process
Upper margin
Lateral angle (head)
Medial angle
Spine
Axillary margin
Lower angle
Infraspinous fossa
Lateral angle (head)
Dorsal surface
Axillary margin
Vertebral margin

from in front

Lower angle

from behind

Acromion process
Coracoid process
Spine
Head
Glenoid fossa
Dorsal surface
Costal (rib) surface
Axillary margin

from the outer side

35

The CLAVICLE, collarbone

The slender clavicle [L. *clavis,* a key] forms the only bony connection of the upper limb with the trunk; and it is the last bone to attain full growth (about 6 inches in length). It springs laterally from the sternum and crosses the summit of the rib cage to meet the acromion process of the scapula.[1] In pivot movements from the pit of the neck, the clavicle calls to mind the jib of a crane—with the entire upper limb slung from its outer end. The clavicle consists of a shaft and its two articular ends.

The MEDIAL END or *sternal end* of the clavicle articulates, at one side of the pit of the neck, with the upper margin of the sternum (modified ball-and-socket joint).[2] This joint is a pivot for the great range of movement in the upper limb.

The LATERAL END or *acromial end* of the clavicle joins the large acromion process of the scapular spine (plane joint).[3] In effect, the latter is an extension of the clavicle itself but is a step down from the clavicle.

The SHAFT of the clavicle describes a double curve: the longer, medial curve bends forward, and the shorter, lateral curve bends backward. The *deltoid tubercle* (for attachment of deltoid muscle) is a roughened prominence found at the front of the shaft, between the two curves. It occupies a position directly above the coracoid process of the scapula.[4]

The sternal ends of right and left clavicles are separated by about one inch. This *suprasternal space* is the familiar pit of the neck.[5] Above and below the middle of each clavicle, in life, are conspicuous surface hollows: the *supraclavicular fossa* and *infraclavicular fossa,* respectively. The center portion of the bone remains clearly visible. The forward part of the shoulder girdle[6] can be traced from one side to the other and seen, as from above, to resemble a Cupid's bow.

[1] Cf. p. 6.
[2] Cf. p. 28, 31.
[3] See opp. page.
[4] See opp. page.
[5] See also p. 26: *Sternum.*
[6] The rear part is formed by the scapulæ.

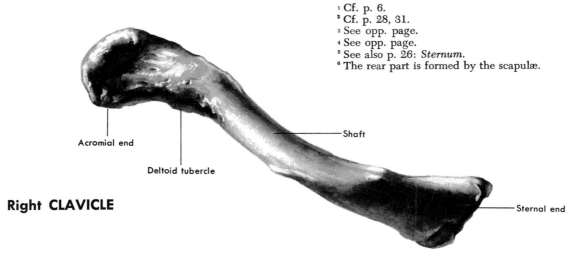

Acromial end

Deltoid tubercle

Shaft

Right CLAVICLE

Sternal end

from above

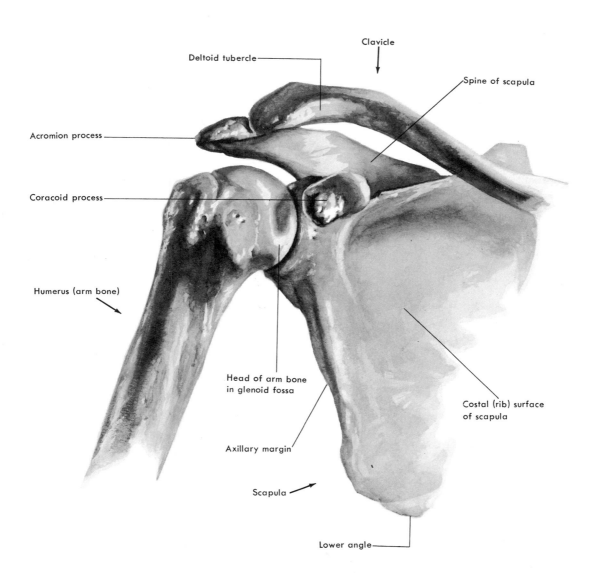

Deltoid tubercle

Clavicle

Spine of scapula

Acromion process

Coracoid process

Humerus (arm bone)

Head of arm bone
in glenoid fossa

Costal (rib) surface
of scapula

Axillary margin

Scapula

Lower angle

RIB I

STEP DOWN TO CHEST

SCAPULA

CLAVICLE MEETS A

38

TROWEL - SHAPED

EDGE

FULL
PLANE

30°

STEP-DOWN
TO ACROMIONS

39

The HUMERUS, bone of the upper arm

The humerus [L. shoulder] is the longest and heaviest bone of the upper limb, and the only bone of the arm proper. In length, the average humerus measures about 13 inches, or half again the height of the skull. It consists of a narrow shaft enlarged at each articular end.

The PROXIMAL 'END is composed of the head and tubercles. The *head* is a smooth half-sphere looking somewhat backward to articulate with the shoulder blade (ball-and-socket joint). Flanking the head from in front are *major and minor tubercles*, separated from each other by the *intertubercular groove*. The squared major tubercle, on the outside, stands as the outermost bony projection of the shoulder and gives attachment to scapular muscles.

The SHAFT, as seen from the side, suggests an S-curve—especially in its lower half, which arches backward. This concavity is filled by a muscle (brachialis) low on the front of the arm. The high muscle (triceps) at the back is left to bulge noticeably backward.[1] Midway down the outside of the shaft is the *deltoid tuberosity* (attachment for deltoid muscle).

The DISTAL END is a broad plate, modified so as to articulate in a special way with each of the two forearm bones. It is most directly associated with the ulna (inner forearm bone), which swings up and down on the oblique spool called the *trochlea* [L. pulley]

(hinge joint). Laterally, articulation with the radius (outer forearm bone) is made at the ball-shaped *capitulum* (converse ball-and-socket joint).[2] Here the capitulum provides a surface upon which the indented head of the radius may glide and revolve. Directly above the capitulum and trochlea, in front, are pits that allow a far upward-bending of the forearm bones. Behind, the *olecranon fossa* receives the rear (olecranon) process of the ulna in full backward extension. At the sides two swellings appear, called *medial and lateral epicondyles*. The medial epicondyle is the most prominent in both skeleton and live subject. When the arm hangs at the side, this projection is found at or below the lowest margin of the rib cage. The lateral epicondyle is at the bottom of a pit in the fully extended fleshy elbow, protruding itself only in flexion.

FLEXION OF THE ELBOW

It should be noted that the extended ulna points laterally to form an angle with the humerus (more pronounced in the female); further, that its hinge movement is associated with the oblique trochlea (of the humerus), whose axis bisects the angle formed. It follows, then, that flexion at the elbow will bring the ulna in line with the humerus.

[1] Cf. p. 115.
[2] Cf. pp. 43, 45.

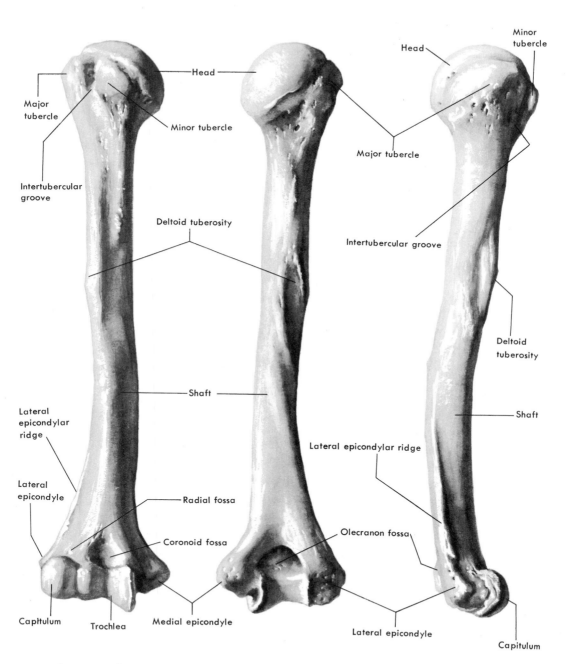

Head

Major tubercle

Minor tubercle

Intertubercular groove

Deltoid tuberosity

Lateral epicondylar ridge

Lateral epicondyle

Radial fossa

Coronoid fossa

Capitulum

Trochlea

Medial epicondyle

Head

Major tubercle

Shaft

Olecranon fossa

Lateral epicondyle

Head

Minor tubercle

Major tubercle

Intertubercular groove

Deltoid tuberosity

Shaft

Lateral epicondylar ridge

Capitulum

from in front **from behind** **from the outer side**

The RADIUS and ULNA, spoke bone and elbow bone [1]

The radius and ulna extend at an angle laterally from the lower end of the humerus. Both are shorter and more slender than the bone of the upper arm, and they support the forearm on its thumb and little-finger sides respectively. The radius is lower than the ulna, as if it had slipped downward, and is more concealed. [2] Both are somewhat flattened in front and high at the rear, with blade-like neighboring edges. Moreover, both have reverse curves so that, while the radius lies snugly against the ulna above, their lower halves are bowed outward. Hence, the space between bones is appreciable only below. The ulna is largest above, having firm articulation there with the humerus, and tapers noticeably downward. No bony connection is made with the wrist. The radius, however, is largest below, displaying a broad articular surface for wristbones. Above, it tapers to the elbow where it has only passive connection with the humerus. Thus, a transfer of power is made in the forearm: a shifting from humerus and ulna above to radius and hand below. Each forearm bone is divisible into its shaft and two articular ends.

ULNA

The PROXIMAL END of the ulna [L. elbow] is an enlargement much like a claw, designed to grasp the lower end of the humerus. [3] The *olecranon process* [G. *olene*, elbow, + *kranion*, head] is the rear square mass of this region, conspicuous in life as the hard knob at the back of the elbow (attachment for triceps muscle). It is capable of being received in extension by the corresponding olecranon fossa of the humerus. [4] In front, the pointed *coronoid process* [G. *korone,* crow: resemblance to beak] is directed toward a pit in the humerus where it may arrive in flexion. The intervening hollow, called the *semilunar notch,* is an articular surface riding upon the grooved trochlea of the humerus (hinge joint). At the outer side of the coronoid process is a shallow depression, the *radial notch,* for reception of the head of the radius (pivot joint). Below the coronoid process is the *ulnar tuberosity* (attachment for brachialis muscle).

The SHAFT tapers in its descent. Above, it leans toward the radius; below, it springs away from that bone. The *ulnar crest,* at the back of the shaft, is superficial in its entire length—running from elbow to little-finger side of wrist.

The DISTAL END, or *head,* is small and rounded, and has articulation with the radius (pivot joint). It is readily seen protruding from the little-finger side of the forearm, just above the wrist. The *styloid process* is a spur pointing downward from the rear, medial side of the head.

[1] Description based on supine (parallel) position of bones.
[2] Associate *ulna* with *upper,* since it is placed higher than the radius.
[3] See also p. 40: *Flexion of the Elbow.*
[4] Cf. pp. 41, 45.

RADIUS

The PROXIMAL END of the radius [L. shaft] is slender. Perched at its summit is the radial *head*, shaped like a thick button. The circular character of this head allows it to revolve within the corresponding radial notch of the ulna (pivot joint). At the same time, the concave upper surface of the head is an articular *facet* gliding upon the capitulum of the humerus (converse ball-and-socket joint).[5] Below the head, and facing the tuberosity of the ulna, is the large *radial tuberosity* (attachment for biceps muscle).

The SHAFT of the radius expands as it descends from the elbow. Above, it lies close to the ulna; below, it arches away from that bone.

The DISTAL END is a wide block scooped out to receive the wristbones (ellipsoid joint).[6] The narrow medial surface of this block is indented to fit over the small ulnar head and is called the *ulnar notch*. Laterally, the lower end of the radius is superficial as a small spur, the *styloid process.*

SUPINATION AND PRONATION

In addition to the hinge-like movements of flexion and extension upon the humerus, the bones of the forearm are capable of turning the hand face up or face down. These movements are called, respectively, *supination* and *pronation*. The ulna is the stationary bone, leaving the radius to bring about the alteration. The radial head resembles a wheel, revolving within the radial notch of the ulna. This upper revolution is a pivot for a much wider one at the wrist, where the broad radial block swings around the small ulnar head. SUPINATION requires that both bones be parallel, with thumb directed away from the body. PRONATION is brought about when the radius turns on its pivot above, crosses the ulnar shaft obliquely, and leaves the thumb directed toward the body. Complete pronation involves some rotation of the upper arm and, therefore, a rotation of the axis of epicondyles on the humerus.

[5] Cf. p. 45.
[6] Cf. p. 53.

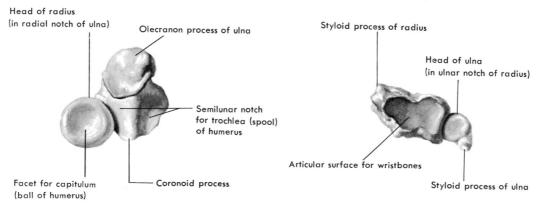

Right RADIUS and ULNA

Head of radius (in radial notch of ulna)

Olecranon process of ulna

Semilunar notch for trochlea (spool) of humerus

Facet for capitulum (ball of humerus)

Coronoid process

Styloid process of radius

Head of ulna (in ulnar notch of radius)

Articular surface for wristbones

Styloid process of ulna

from above

from below

43

Right RADIUS and ULNA

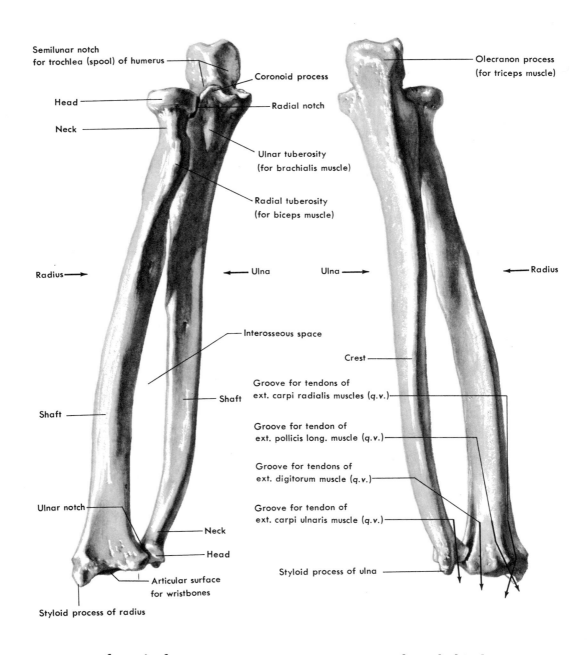

Semilunar notch for trochlea (spool) of humerus

Coronoid process

Head

Radial notch

Neck

Ulnar tuberosity (for brachialis muscle)

Radial tuberosity (for biceps muscle)

Olecranon process (for triceps muscle)

Radius→

←Ulna

Ulna→

←Radius

Interosseous space

Crest

Shaft

Groove for tendons of ext. carpi radialis muscles (q.v.)

Shaft

Groove for tendon of ext. pollicis long. muscle (q.v.)

Groove for tendons of ext. digitorum muscle (q.v.)

Groove for tendon of ext. carpi ulnaris muscle (q.v.)

Ulnar notch

Neck

Head

Styloid process of ulna

Articular surface for wristbones

Styloid process of radius

from in front

from behind

from behind the outer side

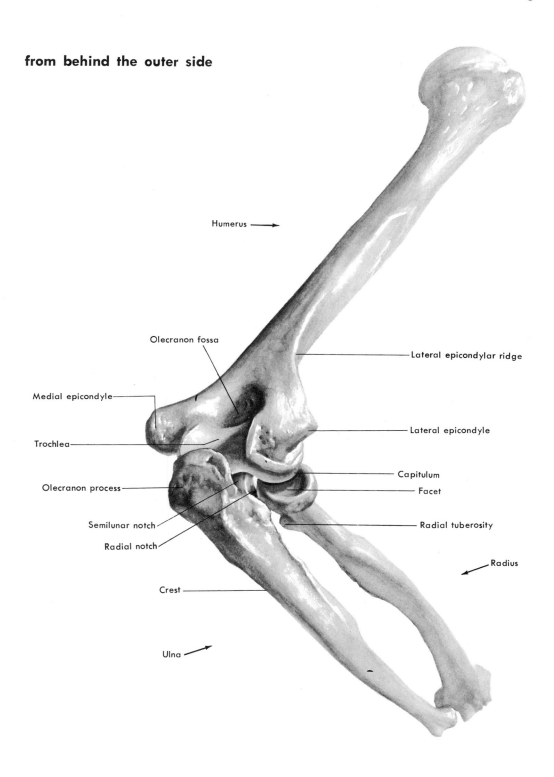

Humerus ⟶

Olecranon fossa

Lateral epicondylar ridge

Medial epicondyle

Lateral epicondyle

Trochlea

Capitulum

Olecranon process

Facet

Semilunar notch

Radial tuberosity

Radial notch

Crest

Radius

Ulna ⟶

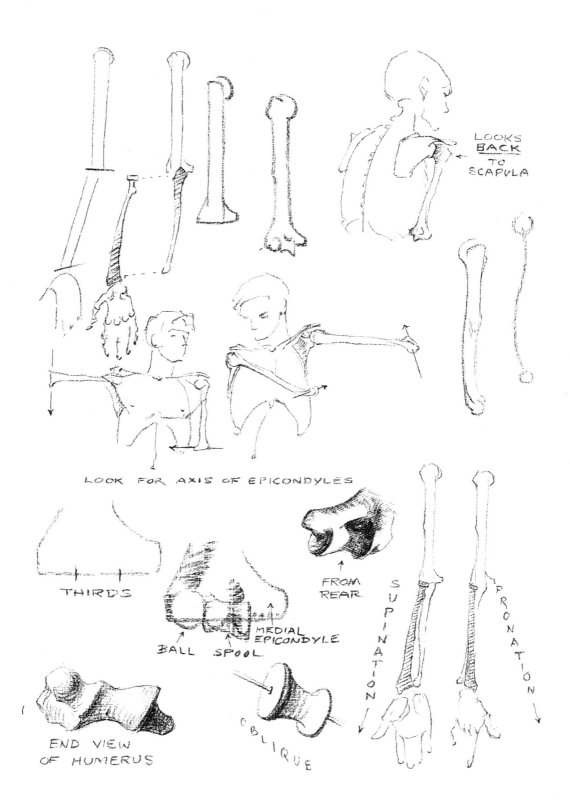

LOOKS
BACK
TO
SCAPULA

LOOK FOR AXIS OF EPICONDYLES

THIRDS

FROM
REAR

SUPINATION

PRONATION

BALL SPOOL

MEDIAL
EPICONDYLE

END VIEW
OF HUMERUS

OBLIQUE

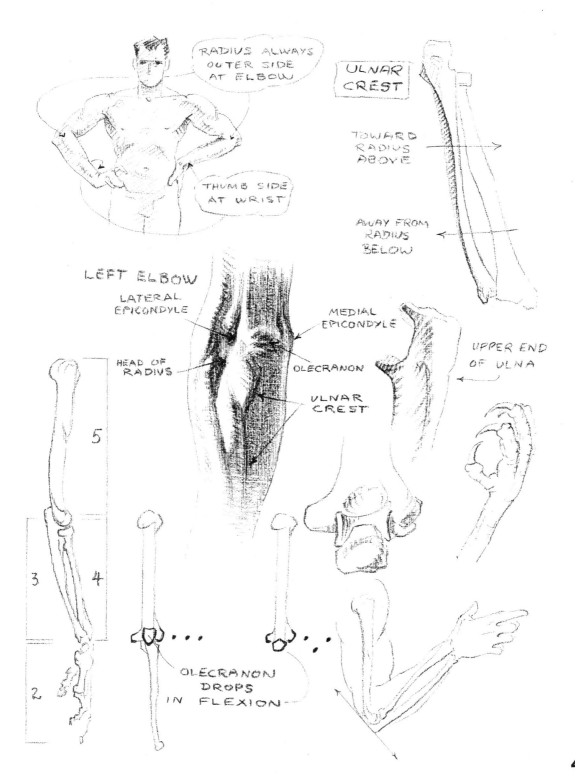

RADIUS ALWAYS
OUTER SIDE
AT ELBOW

THUMB SIDE
AT WRIST

ULNAR
CREST

TOWARD
RADIUS
ABOVE

AWAY FROM
RADIUS
BELOW

LEFT ELBOW

LATERAL
EPICONDYLE

MEDIAL
EPICONDYLE

HEAD OF
RADIUS

OLECRANON

ULNAR
CREST

UPPER END
OF ULNA

5

3 4

2

OLECRANON
DROPS
IN FLEXION

The HAND and WRIST

The hand and wrist form the terminus of the upper extremity. In length the unit is two thirds of a forearm, or somewhat less than one head-length. The skeleton of the wrist consists of 8 irregular CARPAL BONES. There are 5 slender METACARPALS, embedded in the palm of the hand, and 14 PHALANGES (knucklebones), which form the independent parts of the fingers.

CARPALS

PROXIMAL ROW

(beginning thumb side)
1. *Navicular* [boat-shaped]
2. *Lunate* [crescent-shaped]
3. *Triquetrum* [three-cornered]
4. *Pisiform* [pea-shaped]

DISTAL ROW

(beginning thumb side)
5. *Major multangular* [large, many corners]
6. *Minor multangular* [small, many corners]
7. *Capitate* [head-shaped]
8. *Hamate* [hook-shaped]

The mass of carpals [G. *karpos,* wrist] shows a rounded upper surface for contact with the scooped-out end of the radius (ellipsoid joint).[1] It has the form of an arch, supported by two spurs on the palmar side of the wrist. At the root of the thumb, close to the center of the fleshy wrist, the adjacent tubercles of major multangular and navicular bones produce a *thumb-side spur.* Slightly higher, at the little-finger side, close to the inner contour of the fleshy wrist, the 'hook' of the hamate and the small pisiform bone produce a *little-finger-side spur.* Both can be seen when the hand is bent back. In effect, the spurs are like a mooring chock steering finger tendons to the palm. And more important, they give anchorage to various muscles and tendons. The segments of the thumb arise from a bony jog at the radial side of the wrist. (Carpals unite among themselves in plane joints.)

METACARPALS

The metacarpals [G. *meta*, beyond, + *karpos*, wrist] lie fanwise in the palm of the hand. All except thumb radiate from an imaginary center above the lower end of the radius. Metacarpals are numbered I–V, beginning at the thumb. Those of index and middle fingers are longest, and their rounded ends may be found midway between radius and longest finger tip. Successively shorter are the metacarpals of ring and little fingers. Shortest of all is that of the thumb, found to be in a plane nearly perpendicular to the plane of other metacarpals. Each bone is convex dorsally and consists of a proximal *base,* a *shaft,* and a distal *head.* Its block-like base articulates with the wrist above (all plane joints except thumb, which has a saddle joint). The head articulates with its adjoining phalanx below (condyloid joint). The hollow in the palm of the hand is explained, in part, by the concave underside of metacarpals.[2]

[1] Cf. pp. 43, 53.
[2] Cf. p. 123: *Observations* (thenar and hypothenar eminences).

PHALANGES

The phalanges [G. *phalanx,* a line of soldiers] correspond to the visible segments of the fingers and continue the metacarpal radiation distalward.[3] All fingers except the thumb, which is independent, lie in lines converging upon a point at the center of the wrist. Each finger has three phalanges, except the thumb, which has but two. *Proximal phalanges* (where rings are worn) are longest, adjoining the metacarpals. *Median phalanges* (where we rap on doors) are next in line, but absent in the thumb. *Distal phalanges* (saddled with fingernails) are shortest of all.[4] Thus, fingers II-V might be described as having a segmentation arranged in 'diminishing thirds.' In plotting the segments, it is convenient to state the combined length of the last two bones as equal to the length of the first. Each phalanx is slightly convex dorsally and consists of a proximal *base,* a *shaft,* and a distal *trochlea* [L. pulley], except the last phalanx, which turns upward to end in a rounded stump. (Metacarpo-phalangeal joints are condyloid. Interphalangeal joints are hinge type.)

FINGERS II-V: THEIR LENGTHS AND TWISTS

The special length of the middle finger is attributed to relatively longer phalanges. Index and ring fingers are about the same length, falling short of the middle finger by nearly half a segment. In length again, the little finger falls short of its neighbor (ring finger) by one full segment. The middle finger is not only longest of all, but larger and straighter. As if it were the 'boss of the gang,' other fingers turn toward it. But they are twisted into S-curves, being impeded by the large first row of interphalangeal joints (puckered with wrinkles at their backs in extension).

THUMB

The head of the thumb metacarpal may be seen as the mobile apex of a nearly isosceles triangle whose base connects the carpal root of the thumb (maj. multangular) with the head of the index metacarpal. This leaves the thumb-metacarpal head far short of the index head. The thumb metacarpal, however, fails to reach the arc described by the ends of its companions. It is rather the thumb's interphalangeal (wrinkled) joint that arrives on a line with the other metacarpal heads. Briefly summed up, the last segment of the thumb reaches a position where it can be contained between both joints of the index first phalanx, with room to spare.

[3] Fingers are numbered I-V, beginning at the thumb; the ring finger, commonly 'third finger,' is herein called the fourth.

[4] Phalanges are often more conveniently designated by number—the proximal phalanx becoming the 'first phalanx.'

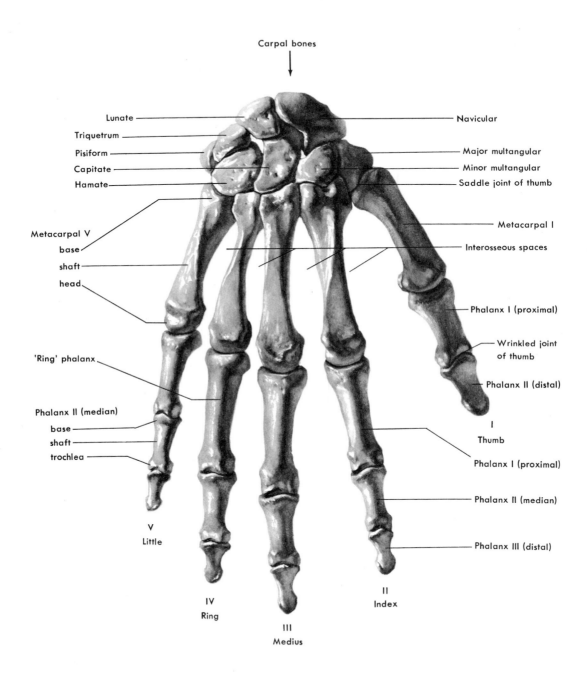

Carpal bones

Lunate ———————————— Navicular

Triquetrum ——————————

Pisiform ————————————— Major multangular

Capitate ————————————— Minor multangular

Hamate————————————— Saddle joint of thumb

Metacarpal V ——————————— Metacarpal I

base

shaft ———— Interosseous spaces

head

Phalanx I (proximal)

'Ring' phalanx Wrinkled joint of thumb

Phalanx II (distal)

Phalanx II (median)

base I

shaft Thumb

trochlea Phalanx I (proximal)

V Phalanx II (median)

Little

Phalanx III (distal)

IV

Ring II

Index

III

Medius

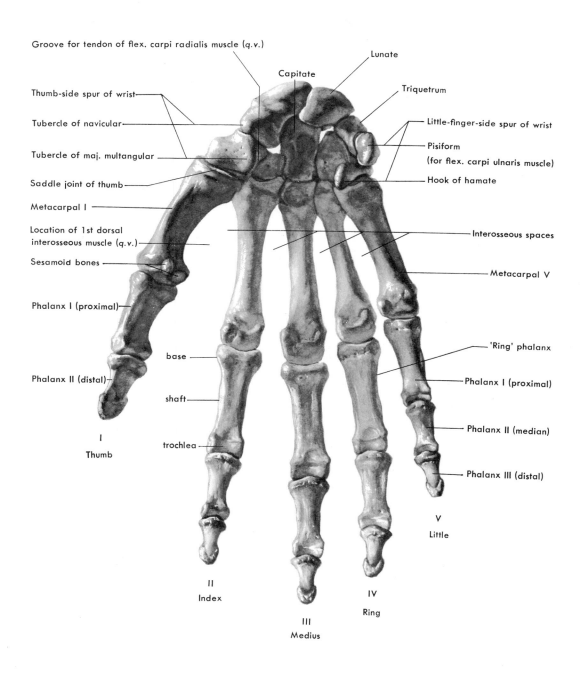

Groove for tendon of flex. carpi radialis muscle (q.v.)

Capitate

Lunate

Triquetrum

Thumb-side spur of wrist

Little-finger-side spur of wrist

Tubercle of navicular

Pisiform
(for flex. carpi ulnaris muscle)

Tubercle of maj. multangular

Saddle joint of thumb

Hook of hamate

Metacarpal I

Location of 1st dorsal
interosseous muscle (q.v.)

Interosseous spaces

Sesamoid bones

Metacarpal V

Phalanx I (proximal)

'Ring' phalanx

base

Phalanx II (distal)

Phalanx I (proximal)

shaft

Phalanx II (median)

I
Thumb

trochlea

Phalanx III (distal)

V
Little

II
Index

IV
Ring

III
Medius

Right HAND

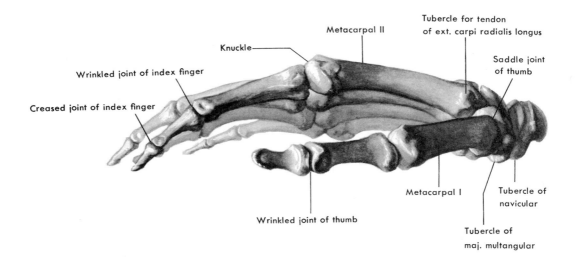

Tubercle for tendon
of ext. carpi radialis longus

Metacarpal II

Knuckle

Saddle joint
of thumb

Wrinkled joint of index finger

Creased joint of index finger

Metacarpal I

Tubercle of
navicular

Wrinkled joint of thumb

Tubercle of
maj. multangular

from the radial side

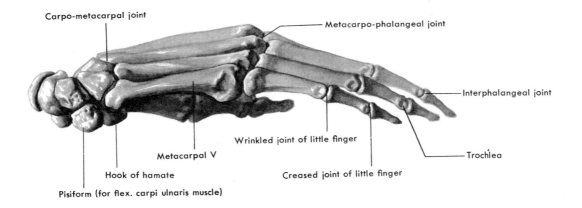

Carpo-metacarpal joint

Metacarpo-phalangeal joint

Interphalangeal joint

Wrinkled joint of little finger

Metacarpal V

Trochlea

Hook of hamate

Creased joint of little finger

Pisiform (for flex. carpi ulnaris muscle)

from the ulnar side

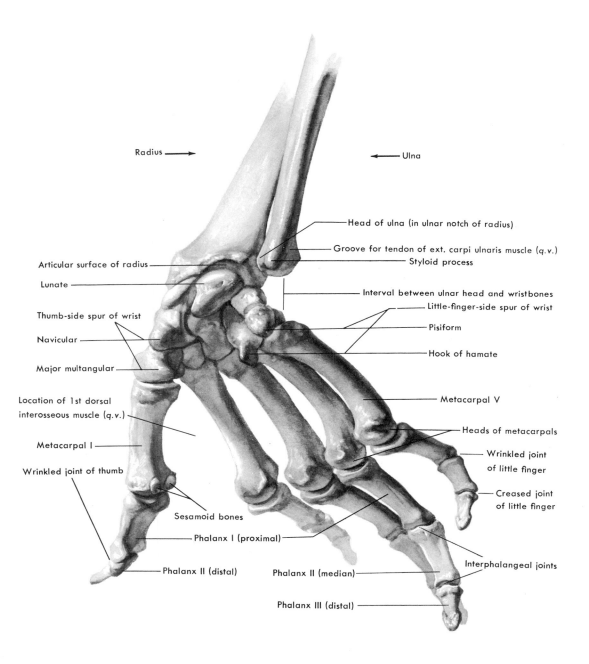

Radius →

← Ulna

Head of ulna (in ulnar notch of radius)

Groove for tendon of ext. carpi ulnaris muscle (q.v.)

Styloid process

Articular surface of radius

Interval between ulnar head and wristbones

Lunate

Little-finger-side spur of wrist

Thumb-side spur of wrist

Pisiform

Navicular

Hook of hamate

Major multangular

Metacarpal V

Location of 1st dorsal
interosseous muscle (q.v.)

Heads of metacarpals

Metacarpal I

Wrinkled joint
of little finger

Wrinkled joint of thumb

Creased joint
of little finger

Sesamoid bones

Phalanx I (proximal)

Interphalangeal joints

Phalanx II (distal)

Phalanx II (median)

Phalanx III (distal)

from behind and below

53

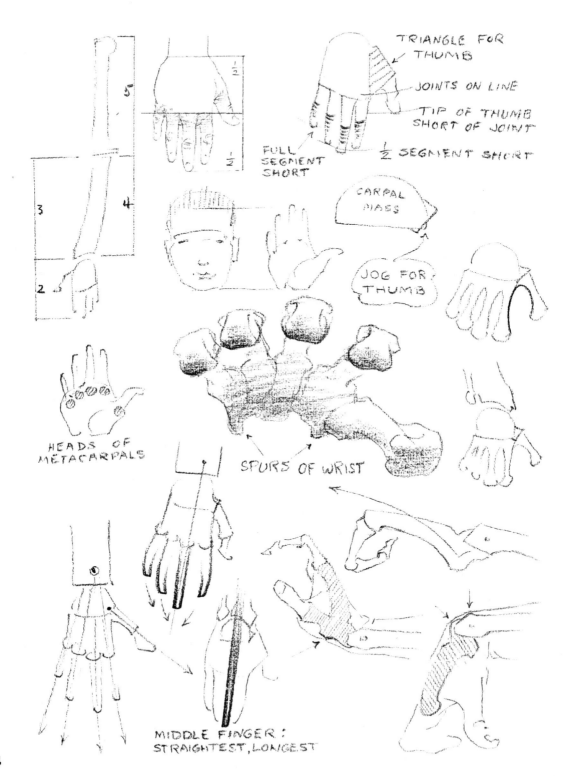

TRIANGLE FOR THUMB

JOINTS ON LINE

TIP OF THUMB SHORT OF JOINT

½ SEGMENT SHORT

FULL SEGMENT SHORT

CARPAL MASS

JOG FOR THUMB

HEADS OF METACARPALS

SPURS OF WRIST

MIDDLE FINGER: STRAIGHTEST, LONGEST

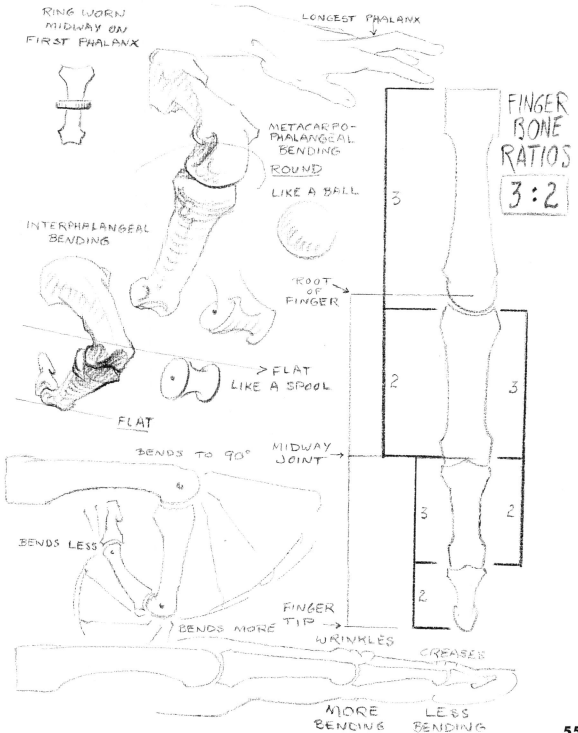

RING WORN MIDWAY ON FIRST PHALANX

LONGEST PHALANX

METACARPO-PHALANGEAL BENDING

ROUND

LIKE A BALL

INTERPHALANGEAL BENDING

FLAT LIKE A SPOOL

FLAT

BENDS TO 90°

MIDWAY JOINT

BENDS LESS

BENDS MORE

FINGER TIP

WRINKLES

CREASES

MORE BENDING

LESS BENDING

ROOT OF FINGER

FINGER BONE RATIOS

3:2

3

2

3

3

2

2

The OS COXÆ, hipbone

The os coxæ [L. bone of the hip] is a massive plate of bone entering into the support of the trunk and serving as an articular root for the thighbone. It unites in front with its fellow of the opposite side and joins the sacrum behind to form the great bony ring called the *pelvis*.[1]

In general shape, the os coxæ resembles a propeller or 'figure 8' whose upper and lower sections have been twisted at right angles to each other. At the center of the '8,' but below the center of the bone, is the *acetabulum* [L. vinegar cup], a deep socket for reception of the head of the thighbone (ball-and-socket joint).[2] Three separate bones have grown together in the adult to form the os coxæ, each one having root in the hub-like acetabulum (see diagram on opp. page): (1) the ILIUM, above; (2) the ISCHIUM, below; and (3) the PUBIS, in front. The upper half of the figure 8 is made by the ilium, the lower half by the ischium and pubis. The os coxæ stands about 8½ inches, or very nearly equal to the height of the skull.

ILIUM

The part of the iliac bone [L. *ilium*, flank] that helps to form the acetabulum is called the *body*. Above, the bone expands into a broad, thin wing, the *ala*. Of the two inner surfaces of the ala, the forepart is the concave *iliac fossa*, and the roughened rear part is an *articular surface* for the sacrum (plane joint). Outwardly, the ala presents two curved ridges: the *anterior and posterior gluteal lines* (defining the margins of gluteal muscles). The thickened upper border, or *crest*, describes a sharp upward curve terminating in front at the *anterior superior iliac spine* and behind at the *posterior superior iliac spine*. Below each of these is a secondary prominence, named correspondingly: *anterior inferior and posterior inferior iliac spine*. The iliac crest is a surface landmark—conspicuous at its forward end, hidden at center by the overhanging promontory of the flank muscle,[3] and exposed again behind.

ISCHIUM

The part of the ischial bone [G. *ischion*, hip] that helps to form the acetabulum is called the *body*. From its rear surface projects the *ischial spine*, forming the *great sciatic notch* above and the *small sciatic notch* below [*sciatic*, formerly *ischiadic*]. The remainder of the bone is called the *superior ramus*, behind, and the *inferior ramus*, below. The *ischial tuberosity* (attachment for hamstring muscles) projects behind from the superior ramus; the inferior ramus below is continuous with that of the pubis in front.

[1] Cf. pp. 60-63.
[2] Cf. p. 65.
[3] Cf. p. 106: *Iliac furrow.*

PUBIS

The part of the pubic bone [L. *puber,* adult] that helps to form the acetabulum is called the *body.* A *superior ramus* extends forward from the body to the *pubic crest.* This ramus presents, on its upper surface, the sharp *pectineal line,* which, in turn, ends in front at the *pubic tubercle.* The *inferior ramus* turns downward and backward from the crest, leaving a smooth *articular surface* for union with the pubis of the opposite side. The union is called the *symphysis pubis* (cartilage joint).[4] The ramus of the pubis then becomes continuous below with the ramus of the ischium. The largest foramen (aperture) in the skeleton is situated in this lower part of the os coxæ. It is encircled by the rami of the ischium and pubis, and is known as the *obturator foramen.* This feature, however, holds no significance for the artist. It would be simpler to ignore the foramen and conceive of the ischium and pubis as a solid continuous plate.

[4] Cf. pp. 60-63.

Right HIPBONE, child, age 5½ years (showing segmentation)

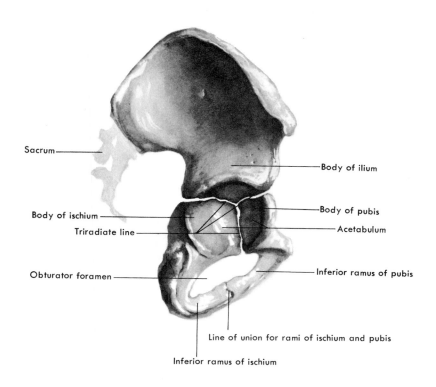

Sacrum

Body of ischium

Triradiate line

Obturator foramen

Body of ilium

Body of pubis

Acetabulum

Inferior ramus of pubis

Line of union for rami of ischium and pubis

Inferior ramus of ischium

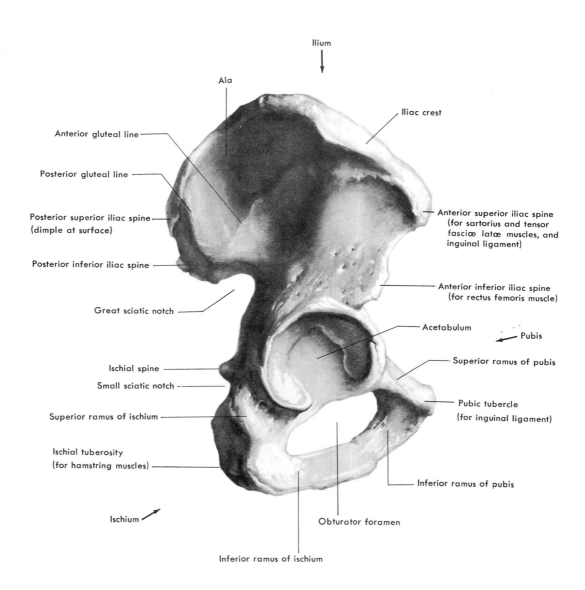

Ilium

Ala

Iliac crest

Anterior gluteal line

Posterior gluteal line

Posterior superior iliac spine
(dimple at surface)

Anterior superior iliac spine
(for sartorius and tensor
fasciœ latœ muscles, and
inguinal ligament)

Posterior inferior iliac spine

Anterior inferior iliac spine
(for rectus femoris muscle)

Great sciatic notch

Acetabulum

Pubis

Ischial spine

Superior ramus of pubis

Small sciatic notch

Superior ramus of ischium

Pubic tubercle
(for inguinal ligament)

Ischial tuberosity
(for hamstring muscles)

Inferior ramus of pubis

Ischium

Obturator foramen

Inferior ramus of ischium

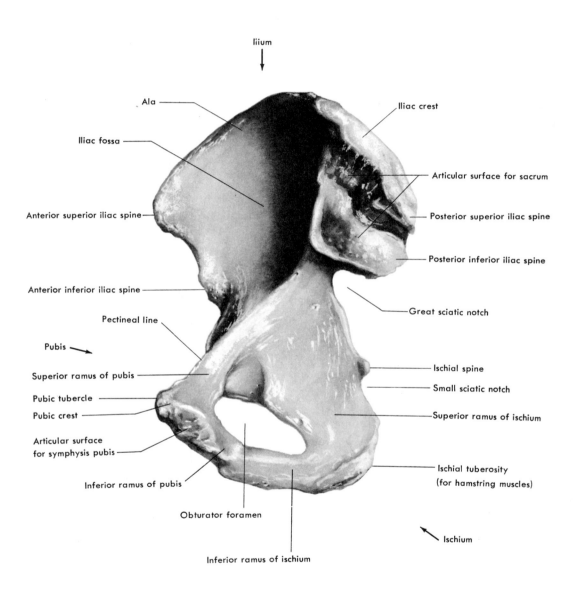

Ilium

Ala

Iliac fossa

Anterior superior iliac spine

Anterior inferior iliac spine

Pectineal line

Pubis

Superior ramus of pubis

Pubic tubercle

Pubic crest

Articular surface
for symphysis pubis

Inferior ramus of pubis

Obturator foramen

Inferior ramus of ischium

Iliac crest

Articular surface for sacrum

Posterior superior iliac spine

Posterior inferior iliac spine

Great sciatic notch

Ischial spine

Small sciatic notch

Superior ramus of ischium

Ischial tuberosity
(for hamstring muscles)

Ischium

The PELVIS, hip girdle

The pelvis [L. basin] is the great bony ring formed by two HIPBONES, the SACRUM, and the COCCYX.[1] Although it occupies a large part of the hip region, the pelvis reaches the surface at only a few points. A pedestal for the spine is furnished by the triangular sacrum, wedged downward like a keystone between the hipbones (plane joints). These, in turn, divide the weight of the trunk between right and left thighbones, with which they articulate at the acetabula (ball-and-socket joints).[2] The height of the pelvis is about equal to that of the skull (8½ inches). The inclination of the male pelvis, standing, is such that the pubic tubercles lie in a vertical plane common with the anterior superior iliac spines. In the female the ilium projects more forward.[3]

INGUINAL LIGAMENTS

The *inguinal ligament* is a cord stretching from the anterior superior iliac spine to the pubic tubercle. The ligaments of right and left sides define the lower abdominal margin. Their presence, in life, is partially indicated by oblique grooves, the *furrows of the groin* (inguinal furrows), which are steeper in the male subject.

PUBIS

The midline joint between pubic bones is the *symphysis pubis* (cartilage joint). Below the symphysis, the underborders of pubic bones describe the angle of the *pubic arch* and delimit the genital zone. In the live subject, a fleshy elevation in the shape of a keystone surmounts the arch. This is called the *mons pubis*[4] and consists of a thick pad of fat (pre-pubic fat) serving to cushion the joint of the symphysis. It conceals the pubic tubercles as well as the converging ends of inguinal ligaments, and is something of a bridge from thigh to thigh.

ANATOMICAL CENTER

In the male, the apex of the pubic arch is indicated by the root of the genitals, and stands as the *front vertical midpoint*. On the back, about halfway from sacral triangle to buttock furrow, a *rear vertical midpoint* can be imagined. In the female, the midpoints are anatomically higher—at the crest of the mons pubis in front, and a trifle closer to the sacral triangle in back.

[1] Cf. pp. 56-9: *Hipbone;* pp. 22, 25: *Sacrum and Coccyx.*
[2] Cf. pp. 58, 65.
[3] For distinctions of Female Pelvis, see p. 64.

[4] Also, specif. female: *mons Veneris* [mount of Venus].

from in front

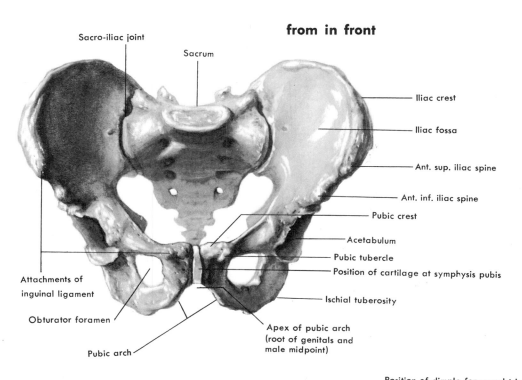

Sacro-iliac joint

Sacrum

Iliac crest

Iliac fossa

Ant. sup. iliac spine

Ant. inf. iliac spine

Pubic crest

Acetabulum

Pubic tubercle

Position of cartilage at symphysis pubis

Ischial tuberosity

Attachments of
inguinal ligament

Obturator foramen

Pubic arch

Apex of pubic arch
(root of genitals and
male midpoint)

from behind

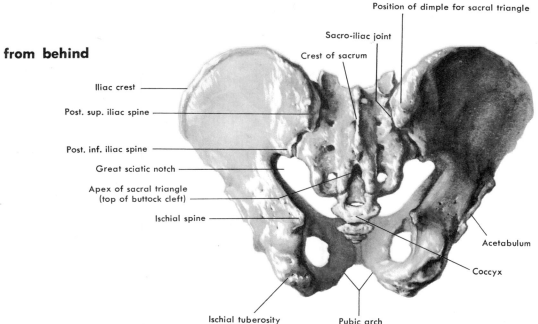

Position of dimple for sacral triangle

Sacro-iliac joint

Crest of sacrum

Iliac crest

Post. sup. iliac spine

Post. inf. iliac spine

Great sciatic notch

Apex of sacral triangle
(top of buttock cleft)

Ischial spine

Acetabulum

Coccyx

Ischial tuberosity

Pubic arch

61

PELVIS (Male)

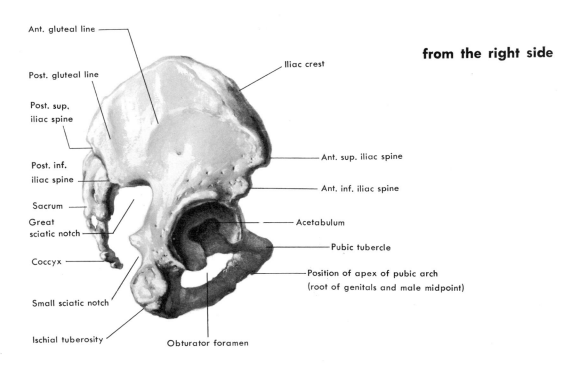

Ant. gluteal line

Post. gluteal line

Post. sup.
iliac spine

Post. inf.
iliac spine

Sacrum

Great
sciatic notch

Coccyx

Small sciatic notch

Ischial tuberosity

Obturator foramen

Iliac crest

from the right side

Ant. sup. iliac spine

Ant. inf. iliac spine

Acetabulum

Pubic tubercle

Position of apex of pubic arch
(root of genitals and male midpoint)

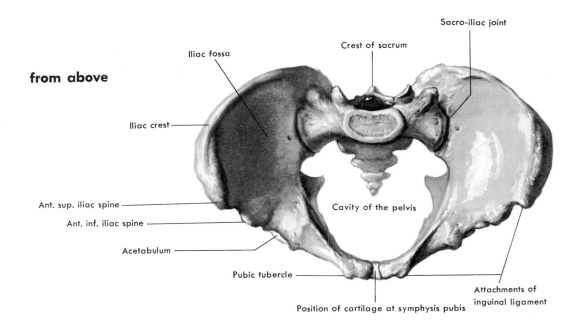

from above

Iliac fossa

Crest of sacrum

Sacro-iliac joint

Iliac crest

Ant. sup. iliac spine

Ant. inf. iliac spine

Acetabulum

Pubic tubercle

Cavity of the pelvis

Attachments of
inguinal ligament

Position of cartilage at symphysis pubis

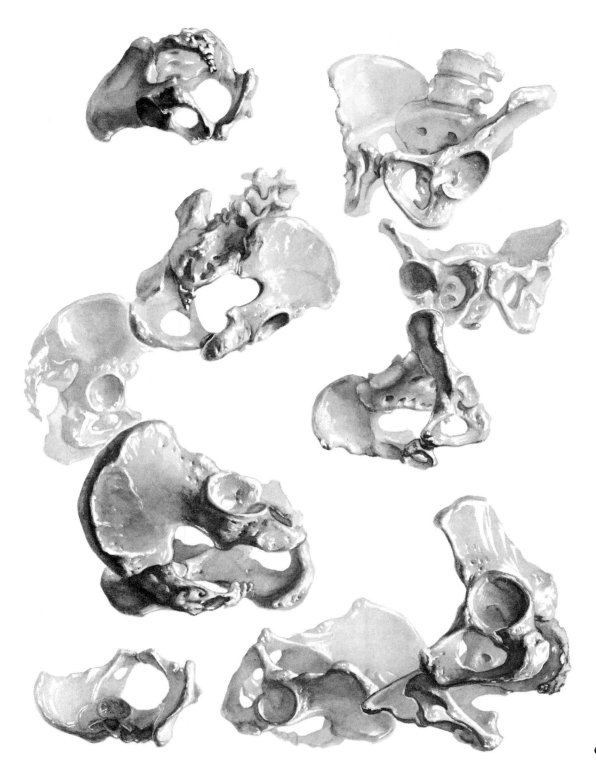

DISTINCTIONS OF FEMALE PELVIS
Female Pelvis, schematic, shown against phantom of Male Pelvis

from in front

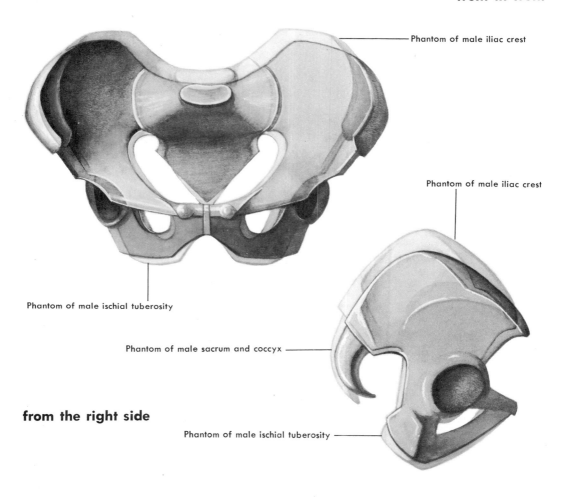

Phantom of male iliac crest

Phantom of male iliac crest

Phantom of male ischial tuberosity

Phantom of male sacrum and coccyx

from the right side

Phantom of male ischial tuberosity

Since greater pelvic diameters must be maintained in the female, the following specific deviations may be noted:

1. Acetabula are widely separated.
2. Iliac crest is more rounded.
3. Anterior superior iliac spines are farther apart, project more forward than pubic tubercles, and are somewhat lower in relation to them.
4. Pubic arch is wider with more rounded apex; it will accommodate a right angle (90°), whereas male angle is less.
5. Sacrum is wider, shorter, flatter above, and turned more forward below; coccyx, too, is turned more forward.

The male pelvis is characterized by height, uprightness, angularity, weight, thickness of parts, and small cavity. The female pelvis is characterized by breadth, forward tilt, generous angles, lightness, thinness of parts, and spacious cavity.

64

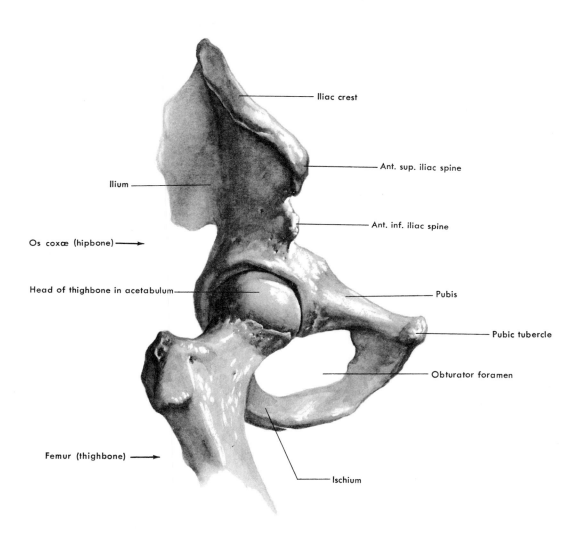

Iliac crest

Ant. sup. iliac spine

Ilium

Ant. inf. iliac spine

Os coxæ (hipbone) ➝

Head of thighbone in acetabulum

Pubis

Pubic tubercle

Obturator foramen

Femur (thighbone) ➝

Ischium

from in front of the outer side

90° TWIST

FEMALE

MALE

66

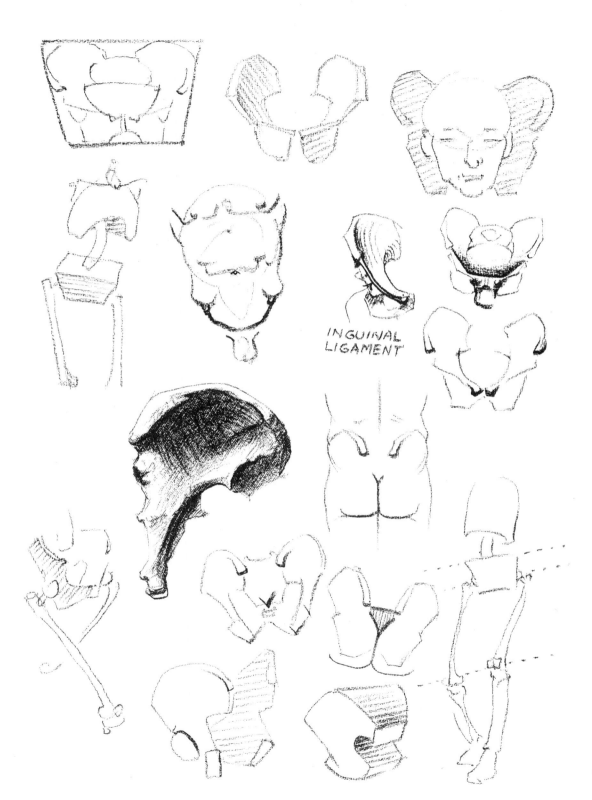

INGUINAL
LIGAMENT

The FEMUR, thighbone

The heaviest and longest bone of the skeleton is the femur [L. thigh], situated in the thigh. Its average length is about 18 inches, or greater than twice the height of the skull. Most of the femur lies deeply embedded in thigh muscles, slanting inward from pelvis to knee. It is superficial above, however, at the outer side of the hip, and below where it enters into the form of the knee. The bone is divisible into a shaft and two articular ends.

The PROXIMAL END consists of a head, neck, and two projections called trochanters. The *head* is a spherical knob socketed within the acetabulum of the hipbone (ball-and-socket joint).[1] The *neck* is an oblique offshoot from the shaft, supporting the head at its medial end. Prominent bulges at the root of the neck are the trochanters. The *great trochanter* is found at the summit of the femoral shaft and easily felt at the surface of the hip. The span between great trochanters of right and left sides marks the greatest breadth of the male hips. In the female, the broadest level is lower (due to a deposit of fat).[2] The *small trochanter* protrudes toward the pelvis from the hinder surface of the bone, somewhat lower than the great trochanter.

The SHAFT is smooth and cylindrical, bent forward, and directed obliquely downward toward the midline. In the lower third of its descent, it widens to become continuous with the terminal swelling of the bone. Behind, the shaft is marked with a ridge, the *linea aspera* [L. rough line], bifurcating both above and below toward the ends of the bone. The flat, triangular area enclosed within the lower bifurcation is the *popliteal surface* [L. *poples*, ham or back of the knee].

The DISTAL END consists of two condyles and epicondyles, the intervening notch behind, and the patellar surface in front. The large *medial and lateral condyles* are smooth, rounded swellings for articulation with reciprocal depressions in the tibia[3] (hinge joint). The *medial and lateral epicondyles* are found as small, rough eminences upon the outer condylar surfaces. It should be noted that the medial epicondyle is the higher of the two, and that the lateral condyle pushes more forward. All this constitutes a massive block that greatly increases the breadth of the distal end and, together with the tibia, forms the largest joint in the body. Between the two condyles, behind, is the *intercondylar notch*. In front is the smooth, indented *patellar surface*, upon which the kneecap may glide (plane joint) when the leg is straightened.

[1] Cf. pp. 56, 65.
[2] Cf. p. 151: *Subtrochanteric fat.*

[3] Shinbone.

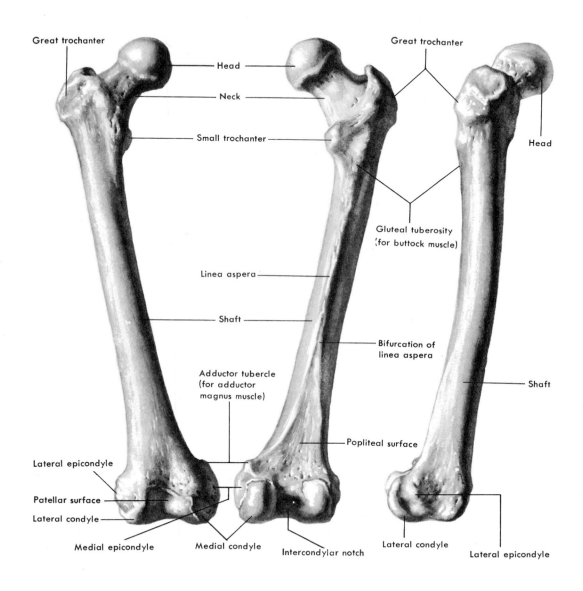

Great trochanter

Head

Neck

Small trochanter

Great trochanter

Head

Gluteal tuberosity
(for buttock muscle)

Linea aspera

Shaft

Bifurcation of
linea aspera

Shaft

Adductor tubercle
(for adductor
magnus muscle)

Popliteal surface

Lateral epicondyle

Patellar surface

Lateral condyle

Medial epicondyle

Medial condyle

Intercondylar notch

Lateral condyle

Lateral epicondyle

from in front **from behind** **from the outer side**

The PATELLA, kneecap

In certain parts of the body, small bones are developed within tendons close to joints, for the purpose of reinforcement or better leverage. Such bones are called *sesamoid bones* [seed-shaped], of which the patella (kneecap) is by far the largest.[1] Its shape and size correspond roughly to the circumference made by joining thumb and index-finger tips. The patella is somewhat flat and triangular with *base* above and *apex* below; its situation is at the front of the knee joint. The patella associates with the smooth, indented patellar surface of the femur, where it glides upon its two *articular surfaces* (plane joint). However, its movement is strictly in accordance with that of the tibia,[2] to whose tuberosity it is rigidly bound by the *patellar ligament*. The ligament is derived from fibers of the broad tendinous strap (quadriceps tendon, p. 128), which secures thigh muscles to the kneecap.

One might say the tendinous strap swallows up the kneecap on its way to the leg bone. Just as a python bulges with the form of the pig it has swallowed whole, so does the tendinous strap swell and betray its victim —the kneecap. In flexion, the tibia draws the patella downward to shield the exposed intercondylar space. Conversely in extension, the patella draws pulley-fashion upon the tibia, via the patellar ligament. Bulging like a pillow, from between the ligament and the joint of the knee, is the *infrapatellar pad of fat*.[3] It is this fat, oozing forward at either side of the ligament, that in life renders obscure the surrounding details of the knee.

[1] Other sesamoid bones (much smaller) are usually found under Metacarpal I (thumb) and Metatarsal I (big toe). See pp. 51, 81.
[2] Shinbone.
[3] Cf. p. 151: *Patellar fat*.

Right PATELLA

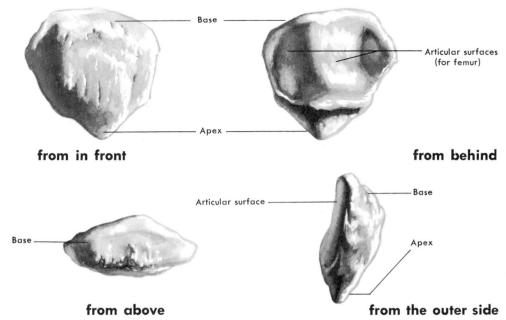

Base

Articular surfaces (for femur)

Apex

from in front

from behind

Articular surface

Base

Base

Apex

from above

from the outer side

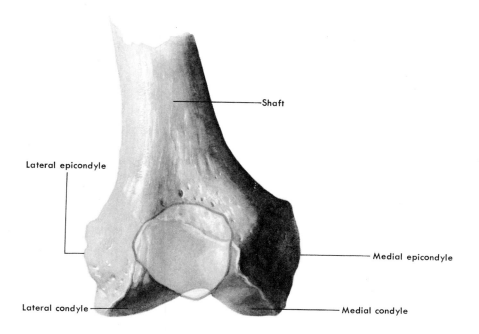

Shaft

Lateral epicondyle

Medial epicondyle

Lateral condyle

Medial condyle

**on front patellar surface of femur
(at extension of knee joint)**

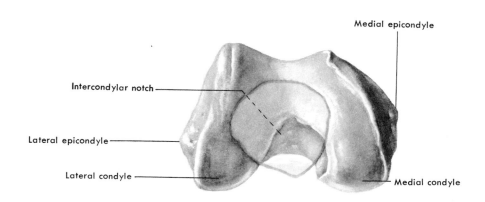

Medial epicondyle

Intercondylar notch

Lateral epicondyle

Lateral condyle

Medial condyle

**on under patellar surface of femur
(at flexion of knee joint)**

71

The TIBIA and FIBULA, shinbone and calf bone

The skeleton of the leg consists of two bones: the heavy tibia medially and the slender fibula laterally. They articulate passively with each other above and below (plane joints). The space intervening between them, as contrasted to that of the forearm bones, is widest above. Both tibia and fibula are nearly equal in length; the tibia measures about 15 inches and the fibula slightly less. But, like the relation of radius to ulna in the forearm, the fibula is placed at a lower level in the leg, as if it had slipped downward. Hence, the tibia alone takes part in the joint of the knee. Below, both leg bones enter into the ankle joint. In direction, the tibia and fibula are more perpendicular than the bone of the thigh. They are divisible into long three-sided shafts and their articular ends.

TIBIA

The PROXIMAL END or *head* of the tibia [L. shinbone] is massive and flattened above, where it alone supports the weight of the femur. Horizontally it expands into *medial and lateral condyles*. These are divided above by the *intercondylar eminence,* and display indented *articular surfaces* for reciprocal convexities of the femoral condyles (hinge joint).[1] Low on the front of the head is a rough elevation, the *tuberosity of the tibia,* to which the patellar liga-ment is attached.[2] Both condyles and tuberosity are superficial.

The SHAFT of the tibia describes a double curve, arching inward above and outward below. Triangular in cross section, it presents three long surfaces and their margins. The *posterior surface* is flat and bounded on its fibular side by a sharp ridge, the *interosseous crest,* and by a rounded *medial margin* on its inner side. The *anterior crest* is a salient ridge at the front of the bone, arising from the tuberosity above. It divides the front of the tibia into *medial and lateral surfaces.* The superficial medial surface and anterior crest are familiarly known as the 'shin.'

The DISTAL END is four-sided. Front and back surfaces are relatively flat. The lateral surface is depressed at the *fibular notch* to receive the fibula. The medial surface is extended beyond the undersurface as the *medial malleolus,* or prominence of the inner side of the ankle. The undersurface of the distal end and the lateral surface of the malleolus are smooth, and articulate with the nearest ankle bone (hinge joint).[3] The medial malleolus is square in outline, and higher and more forward than the corresponding knob (lateral malleolus) of the fibula.

[1] Cf. pp. 69, 75.
[2] Cf. p. 70.
[3] Cf. p. 83.

FIBULA

The PROXIMAL END of the fibula [L. spike] is called the *head*, and joins the under lateral surface of the head of the tibia, far to the rear. It is seen superficially at the end of the outer hamstring of the knee.[4]

The SHAFT is narrow, spike-like, and triangular in cross section. It is very nearly straight and scarcely varies in size as it descends.

The DISTAL END resembles the head in size, but appears to be more flattened. Medially, it fits into the fibular notch of the tibia; laterally, it bulges down over the side

of the ankle and is called the *lateral malleolus*. The distal end of the tibia, with its medial malleolus, provides a roof and medial wall for the housing of the ankle. The fibula completes the housing laterally by its prolongation of the lateral malleolus. This drops even below the level of the tibial spur. Thus, the cavity is closed at the sides and open in front and behind, allowing the foot to swing freely up and down (hinge joint). The distal end of the fibula is V-shaped in outline, and lower and farther back than the corresponding end of the tibia.

[4] Cf. pp. 132, 133.

Right TIBIA and FIBULA

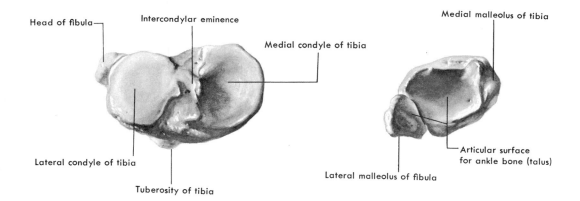

Head of fibula — Intercondylar eminence — Medial condyle of tibia

Medial malleolus of tibia

Lateral condyle of tibia

Tuberosity of tibia

Lateral malleolus of fibula

Articular surface for ankle bone (talus)

from above **from below**

Right TIBIA and FIBULA

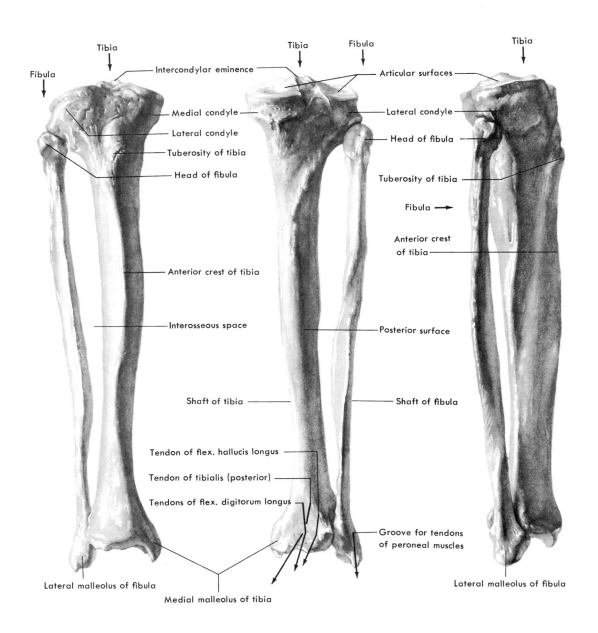

Fibula

Tibia

Intercondylar eminence

Medial condyle

Lateral condyle

Tuberosity of tibia

Head of fibula

Anterior crest of tibia

Interosseous space

Shaft of tibia

Tendon of flex. hallucis longus

Tendon of tibialis (posterior)

Tendons of flex. digitorum longus

Lateral malleolus of fibula

Medial malleolus of tibia

Tibia

Fibula

Articular surfaces

Lateral condyle

Head of fibula

Tuberosity of tibia

Fibula →

Anterior crest of tibia

Posterior surface

Shaft of fibula

Groove for tendons of peroneal muscles

Tibia

Lateral malleolus of fibula

from in front

from behind

from the outer side

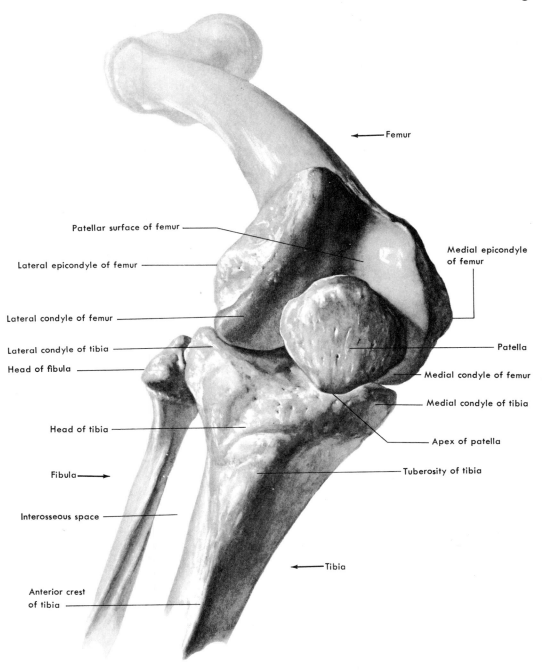

Femur

Patellar surface of femur

Medial epicondyle of femur

Lateral epicondyle of femur

Lateral condyle of femur

Lateral condyle of tibia

Head of fibula

Patella

Medial condyle of femur

Medial condyle of tibia

Head of tibia

Apex of patella

Fibula

Tuberosity of tibia

Interosseous space

Tibia

Anterior crest of tibia

from in front

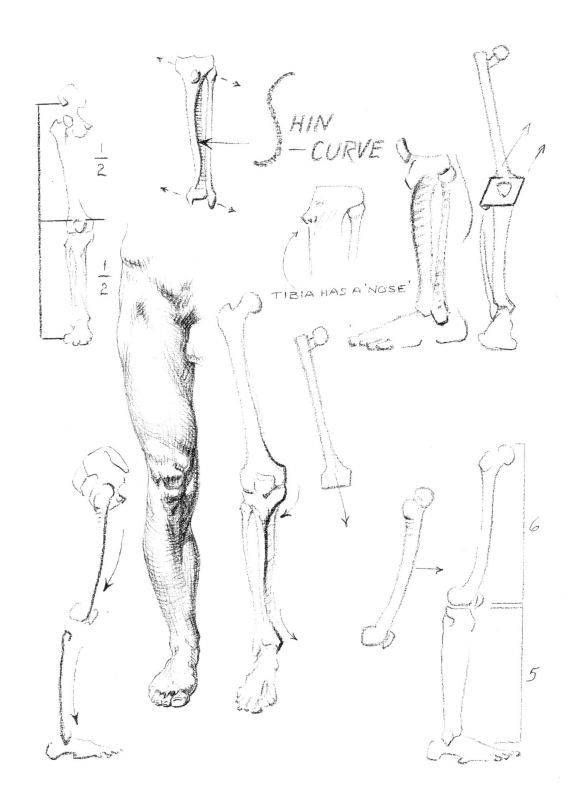

$\frac{1}{2}$

$\frac{1}{2}$

SHIN CURVE

TIBIA HAS A 'NOSE'

6

5

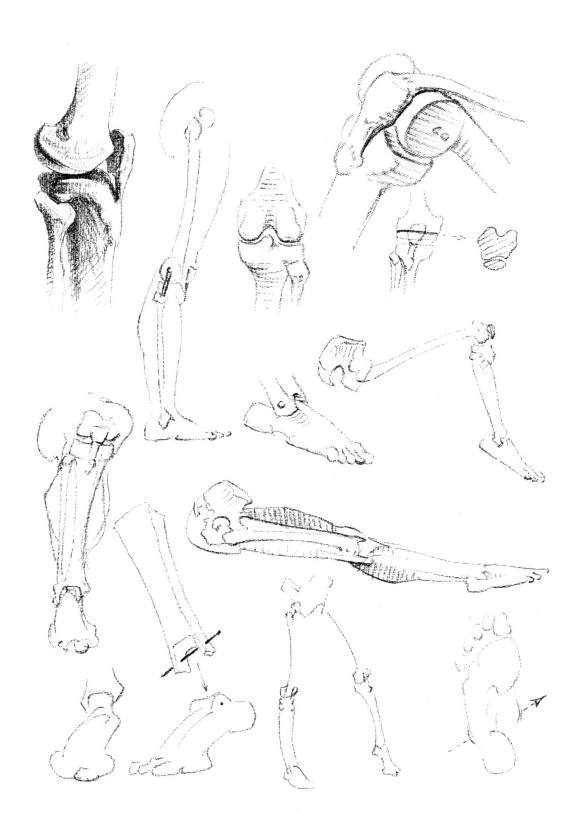

The FOOT and ANKLE

The sole of the foot (from heel to base of the big toe) measures about one head-length. The addition of a big toe increases this unit by something like one fourth. The foot ordinarily rests on the sole or *plantar surface* and exposes the *dorsal surface* above. Movements are more limited than those of the hand. Most extensive are the hinge movements–upward and downward rocking at the ankle, called *dorsi-flexion* (lifting) and *plantar-flexion* (pointing). *Inversion* directs the sole inward toward the opposite foot. *Eversion* directs it slightly outward. There is a pronounced similarity in the skeletal arrangements of hand and foot.[1] The outstanding deviation of a foot is the enlargement and backward projection of one of its bones to form a heel.[2] Whereas the wrist contains 8 bones, the ankle has 7 – called TARSAL BONES.[3] Embedded in the forward body of the foot are 5 METATARSALS. The 14 PHALANGES are the segmented, independent bones of the toes. A cursory glance at the skeletal foot will show that its parts exhibit a wide range of sizes and lengths. This we may gratefully acknowledge as simplifying the problem of proportion.

TARSALS

OBLIQUE RIDING SYSTEM
(to metatarsals I, II, III)
1. *Talus* [ankle or witch bone]
2. *Navicular* [boat-shaped]
3. *Cuneiform* I ⎫
4. *Cuneiform* II ⎬[wedge bones]
5. *Cuneiform* III ⎭

HORIZONTAL SUPPORTING SYSTEM
(to metatarsals IV, V)
6. *Calcaneus* [heelbone]
7. *Cuboid* [block-shaped]

It is helpful to visualize two distinct systems of the tarsus constituted as already shown. While one straddles the other, it is perhaps paradoxical to say that the 'supporting system' itself is but an auxilliary. Continuity from the leg to the big toe is rendered unmistakable by the ramp of the 'riding system.' Slung beneath this ramp, the heel form plods uneventfully along the outer border of the foot to the little toe. Although the heel system is a lever of great importance, its architectural capacity is little more than that of a railroad tie, which is incidental to the running rail. At the forward end, the cuboid gives root to the outer two metatarsals. Between the forward end of the supporting part and the descending ramp of the riding part is the *sinus tarsi*. This is a tunnel leading directly through the ankle joint to the inner side of the heel. It is said the skillful magician may astound his audience by passing a long needle through the entire sinus. Even he reinforces our concept of a 'Great Divide' at the sinus tarsi! The talus, straddling the heelbone, fits into the recess of the leg bones (hinge joint), and there serves as a fulcrum for movements of the foot. The *tuberosity of the navicular*, at the head of the talus, is evident in life below and in front of the tibia. Cuneiforms provide flexible roots for their corresponding metatarsals. Collectively, the tarsal bones form a *tarsal arch* – ascending from horizontal to oblique. (Intertarsal unions are plane joints.)

[1] For comparison with the hand, see pp. 48-53.
[2] Especially developed in Negroid peoples.
[3] Some anatomists, to explain the discrepancy, consider that a homologue of the pisiform bone became fused with the heelbone.

78

METATARSALS

The metatarsals [G. *meta,* beyond, + *tarsos,* flat of the foot] lie in a series of lines converging slightly toward the heel. Except for the metatarsal of the big toe (noticeably shorter than the others), the bones are of nearly equal length and are longer and more slender than the metacarpals of the hand.[4] They are numbered i-v, beginning at the big toe. Each metatarsal is convex dorsally and consists of a proximal *base,* a *shaft,* and a distal *head.* Its block-like base articulates with the ankle behind (plane joint). The head articulates with its adjoining phalanx in front (condyloid joint). In the 'ball' of the foot lies this series of metatarsal heads, springboard for the vault of their shafts. The shaft of Metatarsal v lies horizontally. Its base at the rear is swollen into a knob, the *tuberosity of Metatarsal* v, a bony landmark in the live foot. Other metatarsals climb upward to meet the rising tarsals, the ascent of Metatarsal i being the greatest. The resulting *metatarsal arch,* a continuation of the tarsal arch, explains the re-entering curve in an imprint of the sole of a foot. It comprises, in effect, both longitudinal and transverse arches, which serve as flexible springs. These absorb much of the shock transmitted from body weight in action.

PHALANGES

The phalanges [G. *phalanx,* a line of soldiers] correspond to the visible segments of the toes and continue distalward the series of metatarsal lines.[5] Unlike the errant thumb of the hand, the big toe turns to watch over its family of smaller toes; and the more diminutive these members, the more they look toward the masterly big toe. Each one has three phalanges, except the big toe, which has but two. *Proximal phalanges* are found in all five toes, adjoining the metatarsals. *Median phalanges* are next in line, but absent in the big toe. *Distal phalanges,* at the ends, are to be found in all five toes.[6]

Each phalanx is slightly convex dorsally and consists of a proximal *base,* a *shaft,* and a distal *trochlea* [L. pulley], except the terminal phalanx, which ends in a rough stump. (Metatarso-phalangeal joints are condyloid. Interphalangeal joints are hinge type.)

Except in the big toe, the proximal phalanx of a toe is nearly equal in length to, but narrower than, the median phalanx of its corresponding finger. The remaining phalanges (toes ii-v) are extremely short and blunt.

[4] For comparison with the hand, see pp. 48-53.
[5] Toes are numbered i-v, beginning at the big toe.
[6] Phalanges are often more conveniently designated by number—the proximal phalanx becoming the 'first phalanx.'

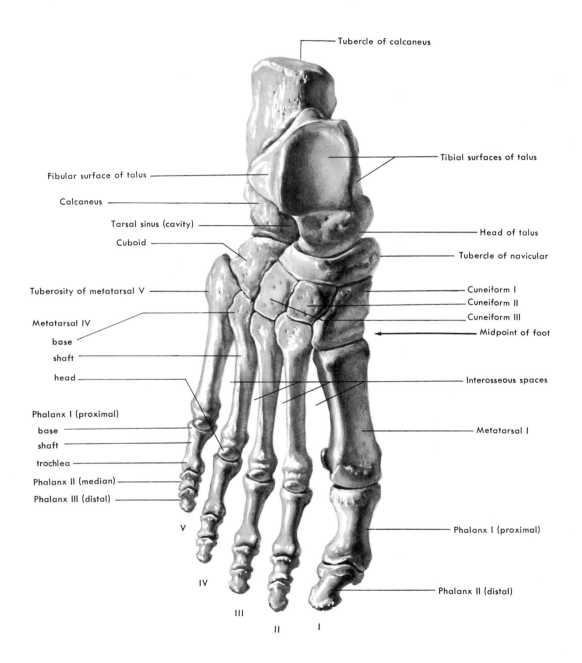

Tubercle of calcaneus

Tibial surfaces of talus

Fibular surface of talus

Calcaneus

Tarsal sinus (cavity)

Cuboid

Head of talus

Tubercle of navicular

Tuberosity of metatarsal V

Cuneiform I
Cuneiform II
Cuneiform III

Metatarsal IV

Midpoint of foot

base

shaft

head

Interosseous spaces

Phalanx I (proximal)

base

shaft

Metatarsal I

trochlea

Phalanx II (median)

Phalanx III (distal)

V

Phalanx I (proximal)

IV

III

Phalanx II (distal)

II I

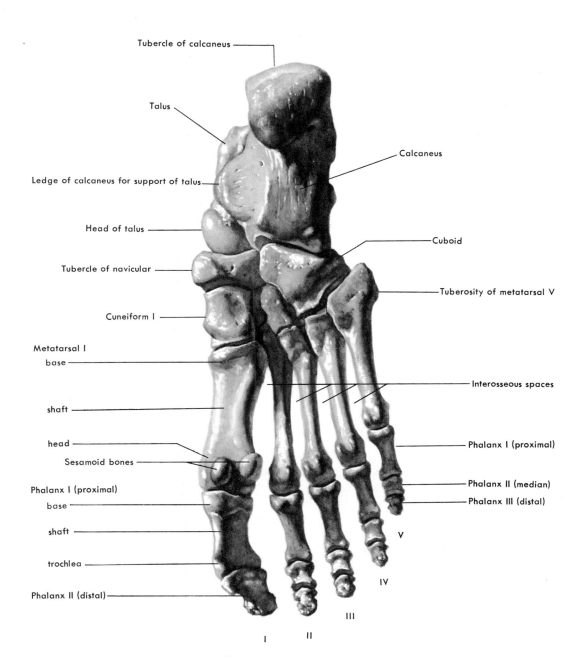

Tubercle of calcaneus

Talus

Ledge of calcaneus for support of talus

Head of talus

Tubercle of navicular

Cuneiform I

Metatarsal I
base

shaft

head

Sesamoid bones

Phalanx I (proximal)
base

shaft

trochlea

Phalanx II (distal)

Calcaneus

Cuboid

Tuberosity of metatarsal V

Interosseous spaces

Phalanx I (proximal)

Phalanx II (median)

Phalanx III (distal)

I

II

III

IV

V

Right FOOT

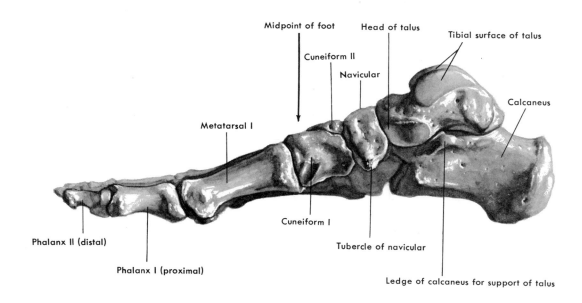

Midpoint of foot

Cuneiform II

Head of talus

Tibial surface of talus

Navicular

Calcaneus

Metatarsal I

Cuneiform I

Phalanx II (distal)

Tubercle of navicular

Phalanx I (proximal)

Ledge of calcaneus for support of talus

from the inner (tibial) side

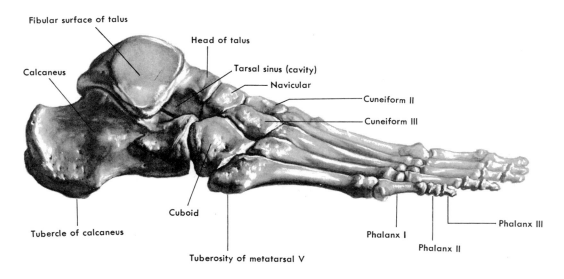

Fibular surface of talus

Head of talus

Calcaneus

Tarsal sinus (cavity)

Navicular

Cuneiform II

Cuneiform III

Cuboid

Phalanx III

Tubercle of calcaneus

Phalanx I

Tuberosity of metatarsal V

Phalanx II

from the outer (fibular) side

from in front of the inner side

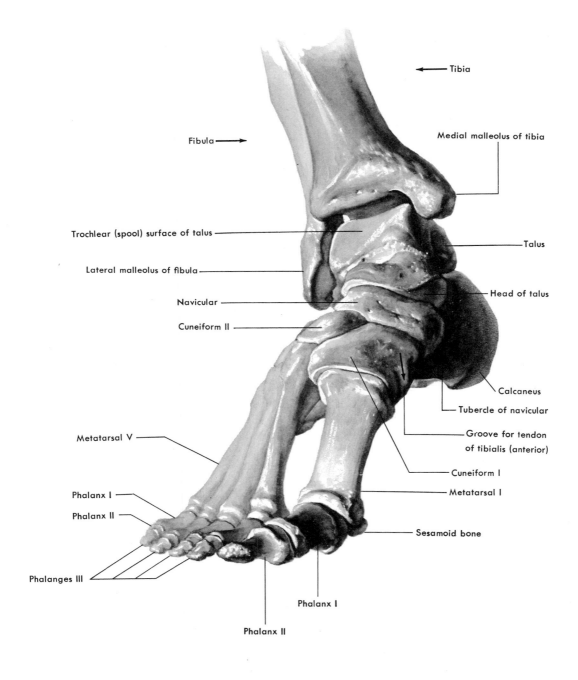

Tibia

Medial malleolus of tibia

Fibula

Trochlear (spool) surface of talus

Talus

Lateral malleolus of fibula

Head of talus

Navicular

Cuneiform II

Calcaneus

Tubercle of navicular

Metatarsal V

Groove for tendon
of tibialis (anterior)

Cuneiform I

Phalanx I

Metatarsal I

Phalanx II

Sesamoid bone

Phalanges III

Phalanx I

Phalanx II

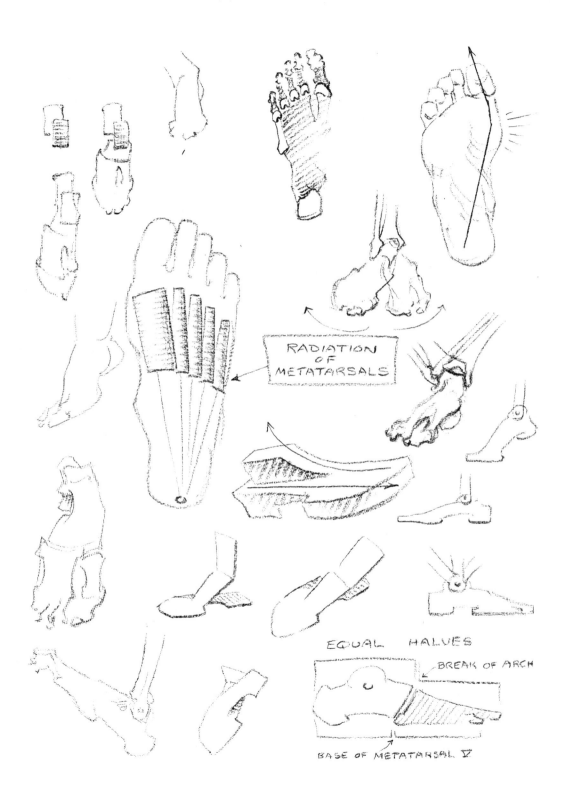

RADIATION
OF
METATARSALS

EQUAL HALVES

BREAK OF ARCH

BASE OF METATARSAL V

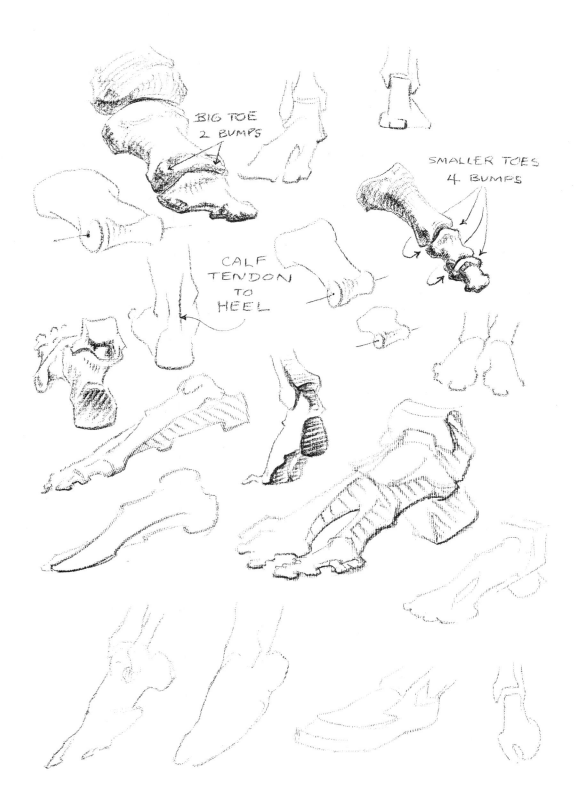

BIG TOE
2 BUMPS

SMALLER TOES
4 BUMPS

CALF
TENDON
TO
HEEL

85

Part II

MUSCLES

Nature is always the same, and therefore the muscles of the figures are not to be varied at whim.

—Tintoretto

The MUSCULATURE

Weaving itself about the skeleton is a compact harness of muscles, the agents of driving force for bodily action. The following pages aim to present only those muscles that help appreciably to build the volumes of the figure and that give a fair account of its mobility.

MUSCULAR FIBER is both contractile and elastic. When bundles of fibers unite to perform common duties, they are spoken of as a *muscle*. The typical muscle is fusiform or spindle-shaped [L. *fusus,* spindle]. It has a fleshy body of contractile-elastic fiber, and its ends are usually of stout unyielding tissue, called *tendon*. These extremities serve to bind the muscle to bone, skin, or other tissue. If the attachment is relatively stationary, it is called the *origin;* if relatively movable, the *insertion*. The particular points of these attachments determine the nature of movement induced. Thus it will be found that the *biceps* of the arm may not only bend the elbow joint but also draw a pronated forearm into supination, since its tendon of insertion fastens to the inner side of the radius.[1] Skeletal muscles may operate on whatever joints they bridge. Again, the biceps of the arm, since this muscle passes over the shoulder joint as well as the elbow, may assist in raising the arm in addition to flexing the forearm.[2]

MUSCULAR PERFORMANCE amounts to a contraction of fleshy fibers, drawing together at the center and swelling the girth of the muscle body. Since one end is more or less fixed by gravity, weight, or the leverage of surrounding muscles, the other end will be drawn toward it and so accomplish the desired act. A contraction therefore often gives to the muscle an appearance of 'crawling' toward its origin. The muscle chiefly responsible for a particular movement is called the *prime mover*. Muscles that stabilize the origin of a prime mover are called *fixation muscles*. When contraction of a prime mover might result in undesired movements at joints en route to its insertion, certain other muscles will be brought into play to steady these joints. Such movement-prevention is carried out by *synergist muscles*. The plan of a jib crane illustrates these principles of muscle function. The hoisting line is the 'prime mover,' acting on the hoisting block. Legs or guy lines stabilizing the center post are 'fixation' agents. And the jib can be secured to the center post by lines that act as 'synergist' agents. But in the body, the execution of a given movement also requires provision for a return from that movement. So most muscles are arranged as *antagonists,* one to another. Thus in the lower limb, *hamstrings* bend the knee while the *quadriceps* straightens the knee.[3] It is well to conceive of the body as being in a state of steady contraction. This condition is described as *muscle tone* and allows the body to maintain its firmness of position. Muscles are not functionless even when at rest. Movement is, in a sense, only the unbalancing of tone— one muscle swelling up at the expense of another (its antagonist), which must 'let go.'

[1] Cf. pp. 119, 120.
[2] Ibid.
[3] Cf. p. 135.

Muscle fiber may shorten to about half its length. A muscle of long fibers (e.g. *sartorius*) is therefore efficient. Since strength is in proportion to number of fibers, a heavy job would require a massive muscle. But shorter fibers are stronger fibers. Where both length and strength are needed, muscle bulk may be reduced by running many short fibers to the edge of a long tendon (e.g. *extensor digitorum longus*).[4] This arrangement resembles the 'vane and shaft' construction of a feather. If it is a one-sided feather, it carries the name of penniform [L. *penna*, feather]; if two-sided, bipenniform. Another way in which muscle is strengthened is by interrupting it with tendinous fiber. This 'link sausage' grouping of two or more muscular bellies again results in more fibers and shorter ones.[5]

A muscle's function is sometimes denoted by its name, as *adductor pollicis* (adductor of the thumb).[6] Other systems of naming muscles are in respect to: shape (e.g. *trapezius*), region (e.g. *temporalis*), position or direction of fibers (e.g. *external oblique*), number of heads or divisions (e.g. *triceps*), and attachments (e.g. *sternomastoid*).

The description of muscles will be given here in tabular form, with each muscle listed in its appropriate functional group, because identical information is needed in respect to all muscles. We should know the principal attachments of a muscle in order to give proper direction to its form, especially when the region is viewed from an unfamiliar angle. We should know something of its action, since that modifies form. Derivation of the name is given in each case to help the beginner over the hurdle of compound muscular jargon. The most important feature of muscle, its shape, will be shown in diagrams and omitted from tabular information. Muscular diagrams in full light and shade can provide a concept of shape that words could only hint at, and then with no little inaccuracy. To describe a muscle as strap-like, or cylindrical, or fan-shaped, is to suggest that two structures so denoted will resemble each other. It seems best to let the diagrams talk about shape. If fresh muscles could be cleaned from the skeleton and spread out one by one before us, we should be able to recognize most of them by their shapes, lengths, and fibrous arrangements. We should begin to sense a 'personality' about each muscle—the sort of impression we gained from familiarity with dry bones. Yet, when we do come to hail the new acquaintances on sight, let us not forget they are after all only parts of something bigger. And as such, their relationships one to another are more important. Specifically, the matter of relationships involves a knowledge of the environs of a muscle, an evaluation of its contours, an observation of any axis it may enter into, and a perception of any continuity or thrust it may exhibit. The clarification of all this is attempted in line drawings.

[4] Cf. pp. 132, 133.
[5] See *rectus abdominis*, p. 104.
[6] The various functions are defined on p. xiii.

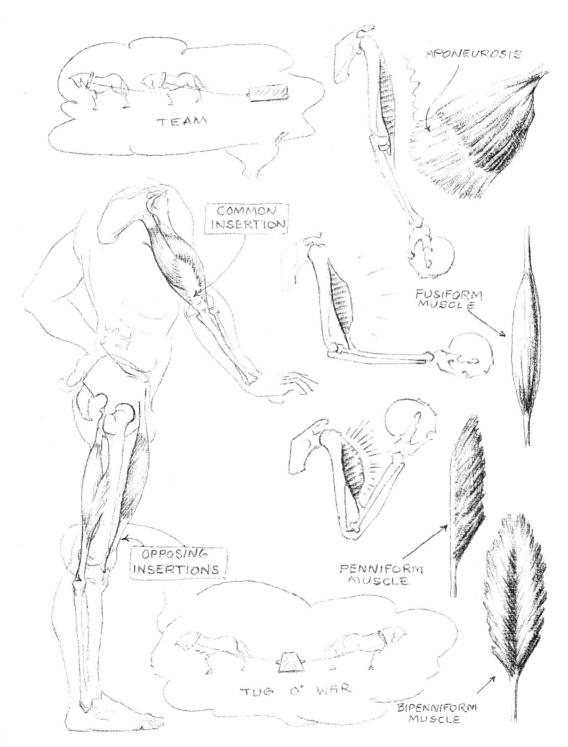

TEAM

APONEUROSIS

COMMON
INSERTION

FUSIFORM
MUSCLE

OPPOSING
INSERTIONS

PENNIFORM
MUSCLE

TUG O' WAR

BIPENNIFORM
MUSCLE

ant.	anterior
cerv.	cervical
dors.	dorsal
ext.	extensor
flex.	flexor
G.	Greek
inf.	inferior
intermed.	intermediate
lat.	lateral (-alis)
L.	Latin
lig.	ligament (s)
lumb.	lumbar
maj.	major
marg.	margin (s)
med.	medial (-alis)
min.	minor
opp.	opposite
palm.	palmar
plant.	plantar
post.	posterior
proc.	process (es)
protub.	protuberance
spin.	spinous
sup.	superior
surf.	surface (s)
thor.	thoracic
trans.	transverse
tub.	tubercle (s)
tuberos.	tuberosity
vert.	vertebra (-bræ, -bral)

N.B. In the following tables phalanges are referred to as 1st, 2nd, or 3rd, according to their proximity to the body of the hand or foot. In the case of thumb or big toe, '2nd phalanx' refers to the terminal segment.

MUSCLE	ORIGIN	INSERTION

JAW (MUSCLES OF MASTICATION)

MUSCLE	ORIGIN	INSERTION
Temporalis	Temporal line and fossa of cranium	Coronoid proc. of mandibula
Masseter	Deep surf. and ant. ⅔ of zygomatic arch	Angle of mandibula

SCALP AND FACE (MUSCLES OF EXPRESSION)[1]

MUSCLE	ORIGIN	INSERTION
Epicranius [a] Occipital belly (toward neck)	Nuchal line of cranium[2]	By aponeurosis to frontal belly
[b] Frontal belly (toward brows)	Aponeurosis from occipital belly	Skin of eyebrows
Orbicularis oculi	Med. rim of orbit	Skin encompassing lid-slit
Levator palpebræ	Rear of orbital roof	Skin of upper eyelid
Corrugator	Nasal part of frontal bone	Skin of eyebrow
Procerus (unpaired)	Nasal bones	Skin between eyebrows
Nasalis	Maxilla, below wing of nose	Wing of nose; common tendon on crest of nose
Orbicularis oris (unpaired)	Neighboring muscles, chiefly buccinator (q.v.)	Skin encompassing lip-rim
Quadratus labii superioris [a] Angular head	Upper side wall of nasal cavity	Wing of nose; nasolabial furrow
[b] Infraorbital head	Below orbit	Nasolabial furrow
[c] Zygomatic head	Zygomatic bone	Nasolabial furrow
Caninus	Canine fossa below orbit	Orbicularis oris muscle; skin at corner of mouth
Zygomaticus	Zygomatic bone (near arch)	Orbicularis oris muscle; skin at corner of mouth
Risorius	Fascia in hollow of cheek	Corner of mouth
Triangularis	Lower mandibular border	Corner of mouth
Quadratus labii inferioris	Lower mandibular border	Skin of lower lip
Mentalis	Above mental protub. of mandibula	Skin of chin
Buccinator (deep to other muscles of mouth)	Both jaws along outer border of roots for molar teeth	Orbicularis oris muscle; skin of lips

[1] For discussion and illustration, see pp. 244-56.
[2] See cut, p. 15.

ACTION	DERIVATION OF NAME
Raises lower jaw	Region of temporal bone
	G. *maseter*, masticator

ACTION	DERIVATION OF NAME
Draws scalp backward	G. *epi*, upon
Draws scalp forward, eyebrows upward; wrinkles forehead transversely	+ *kranion*, skull
Closes eyelids; draws eyebrow downward and medially, cheek upward and medially; makes 'crow's feet'	L. *orbiculus*, small disc + *oculi*, of eye
Raises upper eyelid	L. *palpebra*, eyelid
Draws skin of forehead medially, wrinkles it vertically	L. *rugare*, to wrinkle
Draws skin at root of nose downward, wrinkles it transversely	L. *procerus*, prolonged
Lowers and compresses wing of nose	L. *nasus*, nose
Closes, points, and protrudes the mouth	L. *orbiculus*, small disc + *oris*, of mouth
Raises wing of nose and upper lip; draws upper lip outward; deepens nasolabial furrow	L. *quadratus*, square-shaped [muscle] + *labii*, of lip
Draws corner of mouth upward; both together raise lower lip to close mouth	Origin above canine tooth
Draws corner of mouth outward and upward	Origin on zygomatic bone
Draws corner of mouth outward; causes 'dimple'	L. *risus*, laughter
Draws corner of mouth downward; both together draw upper lip downward to close mouth	Of triangular shape
Draws lower lip outward and downward	L. *quadratus*, square-shaped [muscle] + *labii*, of lip
Raises skin of chin and wrinkles it; protrudes lower lip	L. *mentum*, chin
Draws corner of mouth outward; closes mouth; compresses lips and cheeks	L. *bucca*, cheek

MUSCLE	ORIGIN	INSERTION
THROAT (Superficial)		
Platysma	Fascia and skin of breast and shoulder regions	Fascia of face, overlying jaw; corner of mouth
CANOPY OF THE JAW		
Digastric [a] Anterior belly (toward chin)	Intermed. tendon (fastened by loop of fascia to hyoid bone)	Behind mental tub.
[b] Posterior belly (toward ear)	Covered by mastoid proc. of temporal bone	Intermed. tendon (fastened by loop of fascia to hyoid bone)
Mylohyoid (deep to ant. belly of digastric)	Inner front marg. of mandibula	Midline, from mental protub. to hyoid bone
Stylohyoid (overlies intermed. tendon of digastric)	Styloid proc. of temporal bone	Hyoid bone
CORDS OF THE NECK		
Sternomastoid [a] Medial head (sternal head)	Ant. surf. of manubrium (of sternum); sternoclavicular joint	By common tendon to mastoid proc. of temporal bone (overlies intermed. tendon of omohyoid, *q.v.*)
[b] Lateral head (clavicular head)	Sternal end of clavicle	
ANTERIOR TRIANGLE[1] (Deep muscles of throat)		
Sternothyroid	Deep on post. surf. of manubrium	Thyroid cartilage (see p. 99)
Thyrohyoid	Thyroid cartilage (see p. 99)	
Omohyoid [a] Superior belly (toward jaw)	Intermed. tendon from inf. belly (*q.v.*), deep to sternomastoid	Hyoid bone
Sternohyoid	Post. surf. of manubrium and clavicle	
POSTERIOR TRIANGLE (Side of neck)		
Omohyoid [b] Inferior belly (in hollow above clavicle)	Upper marg. of scapula	Intermed. tendon to sup. belly of omohyoid (*q.v.*), deep to sternomastoid
Scalenus anterior, medius, posterior	Cerv. vert. II-VII	Upper two ribs
Levator scapulæ	Cerv. vert. I-IV	Upper vert. marg. of scapula

[1] The side of the neck, being somewhat square, is divided by the diagonal sternomastoid muscle into two triangles. The anterior triangle is bounded by the midline in front and the canopy of the jaw above, while the posterior triangle is bounded by the clavicle below and trapezius behind. (For trapezius, see p. 102.)

THE NECK

ACTION	DERIVATION OF NAME
Draws lower lip downward and outward; raises skin of neck from underlying parts	G. *platysma*, flat plate

ACTION	DERIVATION OF NAME
Jaw fixed: draws hyoid bone upward; hyoid bone fixed: draws jaw downward	G. *di*, two + *gaster*, belly
Jaw fixed: draws hyoid bone forward and upward, raises tongue; hyoid bone fixed: draws jaw downward	G. *myle*, molar tooth [region] + attachment to hyoid bone
Draws hyoid bone backward and upward	Styloid proc. and hyoid bone attachments

ACTION	DERIVATION OF NAME
Turns head to opp. side and face upward; both together lift face and tip head backward	Condensed from 'sterno-cleido-mastoid'; attachments: sternum, clavicle, mastoid proc.

ACTION	DERIVATION OF NAME
Draws thyroid cartilage downward	Attachments: sternum and thyroid cartilage
Draws thyroid cartilage and hyoid bone toward each other	Attachments: thyroid cartilage and hyoid bone
Draws hyoid bone downward	G. *omos*, shoulder + attachment to hyoid bone
	Attachments: sternum and hyoid bone

ACTION	DERIVATION OF NAME
Draws upon sup. belly of same muscle (*q.v.*)	G. *omos*, shoulder + attachment to hyoid bone
Bend cerv. spine lateralward; right and left sides together bend it forward	G. *skalenos*, uneven
Draws scapula medially and upward	Elevator of scapula

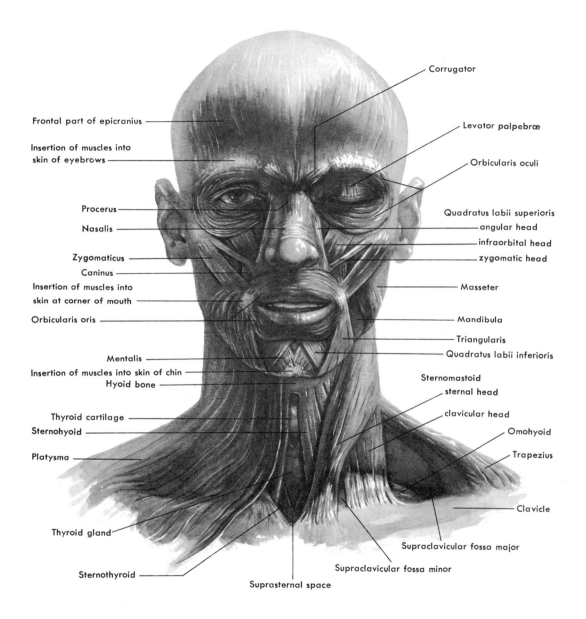

Corrugator

Frontal part of epicranius

Levator palpebræ

Insertion of muscles into skin of eyebrows

Orbicularis oculi

Procerus

Quadratus labii superioris

Nasalis

angular head

infraorbital head

Zygomaticus

zygomatic head

Caninus

Insertion of muscles into skin at corner of mouth

Masseter

Orbicularis oris

Mandibula

Triangularis

Mentalis

Quadratus labii inferioris

Insertion of muscles into skin of chin

Sternomastoid

Hyoid bone

sternal head

Thyroid cartilage

clavicular head

Sternohyoid

Omohyoid

Platysma

Trapezius

Clavicle

Thyroid gland

Supraclavicular fossa major

Sternothyroid

Supraclavicular fossa minor

Suprasternal space

OBSERVATIONS—(1) *Facial muscles are thin, embedded in fat. Grimaces of face are only evidence at surface. (2) Muscles in region of throat suggest curtain of long streamers, pushed apart at center by thyroid cartilage and gland (p. 99). (3) Contour of neck formed by sternomastoid.*

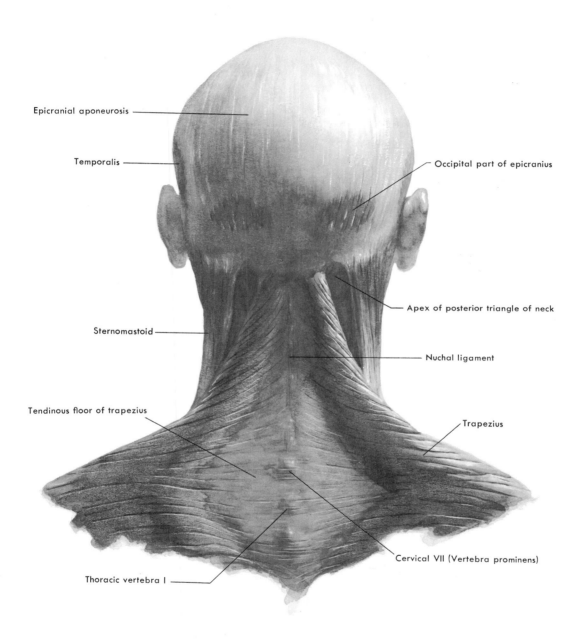

Epicranial aponeurosis

Temporalis

Occipital part of epicranius

Apex of posterior triangle of neck

Sternomastoid

Nuchal ligament

Tendinous floor of trapezius

Trapezius

Cervical VII (Vertebra prominens)

Thoracic vertebra I

OBSERVATIONS—(1) *Transverse line from ear to ear almost entirely tendinous and depressed, delimiting regions of head and nape of neck.*

(2) *Surface muscles at rear of neck attach to skull chiefly at three places: occipital protuberance and both mastoid processes. Depressions either side between attachments.*

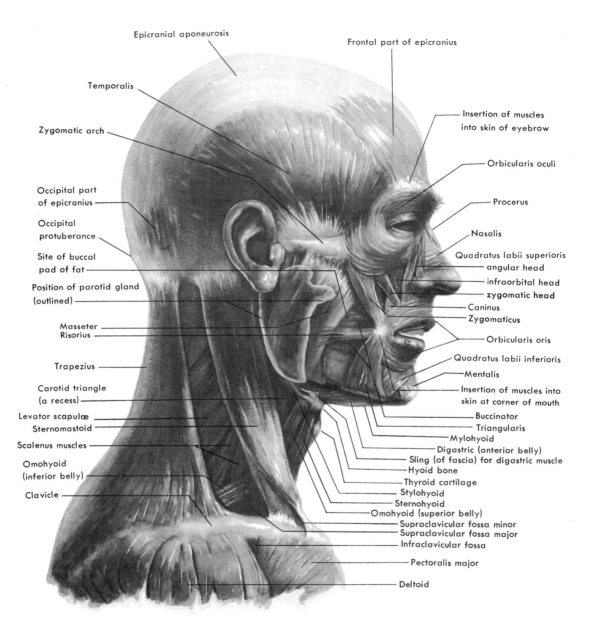

Epicranial aponeurosis

Frontal part of epicranius

Temporalis

Zygomatic arch

Insertion of muscles
into skin of eyebrow

Orbicularis oculi

Occipital part
of epicranius

Procerus

Occipital
protuberance

Nasalis

Site of buccal
pad of fat

Quadratus labii superioris
angular head
infraorbital head
zygomatic head

Position of parotid gland
(outlined)

Caninus
Zygomaticus

Masseter
Risorius

Orbicularis oris

Quadratus labii inferioris

Mentalis

Trapezius

Insertion of muscles into
skin at corner of mouth

Carotid triangle
(a recess)

Buccinator

Levator scapulæ

Triangularis

Sternomastoid

Mylohyoid

Digastric (anterior belly)

Scalenus muscles

Sling (of fascia) for digastric muscle

Hyoid bone

Omohyoid
(inferior belly)

Thyroid cartilage

Stylohyoid

Clavicle

Sternohyoid

Omohyoid (superior belly)

Supraclavicular fossa minor

Supraclavicular fossa major

Infraclavicular fossa

Pectoralis major

Deltoid

OBSERVATIONS—(1) *Muscles of mastication converge forward toward cheekbone: temporalis inside zygomatic arch, masseter outside.* (2) *Parotid gland, with size and shape of ear, overlies rear borders of jawbone and masseter muscle; directs fleshy contour of jaw behind* lobe of ear. (3) *Triangles of neck (p. 94) are created by diagonal sternomastoid. Posterior triangle depressed, contents obscure. Anterior triangle raised by thyroid cartilage and gland (p. 99). (4) Tension on hyoid bone accounts for angular cut in front contour from chin to pit of neck.*

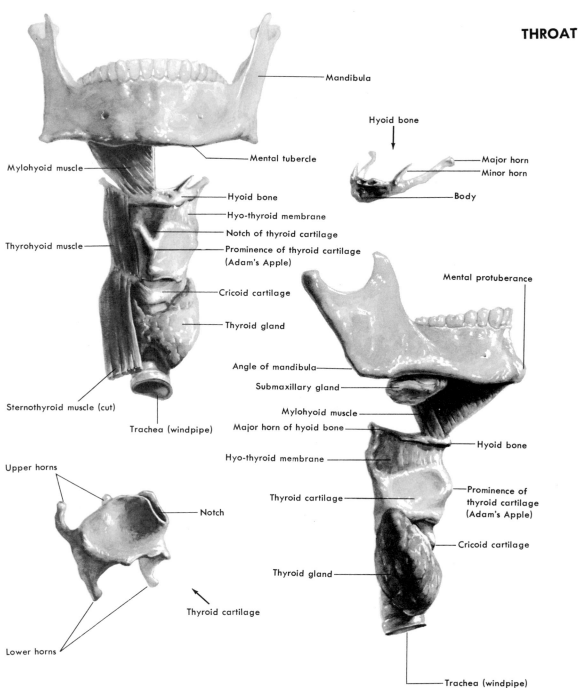

Mandibula

Hyoid bone

Major horn
Minor horn
Body

Mental tubercle

Mylohyoid muscle

Hyoid bone
Hyo-thyroid membrane
Notch of thyroid cartilage
Thyrohyoid muscle
Prominence of thyroid cartilage (Adam's Apple)

Cricoid cartilage

Thyroid gland

Mental protuberance

Sternothyroid muscle (cut)

Trachea (windpipe)

Angle of mandibula
Submaxillary gland
Mylohyoid muscle
Major horn of hyoid bone
Hyoid bone
Hyo-thyroid membrane
Thyroid cartilage
Prominence of thyroid cartilage (Adam's Apple)
Cricoid cartilage
Thyroid gland

Upper horns

Notch

Thyroid cartilage

Lower horns

Trachea (windpipe)

OBSERVATIONS—(1) *Hyoid bone U-shaped, gives re-entering angle to side profile of neck. (2) Thyroid cartilage sharp at forward end (Adam's Apple) especially in male. Prominence determined by angle between right and left sides. Seen from front, shows V-shaped notch as in folding of tricornered hat. (3) Cricoid cartilage* (ring-shaped) *seldom conspicuous. (4) Thyroid glands wrap around windpipe from either side, meet in front to give roundness to lower throat, especially full in female. (5) Submaxillary gland lies in relief between hyoid bone and angle of jaw.*

99

SIZE AND SHAPE
OF EAR

PAROTID
GLAND

PADDING FOR
REAR OF JAW

MASSETER MUSCLE
WITH CHEEK FAT

STYLOHYOID MUSCLE
A "CHOKER"

TRIANGLES OF NECK

CONTOUR
HERE

M

SHARP
RELIEF
HERE

MYLOHYOID MUSCLE
SUBMAXILLARY GLAND

HYOID BONE
DIGASTRIC MUSCLE

HYOID BONE

THYROID CARTILAGE

CRICOID CARTILAGE

MEMBRANE

THYROID GLAND

WINDPIPE

ROTATION OF THROAT

PROFILE DIAMETER OF NECK

SHORTER BELOW

SHARP

LEAN

MALE

BLUNT

FULL

FEMALE

STACKED LIKE A TOTEM POLE

101

MUSCLE	ORIGIN	INSERTION
CHEST		
Pectoralis major (breast muscle)	Med. half of clavicle; ant. surf. of sternum; abdominal sheath (see below)	Ridge on upper ant. surf. of humerus
Pectoralis minor (deep to p. major)	Ant. surf. of ribs III-V	Coracoid proc. of scapula
Serratus [anterior] (s. posterior muscle is deep on back)	Digitations, fan-like, from 8 or 9 uppermost ribs	Vert. marg. of scapula (passing between ribs and scapula)
FLANK		
External oblique (covers internal oblique and transverse muscles)	By 8 digitations from ribs V-XII (upper 4 interweave with slips of serratus, lower 3 with latissimus dorsi [q.v.])	Sheath of rectus abdominis (see below); inguinal lig.; iliac crest (forming horizontal bulge called 'flank pad')
ABDOMEN		
Rectus abdominis (sheath: see below)	Ant. surf. of symphysis pubis; sup. ramus of pubic bone	Costal cartilages V-VII; xiphoid proc. of sternum
BACK		
Sacrospinalis (at side of midline in 'spinal gutter,'[1] deep to latissimus dorsi [q.v.])	Dors. surf. of sacrum; spin. proc. of all lumbar vert. and 2 or 3 lowermost thor. vert.; iliac crest	By many slips to various points of spine and ribs
Rhomboid major (mostly covered by trapezius [q.v.])	Spin. proc. of thor. vert. I-IV	Lower half vert. marg. of scapula
Rhomboid minor (entirely covered by trapezius [q.v.])	Nuchal lig. of neck; spin. proc. of cerv. vert. VI, VII	Vert. marg. of scapula, above rhomboid maj.
Supraspinatus (deep to trapezius [q.v.])	Supraspinous fossa of scapula	Maj. tub. of humerus
Infraspinatus	Infraspinous fossa of scapula	
Teres minor	Axillary marg. of scapula	
Teres major	Lower angle of scapula	Ridge on upper med. surf. of humerus, below and behind insertion of latissimus dorsi (q.v.)
Latissimus dorsi	Spin. proc. of thor. vert. VII on downward; lumbodorsal fascia; iliac crest; digitations from 3 or 4 lowermost ribs	Ridge on ant. surf. of humerus, close to its head, in front of insertion of teres maj.
Trapezius (Cowl or hood muscle)	Occipital protub.; nuchal lig.; supraspinous lig. to thor. vert. XII	Lat. end of clavicle; acromion proc. and spine of scapula

[1] Cf. p. 22.

N.B. The rectus abdominis muscles of both sides are encased throughout by a broad, tendinous sheath. They are separated from each other at the groove of the midline by a tough, fibrous strap, the *linea alba* [L. white line], widest at the navel. And they are divided into lesser bellies by interrupting tendons (*transverse lines*) at the navel and twice (sometimes more) above it. The lateral curved margin of each muscle is marked by a tendinous depression, called the *semilunar line*.

THE TORSO

ACTION	DERIVATION OF NAME
Draws arm forward and medially, rotates it inward, lowers it when raised vertically	L. *pectus,* breastbone
Lowers scapula and clavicle; turns lower angle of scapula medially	
Draws scapula forward and laterally	L. *serra,* a saw (its digitations resemble the notches of a saw)
Pelvis fixed: draws thorax downward, rotates spine to opp. side, both together bend spine forward; thorax fixed: elevates pelvis	*External* to the abdominal cavity, *oblique* in the direction of its fibers
Pelvis fixed: draws thorax downward, bends spine forward; thorax fixed: elevates pelvis	L. *rectus,* straight [muscle] + *abdominis,* of abdomen
Pelvis fixed: straightens spine; thorax and upper spine fixed: draws pelvis backward and upward	Sacral and spinal regions of attachment
Rotates scapula medially and upward	G. *rhombos,* rhombus [-shaped]
Raises arm laterally and forward, rotates it outward	Above spine [of scapula]
Rotates arm laterally; furthers abduction of raised arm	Below spine [of scapula]
Adducts arm and rotates it outward	L. *teres,* round and long
Adducts arm and rotates it inward, lowers it when raised vertically	
Draws arm backward and medially, rotates it inward, lowers it when raised vertically	L. *latissimus,* broadest [muscle] + *dorsi,* of back
Draws scapula toward spine; upper fibers raise scapula, lower fibers draw it down; scapula fixed: draws head backward, rotates it toward opp. side	G. *trapezion,* four-sided shape not a parallelogram

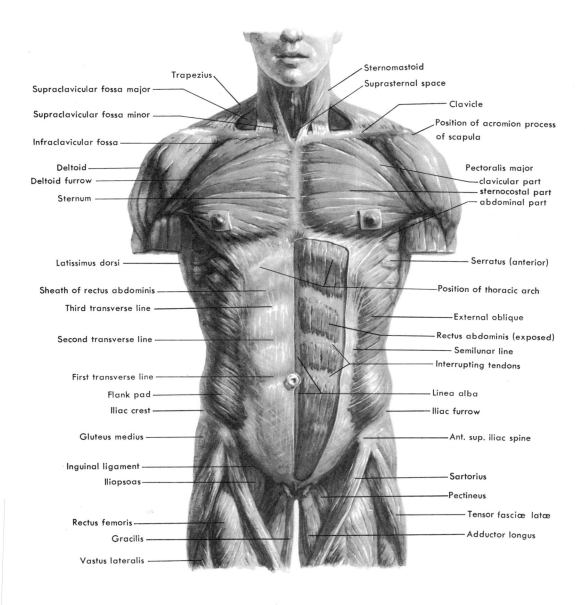

Trapezius
Sternomastoid
Suprasternal space
Supraclavicular fossa major
Supraclavicular fossa minor
Clavicle
Position of acromion process of scapula
Infraclavicular fossa
Deltoid
Pectoralis major
Deltoid furrow
clavicular part
Sternum
sternocostal part
abdominal part

Latissimus dorsi
Serratus (anterior)
Sheath of rectus abdominis
Position of thoracic arch
Third transverse line
External oblique
Second transverse line
Rectus abdominis (exposed)
Semilunar line
Interrupting tendons
First transverse line
Flank pad
Linea alba
Iliac crest
Iliac furrow
Gluteus medius
Ant. sup. iliac spine
Inguinal ligament
Iliopsoas
Sartorius
Pectineus
Tensor fasciæ latæ
Rectus femoris
Adductor longus
Gracilis
Vastus lateralis

OBSERVATIONS—(1) *Pectoralis major sweeps over to arm, separated by fossa and furrow from shoulder muscle; inserts nearly opposite nipple.* (2) *Interrupting tendons of rectus abdominis (see note [N.B.], p. 102) arch progressively higher toward sternum. Lowest line close to (usually above) navel; middle line at lower level of ribs; highest near apex of thoracic arch.* (3) *Navel in line with fullness of flank-pad muscles.* (4) *Abdominal muscles bullet-shaped, narrower than interval between nipples.* (5) *Nipple in perpendicular line with spine of iliac crest and medial corner of infraclavicular fossa.* (6) *Letter V at navel would cut through nipples and extend to acromion of shoulders.*

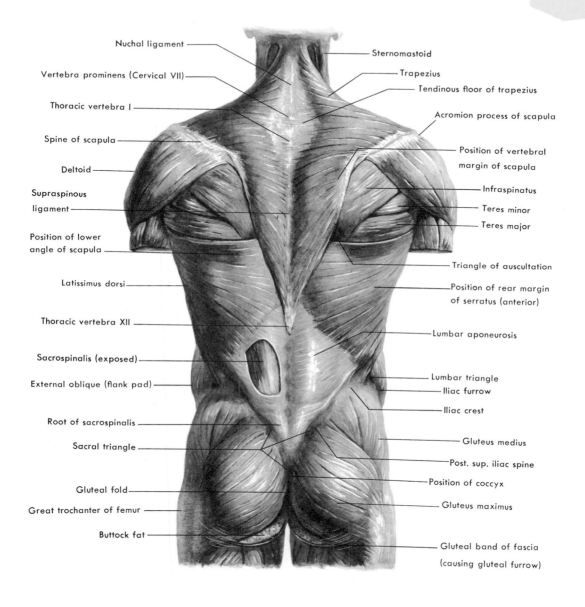

Nuchal ligament

Vertebra prominens (Cervical VII)

Thoracic vertebra I

Spine of scapula

Deltoid

Supraspinous ligament

Position of lower angle of scapula

Latissimus dorsi

Thoracic vertebra XII

Sacrospinalis (exposed)

External oblique (flank pad)

Root of sacrospinalis

Sacral triangle

Gluteal fold

Great trochanter of femur

Buttock fat

Sternomastoid

Trapezius

Tendinous floor of trapezius

Acromion process of scapula

Position of vertebral margin of scapula

Infraspinatus

Teres minor

Teres major

Triangle of auscultation

Position of rear margin of serratus (anterior)

Lumbar aponeurosis

Lumbar triangle

Iliac furrow

Iliac crest

Gluteus medius

Post. sup. iliac spine

Position of coccyx

Gluteus maximus

Gluteal band of fascia (causing gluteal furrow)

OBSERVATIONS—(1) *Trapezius suggests four-pointed star, with lozenge-shaped tendinous depression surrounding vertebra prominens. Lower 'tail' seldom conspicuous. (2) Infraspinatus depressed by special thickness of fascia.* (3) *Latissimus envelops back of trunk, like a bodice.* (4) *Lumbar sheath diamond-shaped.* (5) *Sacral triangle separates midline furrow of back from deep cleft of buttocks. Triangle often depressed at midline, especially in males, indicating roots of sacrospinalis.*

105

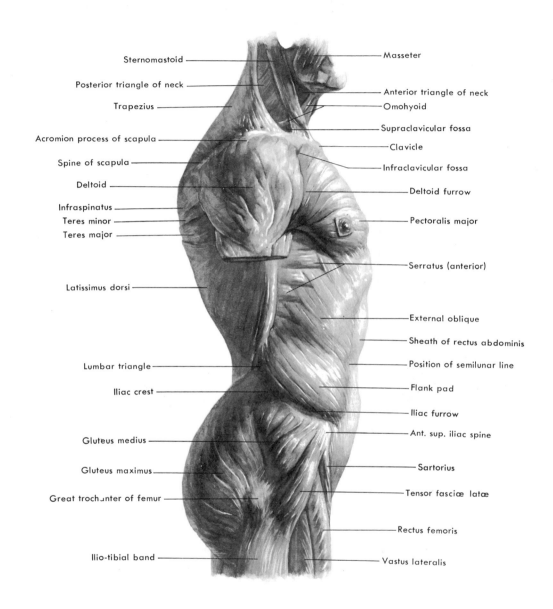

Sternomastoid — Masseter

Posterior triangle of neck — Anterior triangle of neck

Trapezius — Omohyoid

— Supraclavicular fossa

Acromion process of scapula — Clavicle

Spine of scapula — Infraclavicular fossa

Deltoid — Deltoid furrow

Infraspinatus — Pectoralis major
Teres minor —
Teres major —

— Serratus (anterior)

Latissimus dorsi —

— External oblique

— Sheath of rectus abdominis

Lumbar triangle — Position of semilunar line

Iliac crest — Flank pad

— Iliac furrow

— Ant. sup. iliac spine

Gluteus medius —

Gluteus maximus — Sartorius

Great trochanter of femur — Tensor fasciœ latœ

— Rectus femoris

Ilio-tibial band — Vastus lateralis

OBSERVATIONS—(1) *Forward margins of tra-pezius and deltoid together describe double curve whose arcs change direction at clavicle. (2) Upper margin of latissimus dorsi level with lower margin of pectoral. Both margins arch* *upward toward pit of arm. (3) External ob-lique interweaves with serratus and latissimus on line dropping from nipple to posterior spine of iliac crest. (4) Iliac furrow suggests con-tinuity with fleshy part of latissimus.*

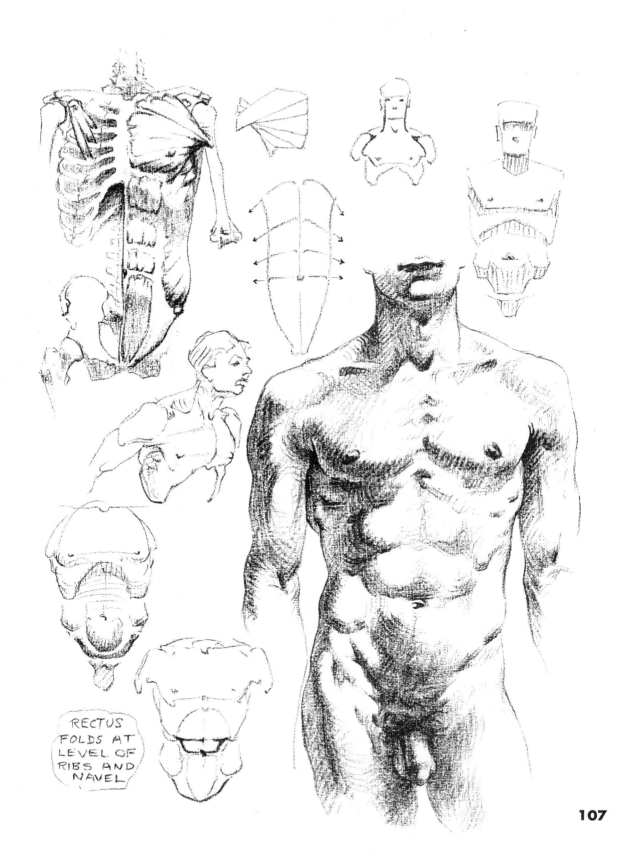

RECTUS
FOLDS AT
LEVEL OF
RIBS AND
NAVEL

107

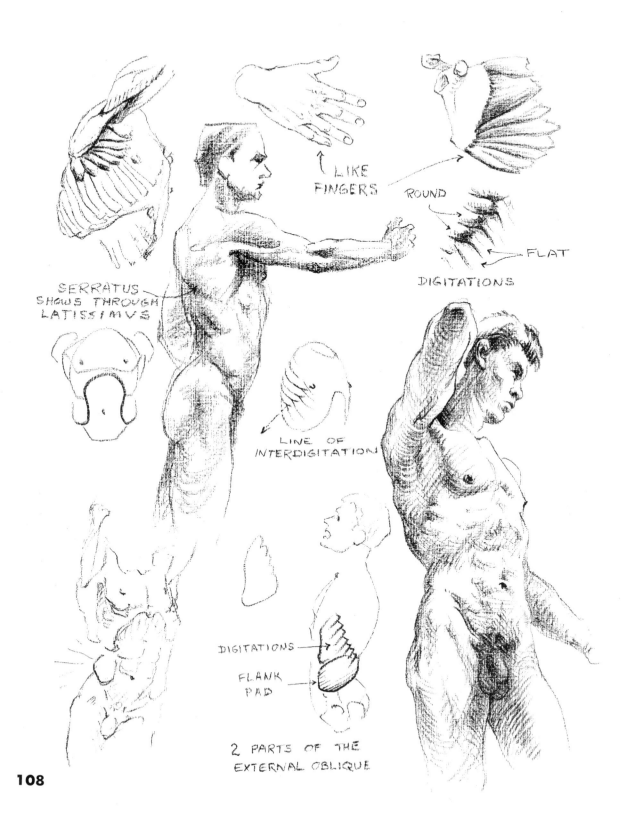

LIKE FINGERS

ROUND

FLAT

DIGITATIONS

SERRATUS SHOWS THROUGH LATISSIMUS

LINE OF INTERDIGITATION

DIGITATIONS

FLANK PAD

2 PARTS OF THE EXTERNAL OBLIQUE

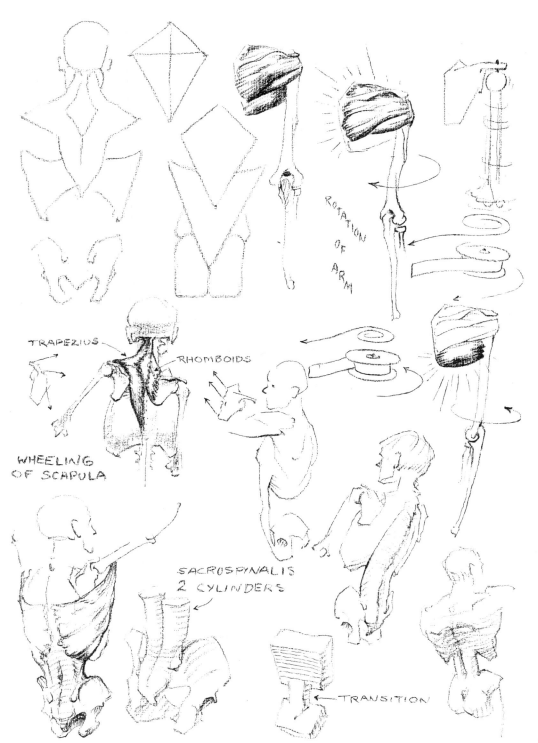

ROTATION OF ARM

TRAPEZIUS

RHOMBOIDS

WHEELING
OF SCAPULA

SACROSPINALIS
2 CYLINDERS

TRANSITION

109

MUSCLE	ORIGIN	INSERTION
SHOULDER		
Deltoid	Lat. end. of clavicle; acromion and spine of scapula	Deltoid tuberos. of humerus
PIT OF ARM (AXILLA)		
Coracobrachialis	Coracoid proc. of scapula, in common with pectoralis min. (p. 102) and short head of biceps (*q.v.*)	Med. marg. of humerus
FLEXOR GROUP OF ARM (Front—low)		
Brachialis (deep to biceps)	Ant. surf. of humerus	By cubital fossa[1] to coronoid proc. of ulna; ulnar tuberos.
Biceps [a] Long head (lateral)	Tuberos. above glenoid fossa of scapula	Entering by cubital fossa to radial tuberos.; tendinous ribbon (*bicipital fascia*)[2] at surface to region below med. epicondyle of humerus—binds flexor group of forearm
[b] Short head (medial)	Coracoid proc. of scapula, in common with coraco-brachialis and pectoralis min. (p. 102)	
EXTENSOR GROUP OF ARM (Rear—high)		
Triceps [a] Long head (middle, or scapular)	Between teres muscles, from tuberos. below glenoid fossa of scapula	Olecranon proc. of ulna
[b] Lateral head	Post. surf. of humerus	
[c] Medial head (partly underlying long head)		
EXTENSOR-SUPINATOR GROUP OF FOREARM (Outer side—high)		
Brachioradialis	Lat. epicondylar ridge of humerus, between triceps and brachialis	Styloid proc. of radius
Ext. carpi radialis longus	Lat. epicondyle and epicon-dylar ridge of humerus	Base of metacarpal II (dors. surf.)
Ext. carpi radialis brevis	Lat. epicondyle of humerus	Base of metacarpal III (dors. surf.)
Ext. [communis] digitorum		By 4 tendons to phalanges of fingers II-V (dors. surf.)
Ext. digiti quinti [proprius]		1st phalanx[3] of little finger (dors. surf.)
Anconeus		Dors. surf. of ulna
Ext. carpi ulnaris	Lat. epicondyle of humerus; dors. surf. of ulna	Base of metacarpal V
Ext. indicis [proprius] (deep)	Dors. surf. of ulna	1st phalanx of index finger

[1] Hollow at front of elbow [L. *cubitum*, elbow].
[2] More properly known as *lacertus fibrosus*.
[3] Phalanges are briefly referred to as 'first, second, and third,' corresponding to proximal, median, and distal. The second segment of the thumb, of course, is its distal phalanx.

110

ACTION | DERIVATION OF NAME

ACTION	DERIVATION OF NAME
Raises arm; anterior fibers draw arm forward, rotate it inward; posterior fibers draw arm backward, rotate it outward	Shape resembles Greek letter Δ
Raises arm forward and adducts it	Attachments: coracoid proc. of scapula and *brachium* [L. arm]
Flexes forearm	L. *brachium*, arm
Raises arm forward, rotates it slightly inward; flexes and supinates forearm	L. *bis*, twice + *caput*, head
Long head adducts arm, draws it backward; three heads together extend forearm	L. *tres*, three + *caput*, head
Flexes forearm; supinates forearm in extension, pronates it in flexion	Attachments: *brachium* [L. arm] and radius
Flexes forearm; supinates forearm in extension, pronates it in flexion; abducts and extends hand	Long extensor of radial side of wrist
Extends and abducts hand	Short extensor of radial side of wrist
Extends hand and fingers II-V; spreads fingers apart	[Common] extensor of digits
Extends 1st phalanx of little finger	Extensor of fifth finger [proper]
Extends forearm	G. *ankon*, elbow
Adducts hand, extends it somewhat	Extensor of ulnar side of wrist
Extends index (pointing) finger, draws it ulnarward	Extensor of index finger [proper]

MUSCLE	ORIGIN	INSERTION
THUMB GROUP OF FOREARM (Emerging from under ext. digitorum[4])		
Abductor pollicis longus	Dors. surf. of ulna and radius; interosseous membrane	Base of metacarpal I
Ext. pollicis brevis	Dors. surf. of radius; interosseous membrane	Base of 1st phalanx of thumb[5]
Ext. pollicis longus (seen only on hand)	Dors. surf. of ulna; interosseous membrane	Base of 2nd phalanx of thumb
FLEXOR-PRONATOR GROUP OF FOREARM (Inner side—low)		
Flex. carpi ulnaris	Med. epicondyle of humerus; olecranon proc. and crest of ulna	Pisiform bone of wrist
Flex. digitorum [sublimis][6] (partly deep)	Med. epicondyle of humerus; ulnar tuberos.; ant. surf. of radius	Palm. surf. of 2nd phalanx of fingers II-V
Flex. pollicis longus (deep)[7]	Ant. surf. of radius	Base of 2nd phalanx of thumb
Palmaris [longus] (p. brevis muscle in palm, unimportant)	Med. epicondyle of humerus	Palmar aponeurosis, fanning into palm of hand
Flex. carpi radialis		Base of metacarpals II and III
Pronator teres	Med. epicondyle of humerus; coronoid proc. of ulna	Ant. and lat. surf. of radius
BACK OF HAND		
Dorsal interosseous I[8]	Neighboring surf. of metacarpals I and II	1st phalanx of index finger
BALL OF THUMB (THENAR EMINENCE)		
Abductor pollicis brevis	Carpal lig. (see footnote, opp. page); tub. of navicular and maj. multangular bones of wrist	Body and head of metacarpal I; base of 1st phalanx of thumb
Opponens pollicis (deep)		
Flex. pollicis brevis		
Adductor pollicis (on palm, opp. Dors. interosseous I)	Metacarpal III	Base of 1st phalanx of thumb
HEEL OF HAND (HYPOTHENAR EMINENCE)		
Abductor digiti quinti	Carpal lig.; pisiform bone of wrist	Base of 1st phalanx of little finger and extensor tendons
Flex. digiti quinti brevis	Carpal lig. (see footnote, opp. page); hook of hamate bone of wrist	Base of 1st phalanx of little finger; body and head of metacarpal V
Opponens digiti quinti (deep)		

[4] Cf. p. 110.
[5] See footnote 3, p. 110.
[6] Distinguished from a *flex. dig. profundus,* which it overlies.
[7] Its contraction deepens a hollow at the wrist.
[8] Other interosseous muscles fill interspaces between metacarpals, but do not affect the surface.

ACTION	DERIVATION OF NAME
Abducts thumb, draws it dorsalward; helps to supinate forearm	Long abductor of thumb [L. *pollex*]
Abducts thumb, draws it dorsalward; extends 1st phalanx; helps to supinate forearm	Short extensor of thumb [L. *pollex*]
Adducts thumb, draws it dorsalward, extends phalanges; helps to supinate forearm	Long extensor of thumb [L. *pollex*]

Flexes and adducts hand	Flexor of ulnar part of wrist
Flexes hand and adducts it somewhat; flexes 1st and 2nd phalanges of fingers ii-v	Flexor of digits [superficial]
Flexes hand and abducts it somewhat; draws thumb dorsalward, flexes 2nd phalanx[9]	Long flexor of thumb [L. *pollex*]
Pronates forearm; flexes hand	Palmar muscle [long]
Pronates forearm; flexes and abducts hand	Flexor of radial part of wrist
Pronates and flexes forearm	L. *teres*, round and long

Thumb fixed: abducts and flexes index finger; index finger fixed: adducts thumb	On dorsum (back) of hand, lodged between bones

Abducts thumb, draws it forward; flexes 1st phalanx, extends 2nd phalanx[10]	Short abductor of thumb [L. *pollex*]
Adducts thumb, draws it forward	Opposing muscle of thumb
Draws thumb forward, flexes 1st phalanx, extends 2nd phalanx	Short flexor of thumb [L. *pollex*]
Adducts thumb, draws it forward; flexes 1st phalanx, extends 2nd phalanx	Adductor of thumb [L. *pollex*]

Abducts little finger, draws it forward; flexes 1st phalanx, extends 2nd and 3rd phalanges	Abductor of finger v
Flexes 1st phalanx of little finger	Short flexor of finger v
Draws little finger forward	Opposing (palm-crossing) muscle of finger v

[9] See footnote 3, p. 110.
[10] Ibid.
N.B. In the fascia of the wrist, a retaining band (annular ligament) is developed to bind down tendons in transit to the hand. Its front and rear portions separately are called *carpal ligaments*. Diagrams: pp. 122-4.

supine prone

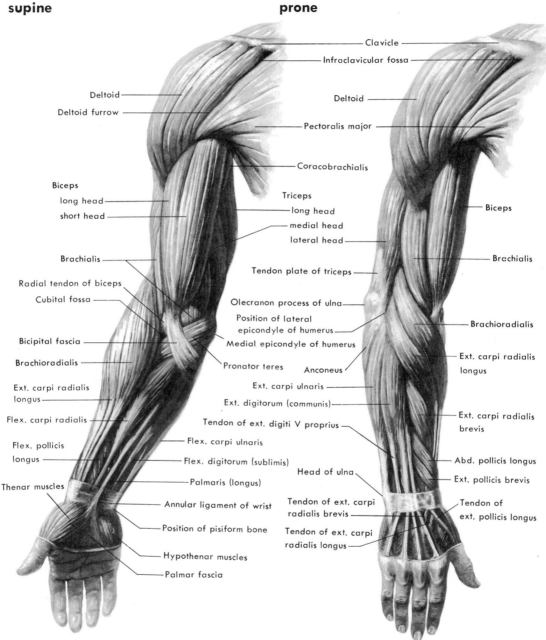

Clavicle
Infraclavicular fossa
Deltoid
Deltoid furrow
Deltoid
Pectoralis major
Coracobrachialis
Biceps
long head
short head
Triceps
long head
medial head
lateral head
Biceps
Brachialis
Radial tendon of biceps
Cubital fossa
Tendon plate of triceps
Brachialis
Olecranon process of ulna
Position of lateral
epicondyle of humerus
Medial epicondyle of humerus
Brachioradialis
Bicipital fascia
Brachioradialis
Pronator teres Anconeus
Ext. carpi radialis
longus
Ext. carpi radialis
longus
Ext. carpi ulnaris
Ext. digitorum (communis)
Flex. carpi radialis
Tendon of ext. digiti V proprius
Ext. carpi radialis
brevis
Flex. pollicis
longus
Flex. carpi ulnaris
Flex. digitorum (sublimis)
Head of ulna
Abd. pollicis longus
Ext. pollicis brevis
Thenar muscles
Palmaris (longus)
Annular ligament of wrist
Tendon of ext. carpi
radialis brevis
Tendon of
ext. pollicis longus
Position of pisiform bone
Tendon of ext. carpi
radialis longus
Hypothenar muscles
Palmar fascia

OBSERVATIONS—(1) *Deltoid winds slightly for-ward to insert.* (2) *Biceps narrower than sil-houette of arm.* (3) *In forearm, extensor-supi-nators are higher than flexor-pronators, and tend to be more angular. Two groups separated by indistinct furrow from cubital fossa to* thumb. *In twist of forearm muscles, the key is IF and OR: those beginning Inside at the elbow pass to the Front; those at the Outside pass to the Rear.* (4) *Forearm muscles slipping out to thumb produce slight fullness above wrist on thumb-side contour.*

supine **prone**

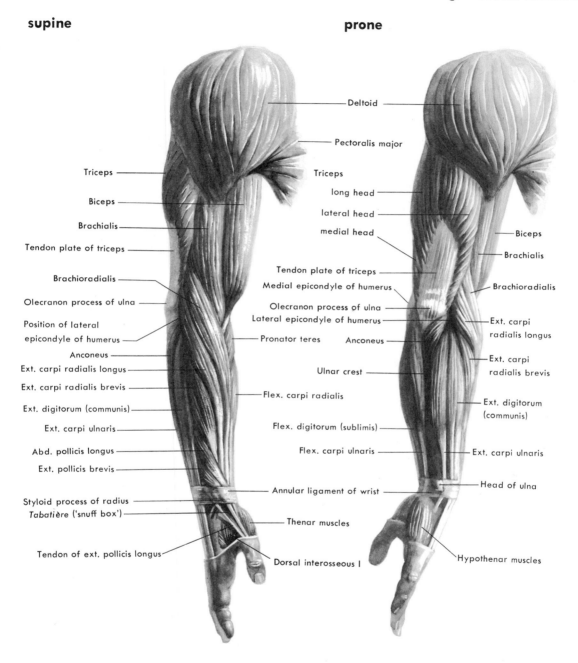

Deltoid

Pectoralis major

Triceps

Triceps

long head

Biceps

lateral head

Brachialis

medial head

Tendon plate of triceps

Biceps

Brachialis

Brachioradialis

Tendon plate of triceps

Olecranon process of ulna

Medial epicondyle of humerus

Brachioradialis

Position of lateral
epicondyle of humerus

Olecranon process of ulna

Lateral epicondyle of humerus

Ext. carpi
radialis longus

Anconeus

Pronator teres

Anconeus

Ext. carpi radialis longus

Ext. carpi
radialis brevis

Ext. carpi radialis brevis

Ulnar crest

Ext. digitorum (communis)

Flex. carpi radialis

Ext. digitorum
(communis)

Ext. carpi ulnaris

Flex. digitorum (sublimis)

Abd. pollicis longus

Flex. carpi ulnaris

Ext. carpi ulnaris

Ext. pollicis brevis

Head of ulna

Styloid process of radius

Annular ligament of wrist

Tabatière ('snuff box')

Thenar muscles

Tendon of ext. pollicis longus

Hypothenar muscles

Dorsal interosseous I

OBSERVATIONS—(1) *Triceps higher than biceps,
tends to be more swollen, less box-like. (2)
Brachialis, brachioradialis, and radial wrist
extensors form chain of double curves, each
arising from behind muscle above and turning
forward below. Forearm muscles slipping out
to thumb arise in same way, but cross other
tendons above wrist to reach back of thumb.
(3) Deep hollow behind ulna, between tendons
of ulnar flexor and extensor.*

115

supine **prone**

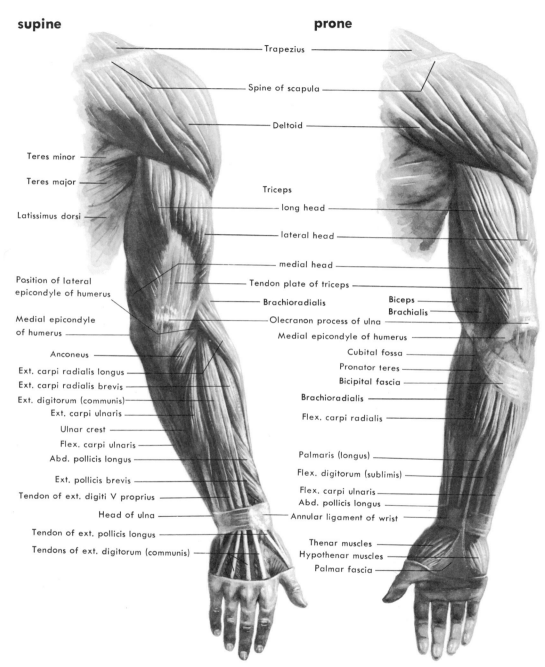

Trapezius

Spine of scapula

Deltoid

Teres minor

Teres major

Triceps

long head

Latissimus dorsi

lateral head

medial head

Tendon plate of triceps

Position of lateral epicondyle of humerus

Brachioradialis

Biceps

Brachialis

Olecranon process of ulna

Medial epicondyle of humerus

Medial epicondyle of humerus

Anconeus

Cubital fossa

Ext. carpi radialis longus

Pronator teres

Ext. carpi radialis brevis

Bicipital fascia

Ext. digitorum (communis)

Brachioradialis

Ext. carpi ulnaris

Flex. carpi radialis

Ulnar crest

Flex. carpi ulnaris

Abd. pollicis longus

Palmaris (longus)

Ext. pollicis brevis

Flex. digitorum (sublimis)

Tendon of ext. digiti V proprius

Flex. carpi ulnaris

Abd. pollicis longus

Head of ulna

Annular ligament of wrist

Tendon of ext. pollicis longus

Thenar muscles

Tendons of ext. digitorum (communis)

Hypothenar muscles

Palmar fascia

OBSERVATIONS—(1) *Deltoid disappears forward to make insertion.* (2) *Triceps bulges in upper half of arm; tendon plate 'points' in.* (3) *Lateral epicondyle a pit in line with knob of elbow;* *anconeus muscle between and below.* (4) *Extensor-supinator muscles spiral out from around the pit.* (5) *Forearm groups separated by ulnar crest running off toward little finger.* (6) *Wrist shows wiry tendons in front, smooth in back.*

116

supine

prone

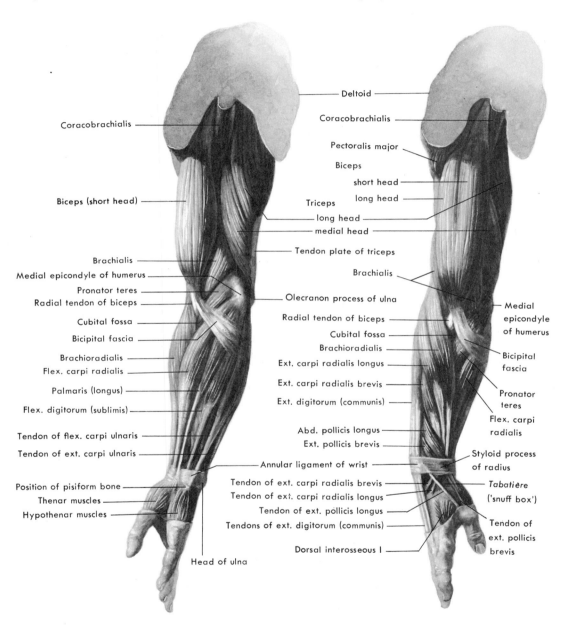

Coracobrachialis

Deltoid

Coracobrachialis

Pectoralis major

Biceps

Biceps (short head)

short head

long head

Triceps

long head

medial head

Tendon plate of triceps

Brachialis

Brachialis

Medial epicondyle of humerus

Pronator teres

Olecranon process of ulna

Radial tendon of biceps

Medial
epicondyle
of humerus

Cubital fossa

Radial tendon of biceps

Bicipital fascia

Cubital fossa

Brachioradialis

Bicipital
fascia

Brachioradialis

Ext. carpi radialis longus

Flex. carpi radialis

Ext. carpi radialis brevis

Pronator
teres

Palmaris (longus)

Ext. digitorum (communis)

Flex. carpi
radialis

Flex. digitorum (sublimis)

Abd. pollicis longus

Tendon of flex. carpi ulnaris

Ext. pollicis brevis

Tendon of ext. carpi ulnaris

Annular ligament of wrist

Styloid process
of radius

Position of pisiform bone

Tendon of ext. carpi radialis brevis

Tabatière
('snuff box')

Thenar muscles

Tendon of ext. carpi radialis longus

Hypothenar muscles

Tendon of ext. pollicis longus

Tendons of ext. digitorum (communis)

Tendon of
ext. pollicis
brevis

Head of ulna

Dorsal interosseous I

OBSERVATIONS—(1) *Forward border of triceps draws back to knob of elbow.* (2) *Coracobrachialis squeezes like a wedge between triceps and biceps.* (3) *Tendinous ribbon of biceps (bicipital fascia) swings inward to lash down muscles from medial epicondyle; in flexion under strain, it may rise in sharp relief.* (4) *Flexor-pronator group of forearm entirely exposed when supine.*

117

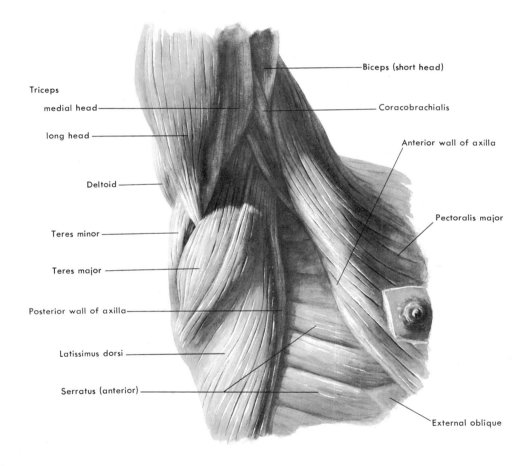

Triceps
medial head
long head

Deltoid

Teres minor

Teres major

Posterior wall of axilla

Latissimus dorsi

Serratus (anterior)

Biceps (short head)

Coracobrachialis

Anterior wall of axilla

Pectoralis major

External oblique

OBSERVATIONS—(1) *Pit of arm bounded in front by pectoral, behind by latissimus dorsi and teres major. Pectoral swings in front of biceps to reach bone of arm; latissimus and teres* swing *in front of triceps to do the same. Latissimus wraps forward around teres to gain higher point on arm.* (2) *Coracobrachialis dips between biceps and triceps.*

118

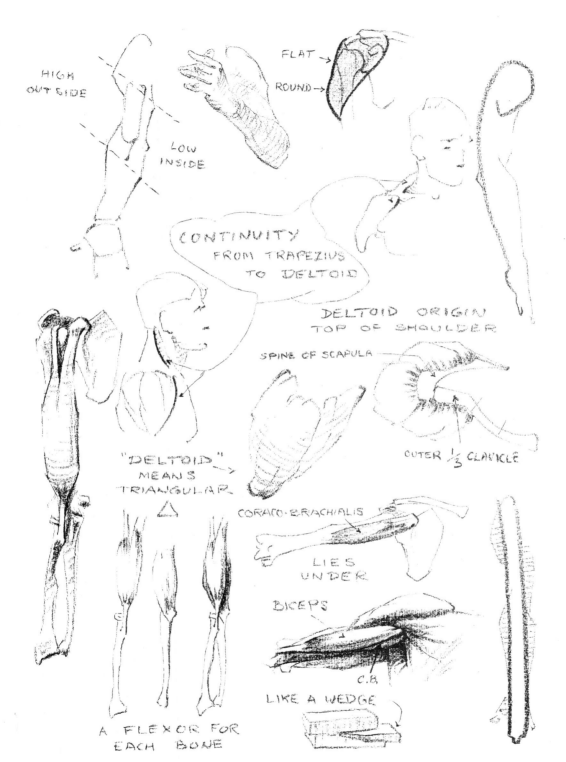

HIGH
OUTSIDE

LOW
INSIDE

FLAT →

ROUND →

CONTINUITY
FROM TRAPEZIUS
TO DELTOID

DELTOID ORIGIN
TOP OF SHOULDER

SPINE OF SCAPULA

OUTER ⅓ CLAVICLE

"DELTOID"
MEANS
TRIANGULAR

CORACO-BRACHIALIS

LIES
UNDER

BICEPS

C.B.

LIKE A WEDGE

A FLEXOR FOR
EACH BONE

119

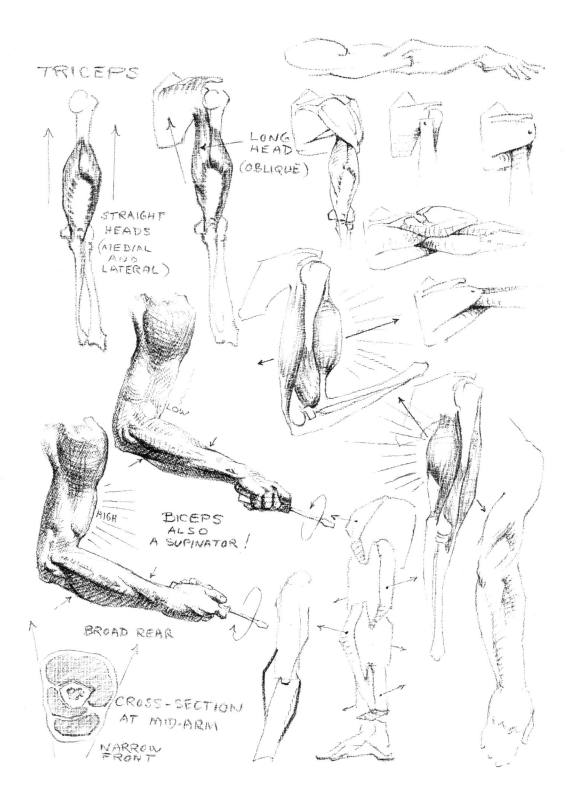

TRICEPS

LONG HEAD (OBLIQUE)

STRAIGHT HEADS (MEDIAL AND LATERAL)

LOW

HIGH

BICEPS ALSO A SUPINATOR!

BROAD REAR

CROSS-SECTION AT MID-ARM

NARROW FRONT

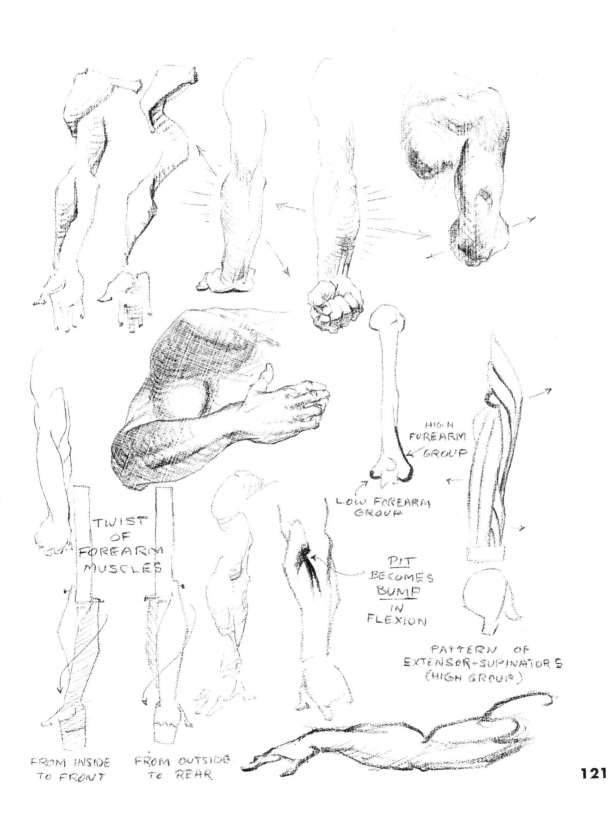

HIGH
FOREARM
GROUP

LOW FOREARM
GROUP

TWIST
OF
FOREARM
MUSCLES

PIT
BECOMES
BUMP
IN
FLEXION

PATTERN OF
EXTENSOR-SUPINATORS
(HIGH GROUP)

FROM INSIDE
TO FRONT

FROM OUTSIDE
TO REAR

121

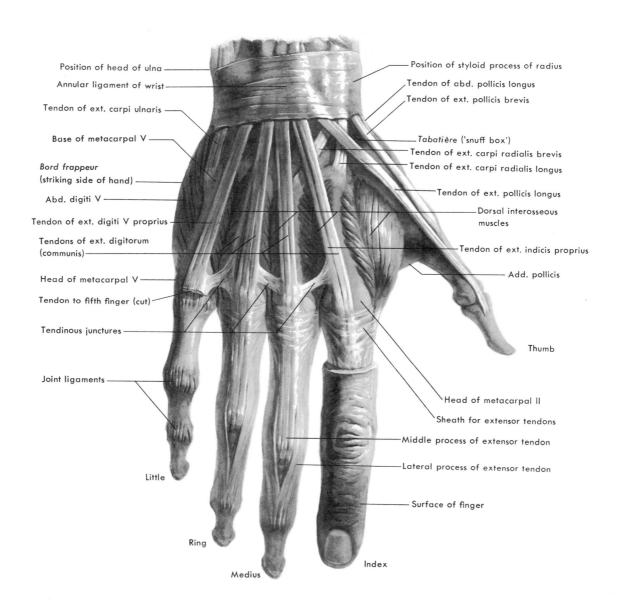

Position of head of ulna

Annular ligament of wrist

Tendon of ext. carpi ulnaris

Base of metacarpal V

Bord frappeur
(striking side of hand)

Abd. digiti V

Tendon of ext. digiti V proprius

Tendons of ext. digitorum
(communis)

Head of metacarpal V

Tendon to fifth finger (cut)

Tendinous junctures

Joint ligaments

Little

Ring

Medius

Position of styloid process of radius

Tendon of abd. pollicis longus

Tendon of ext. pollicis brevis

Tabatière ('snuff box')

Tendon of ext. carpi radialis brevis

Tendon of ext. carpi radialis longus

Tendon of ext. pollicis longus

Dorsal interosseous
muscles

Tendon of ext. indicis proprius

Add. pollicis

Thumb

Head of metacarpal II

Sheath for extensor tendons

Middle process of extensor tendon

Lateral process of extensor tendon

Surface of finger

Index

OBSERVATIONS—(1) *Annular ligament resembles tight bracelet, obscuring tendons at wrist.* (2) *Tendons prominent on back of hand, entering fanwise.* (3) *First dorsal interosseous swells when thumb is adducted.* (4) *Fingers, beyond first row of knuckles, consist of bones harnessed only with ligament and tendon (no muscle).* (5) *First phalanges distinct throughout, but webbing would reach on under side to middle of each first phalanx.*

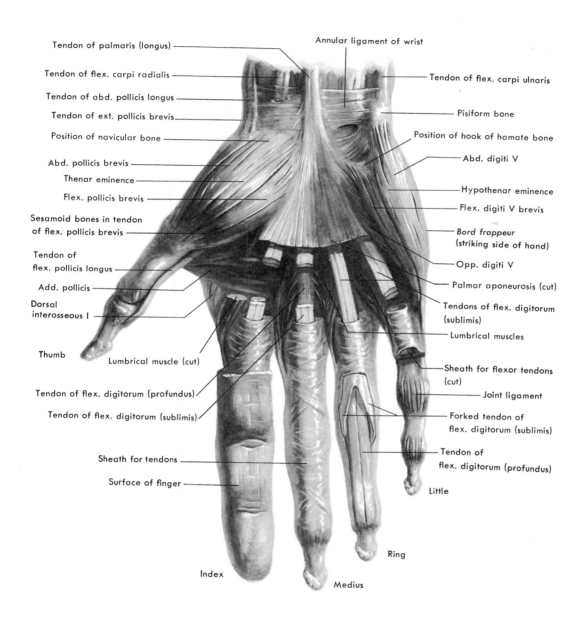

Tendon of palmaris (longus)

Tendon of flex. carpi radialis

Tendon of abd. pollicis longus

Tendon of ext. pollicis brevis

Position of navicular bone

Abd. pollicis brevis

Thenar eminence

Flex. pollicis brevis

Sesamoid bones in tendon
of flex. pollicis brevis

Tendon of
flex. pollicis longus

Add. pollicis

Dorsal
interosseous I

Thumb

Lumbrical muscle (cut)

Tendon of flex. digitorum (profundus)

Tendon of flex. digitorum (sublimis)

Sheath for tendons

Surface of finger

Annular ligament of wrist

Tendon of flex. carpi ulnaris

Pisiform bone

Position of hook of hamate bone

Abd. digiti V

Hypothenar eminence

Flex. digiti V brevis

Bord frappeur
(striking side of hand)

Opp. digiti V

Palmar aponeurosis (cut)

Tendons of flex. digitorum
(sublimis)

Lumbrical muscles

Sheath for flexor tendons
(cut)

Joint ligament

Forked tendon of
flex. digitorum (sublimis)

Tendon of
flex. digitorum (profundus)

Little

Index

Medius

Ring

OBSERVATIONS—(1) *Tendons prominent at wrist (palmaris and both flexors of wrist); palmaris, sometimes absent, only tendon not bound by annular ligament; its extension in hollow of palm obscured by fat. (2) Associate* THenar *(eminence) with* THumb; *associate Hypothenar (eminence) with Heel (of hand); both eminences together provide ∧-shaped rim for hollow of palm. (3) Pisiform bone prominent at root of little-finger muscles. (4) Webbing between fingers would half conceal first row of phalanges.*

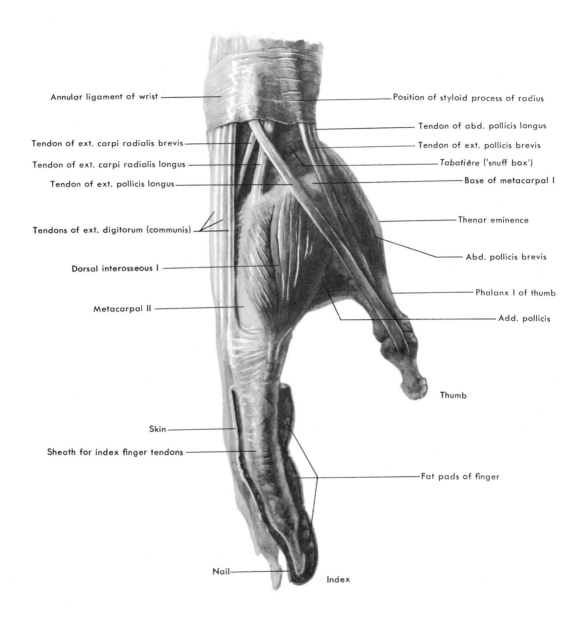

Annular ligament of wrist

Tendon of ext. carpi radialis brevis

Tendon of ext. carpi radialis longus

Tendon of ext. pollicis longus

Tendons of ext. digitorum (communis)

Dorsal interosseous I

Metacarpal II

Skin

Sheath for index finger tendons

Nail

Index

Position of styloid process of radius

Tendon of abd. pollicis longus

Tendon of ext. pollicis brevis

Tabatière ('snuff box')

Base of metacarpal I

Thenar eminence

Abd. pollicis brevis

Phalanx I of thumb

Add. pollicis

Thumb

Fat pads of finger

OBSERVATIONS—(1) *Associate* THenar *(eminence) with* THumb. *(2) First dorsal interosseous prominent between thumb and index finger. (3) Pit called 'snuff box' [tabatière] lies at root of thumb between tendons of long and* short extensors of thumb. (4) Process of radius prominent on thumb side of wrist. (5) Long extensor tendon of thumb converges above toward index-finger tendon, but does not meet it.

124

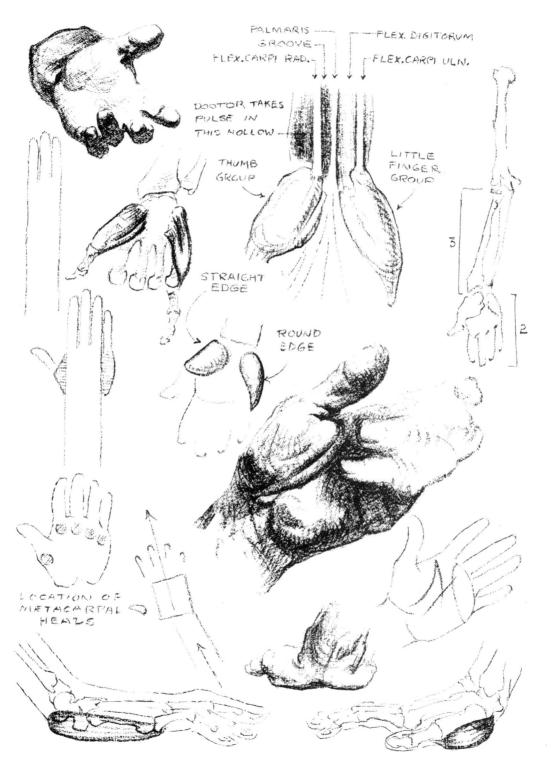

PALMARIS
GROOVE

FLEX. CARPI RAD.

FLEX. DIGITORUM

FLEX. CARPI ULN.

DOCTOR TAKES
PULSE IN
THIS HOLLOW

THUMB
GROUP

LITTLE
FINGER
GROUP

STRAIGHT
EDGE

ROUND
EDGE

3

2

LOCATION OF
METACARPAL
HEADS

125

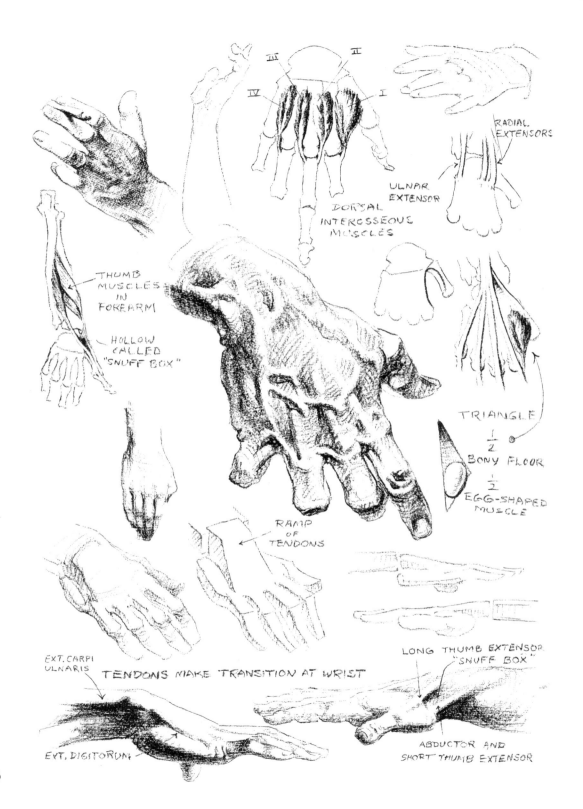

III II

IV I

RADIAL
EXTENSORS

ULNAR
EXTENSOR

DORSAL
INTEROSSEOUS
MUSCLES

THUMB
MUSCLES
IN
FOREARM

HOLLOW
CALLED
"SNUFF BOX"

TRIANGLE
$\frac{1}{2}$ BONY FLOOR
$\frac{1}{2}$ EGG-SHAPED
MUSCLE

RAMP
OF
TENDONS

EXT. CARPI
ULNARIS

TENDONS MAKE TRANSITION AT WRIST

LONG THUMB EXTENSOR
"SNUFF BOX"

EXT. DIGITORUM

ABDUCTOR AND
SHORT THUMB EXTENSOR

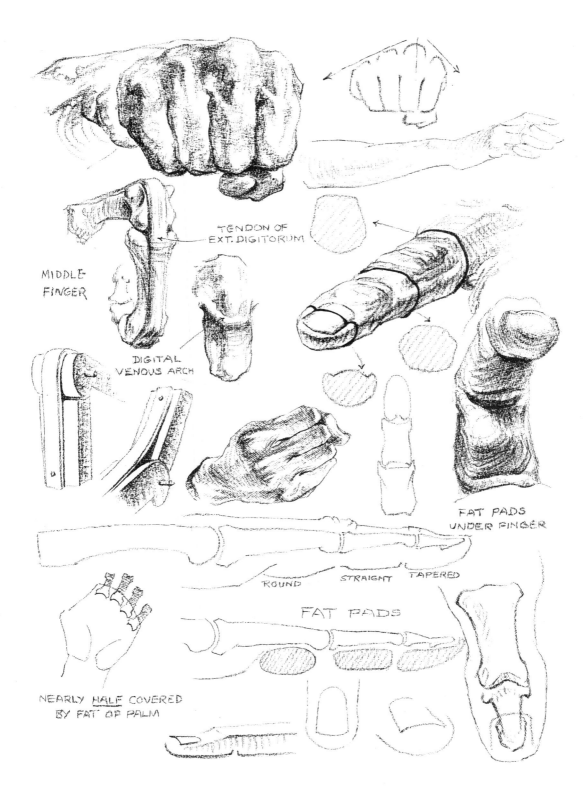

MIDDLE
FINGER

TENDON OF
EXT. DIGITORUM

DIGITAL
VENOUS ARCH

FAT PADS
UNDER FINGER

ROUND STRAIGHT TAPERED

FAT PADS

NEARLY HALF COVERED
BY FAT OF PALM

MUSCLE	ORIGIN	INSERTION
GROIN AND ADDUCTOR GROUP OF THIGH		
Iliopsoas (iliacus + psoas)	Iliac fossa; lower 4 or 5 vert.; pouring out under inguinal lig. (p. 60)	Small trochanter of femur
Pectineus	Sup. ramus and pectineal line of pubis	Below small trochanter of femur
Adductor longus	Sup. ramus of pubis	Linea aspera of femur
Adductor magnus	Inf. ramus and tuberos. of ischium	Linea aspera and med. epicondyle of femur
Gracilis	Inf. rami of pubis and ischium	Tuberos. of tibia, behind tendon of sartorius (*q.v.*)
ILIAC 'REINS' TO KNEE		
Sartorius (tailor's muscle)	Ant. sup. iliac spine	Behind med. epicondyle of femur to tuberos. of tibia
Tensor fasciæ latæ		Ilio-tibial band (see below: 'Fascia lata')
EXTENSOR GROUP (QUADRICEPS) OF THIGH (Front—high)		
Vastus medialis	Linea aspera of femur	Common tendon to patella (quadriceps tendon); continues over patella into fibers of patellar lig. (p. 70)
Vastus lateralis	Great trochanter and linea aspera of femur	
Vastus intermedius (covered by rectus femoris [*q.v.*])	Ant. surf. of shaft of femur	
Rectus femoris	Ant. inf. iliac spine	
BUTTOCK AND ABDUCTOR GROUP OF THIGH		
Gluteus maximus (buttock muscle)	Lat. surf. of ilium (behind post. gluteal line); post. surf. of sacrum and coccyx and their ligaments	Post. surf. of shaft of femur, below trochanters; ilio-tibial band (see below: 'Fascia lata')
Gluteus medius (overlies deep gluteus minimus)	Lat. surf. of ilium (between ant. and post. gluteal lines)	Great trochanter of femur
FLEXOR GROUP (HAMSTRING MUSCLES) OF THIGH (Rear—low)		
Biceps femoris [a] Short head	Linea aspera of femur	Head of fibula
[b] Long head (partly conceals short head)	Ischial tuberosity of pelvis	
Semimembranosus		Med. condyle of tibia
Semitendinosus		Tuberos. of tibia (in common with gracilis, behind sartorius tendon)

N.B. The FASCIA LATA of the thigh gives rise to thick bands for binding long thigh muscles: (1) *ilio-tibial band* from region of great trochanter to lat. condyle of tibia; (2) band creating *gluteal fold* of buttock (indistinct in relaxation); (3) *popliteal band* across hamstring tendons; (4) *band of Richer* across vastus med. (producing 'suprapatellar bulge'). Diagrams: pp. 132-3.

ACTION	DERIVATION OF NAME
Pelvis fixed: flexes thigh, rotates it outward; thigh fixed: bends pelvis and spine laterally and forward	L. *ilium,* flank + G. *psoa,* muscle of the loin
Adducts and flexes thigh, rotates it outward	L. *pecten,* a comb
Adducts and flexes thigh	Long adductor
Adducts and extends thigh	Great adductor
Adducts and flexes thigh; flexes leg, rotates it inward	L. slender
Flexes and abducts thigh, rotates it outward; flexes leg, rotates it inward	L. *sartor,* tailor (ref. to cross-legged position)
Provides tension for ilio-tibial band; flexes and abducts thigh, rotates it inward	Tensing muscle of the broad fascia [of thigh]
Extends leg; rectus femoris also flexes and abducts thigh	L. *vastus,* huge [muscle] L. *rectus,* straight [muscle] + *femoris,* of thigh
Extends thigh backward, adducts it, rotates it outward; provides tension for ilio-tibial band; muscles of both sides press buttocks together	G. *gloutos,* buttock
Abducts thigh	
Extends thigh backward, adducts it, rotates it outward; flexes leg, rotates it outward	L. *bis,* twice + *caput,* head + *femoris,* of thigh
Extends thigh backward, adducts it, rotates it inward; flexes leg, rotates it inward	Deep border of tendon from origin to insertion Tendon of insertion arises midway down on muscle

MUSCLE	ORIGIN	INSERTION
FLEXOR GROUP OF LEG (High—passing behind ankle)		
Gastrocnemius [a] Lateral head (high)[1]	Above lat. condyle of femur	By common tendon (Achilles' tendon or *tendo calcaneus*) to calcaneus (heelbone)
[b] Medial head (low)	Above med. condyle of femur	
Soleus (together with muscles cited above: called the 'calf')	Head of fibula; post. surf. of fibula and tibia	
Flex. digitorum longus	Post. surf. of tibia	Behind inner knob of ankle, forward to sole of foot
Flex. hallucis longus	Post. surf. of fibula	Base of 2nd phalanx[2] of big toe (plant. surf.)
Peroneus longus (to big-toe side)	Head and lat. surf. of fibula	Behind outer knob of ankle, forward to sole of foot
Peroneus brevis (to little-toe side)	Lat. surf. of fibula	Behind outer knob of ankle, to tuberos. of metatarsal v
EXTENSOR GROUP OF LEG (Low—passing in front of ankle)		
Ext. digitorum longus (see also: peroneus tertius, below)	Lat. condyle of tibia; head and crest of fibula; interosseous membrane	Below front of ankle, by 4 tendons to phalanges of toes ii-v (dors. surf.)
Peroneus tertius (5th division of ext. dig. longus)	Fibers from ext. digitorum longus	Base of metatarsal v (dors. surf.)
Ext. hallucis longus	Interosseous membrane; med. surf. of fibula	Base of 2nd phalanx of big toe (dors. surf.)
Tibialis [anterior] (t. posterior not important at surface)	Lat. condyle and surf. of tibia; interosseous membrane	Underside of cuneiform i; base of metatarsal i
BACK OF FOOT		
Ext. hallucis brevis	Sup. and lat. surf. of calcaneus (heelbone)	Base of 1st phalanx of big toe
Ext. digitorum brevis		By separate tendons to 3rd phalanges of toes ii-iv
SOLE OF FOOT		
Abductor hallucis	Med. malleolus of tibia; tub. of calcaneus	Base of 1st phalanx of big toe
Flex. digitorum brevis	Tub. of calcaneus (heelbone)	By 4 tendons to toes ii-v
Abductor digiti quinti	Underside of calcaneus (heelbone)	Tuberos. of metatarsal v; base of 1st phalanx of toe v

[1] The small *Plantaris* muscle is virtually part of the lateral head.
[2] Distal phalanx.
N.B. In the fascia of the ankle, retaining bands are developed to bind down tendons in transit to the foot: (1) *transverse ligament* above ankle; (2) *cruciate ligament* in front of ankle; (3) *laciniate ligament* below inner ankle; (4) *peroneal bands* below outer ankle. Diagrams: pp. 138, 140.

130

LOWER EXTREMITY

ACTION	DERIVATION OF NAME
Flexes leg; flexes foot plantarward (points foot); inverts and adducts foot[3]	G. *gaster,* belly + *kneme,* leg
Flexes foot plantarward (points foot); inverts and adducts foot	L. *solea,* sole [of foot] (affected by muscle)
Flexes foot plantarward (points foot); inverts and adducts foot; flexes 3rd phalanx of toes ii-v	Long flexor of digits
Flexes foot plantarward (points foot); inverts and adducts foot; flexes big toe	Long flexor of big toe [L. *hallux*]
Flexes foot plantarward (points foot); everts and abducts foot	G. *perone,* the fibula (fibular side of leg)

ACTION	DERIVATION OF NAME
Flexes foot dorsalward (raises foot); everts and abducts foot; raises toes ii-v dorsalward	Long extensor of digits
	G. *perone,* the fibula (fibular side of leg) + L. *tertius,* the third
Flexes foot dorsalward (raises foot); everts and abducts foot; raises big toe	Long extensor of big toe [L. *hallux*]
Flexes foot dorsalward (raises foot); inverts foot	Position on tibia

ACTION	DERIVATION OF NAME
Draws big toe up and toward other toes	Short extensor of big toe [L. *hallux*]
Draws toes ii-iv up and laterally	Short extensor of digits

ACTION	DERIVATION OF NAME
Abducts big toe, helps to bend it downward	Abductor of big toe [L. *hallux*]
Curls 2nd phalanx of toes ii-v downward	Short flexor of digits
Curls 1st phalanx of toe v downward, then laterally	Abductor of toe v

[3] For Inversion and Eversion of foot, see pp. xii, xv, 78.

Right LOWER EXTREMITY

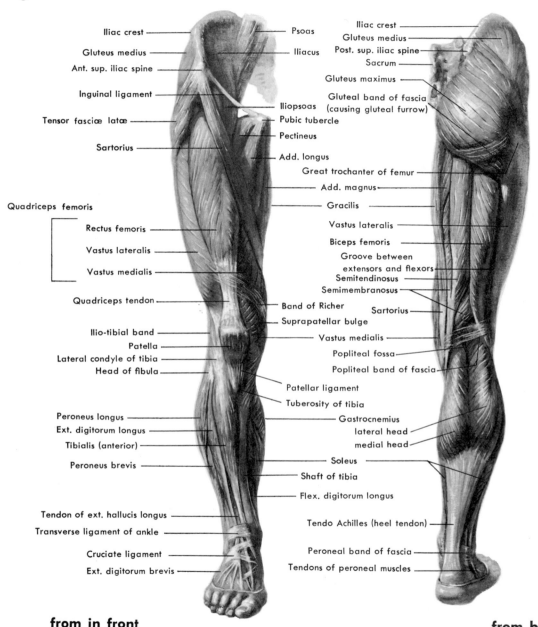

Iliac crest — Psoas
Gluteus medius — Iliacus
Ant. sup. iliac spine —
Inguinal ligament —
Tensor fasciæ latæ — Iliopsoas
Pubic tubercle
Sartorius — Pectineus
Add. longus

Quadriceps femoris
Rectus femoris —
Vastus lateralis —
Vastus medialis —
Quadriceps tendon — Band of Richer
Suprapatellar bulge
Ilio-tibial band — Vastus medialis
Patella —
Lateral condyle of tibia —
Head of fibula —
Patellar ligament
Tuberosity of tibia
Peroneus longus —
Ext. digitorum longus —
Tibialis (anterior) —
Peroneus brevis — Soleus
Shaft of tibia
Flex. digitorum longus
Tendon of ext. hallucis longus —
Transverse ligament of ankle —
Cruciate ligament —
Ext. digitorum brevis —

Iliac crest —
Gluteus medius —
Post. sup. iliac spine —
Sacrum —
Gluteus maximus —
Gluteal band of fascia
(causing gluteal furrow)
Great trochanter of femur —
Add. magnus —
Gracilis —
Vastus lateralis —
Biceps femoris —
Groove between
extensors and flexors
Semitendinosus —
Semimembranosus —
Sartorius —
Popliteal fossa —
Popliteal band of fascia —
Gastrocnemius
lateral head
medial head
Tendo Achilles (heel tendon) —
Peroneal band of fascia —
Tendons of peroneal muscles —

from in front

from behind

OBSERVATIONS—(1) *Oblique sartorius and tibialis suggest descending spiral. (2) ∧-shaped hollow just below spine of iliac crest. (3) Vastus lateralis high, medialis low. (4) Common tendon of quadriceps depressed between vasti muscles. (5) Buttock narrower than silhouette* of hip. *Margin of buttock muscle oblique. Gluteal fold at surface produced by band of fascia: horizontal when muscle is tensed, drooping outward when relaxed. (6) Hamstring tendons grasp leg on either side, like pair of tongs. (7) Popliteal fossa, in life, bulges with fat. (8) Calf high outside, low and rounder inside.*

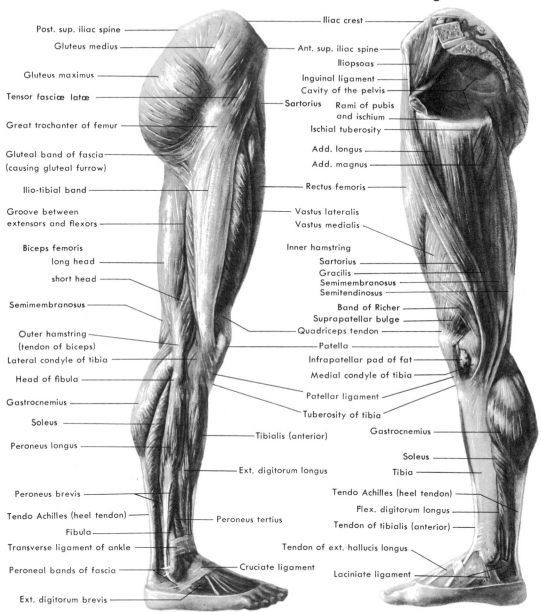

Post. sup. iliac spine
Gluteus medius
Gluteus maximus
Tensor fasciœ latœ
Great trochanter of femur
Gluteal band of fascia (causing gluteal furrow)
Ilio-tibial band
Groove between extensors and flexors
Biceps femoris
long head
short head
Semimembranosus
Outer hamstring (tendon of biceps)
Lateral condyle of tibia
Head of fibula
Gastrocnemius
Soleus
Peroneus longus
Peroneus brevis
Tendo Achilles (heel tendon)
Fibula
Transverse ligament of ankle
Peroneal bands of fascia
Ext. digitorum brevis

Iliac crest
Ant. sup. iliac spine
Iliopsoas
Inguinal ligament
Cavity of the pelvis
Sartorius
Rami of pubis and ischium
Ischial tuberosity
Add. longus
Add. magnus
Rectus femoris
Vastus lateralis
Vastus medialis
Inner hamstring
Sartorius
Gracilis
Semimembranosus
Semitendinosus
Band of Richer
Suprapatellar bulge
Quadriceps tendon
Patella
Infrapatellar pad of fat
Medial condyle of tibia
Patellar ligament
Tuberosity of tibia
Tibialis (anterior)
Ext. digitorum longus
Peroneus tertius
Cruciate ligament

Gastrocnemius
Soleus
Tibia
Tendo Achilles (heel tendon)
Flex. digitorum longus
Tendon of tibialis (anterior)
Tendon of ext. hallucis longus
Laciniate ligament

from the outer side

from the inner side

OBSERVATIONS—(1) *Thigh muscles prominent in front, leg muscles prominent in rear.* (2) *Furrow on outer side of thigh between quadriceps and hamstring group; furrow on inner side by sartorius.* (3) *Vastus medialis (teardrop muscle), when grooved by band of Richer in relaxed hyperextension, shows 'suprapatellar bulge.'* (4) *Knee projects ledge-like in front, rounded at rear.* (5) *Head of fibula prominent; is point of transfer from outer hamstring to peroneus longus.* (6) *Shin exposed on inner side of leg.*

133

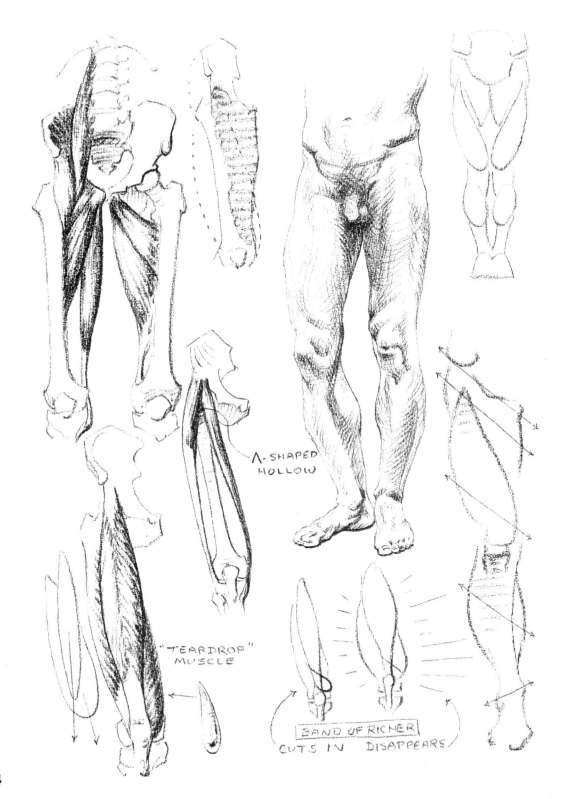

Λ-SHAPED
HOLLOW

"TEARDROP"
MUSCLE

BAND OF RICHER
CUTS IN DISAPPEARS

134

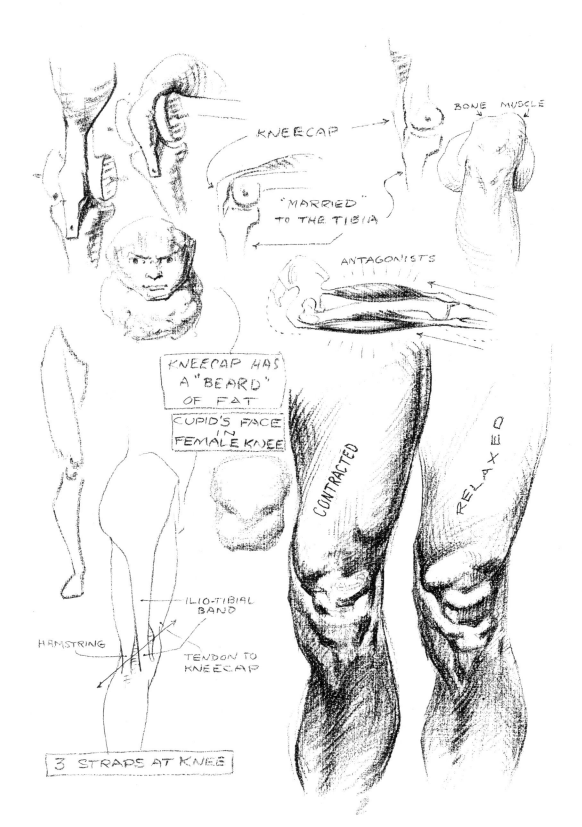

KNEECAP

BONE MUSCLE

"MARRIED"
TO THE TIBIA

ANTAGONISTS

KNEECAP HAS
A "BEARD"
OF FAT

CUPID'S FACE
IN
FEMALE KNEE

CONTRACTED

RELAXED

ILIO-TIBIAL
BAND

HAMSTRING

TENDON TO
KNEECAP

3 STRAPS AT KNEE

135

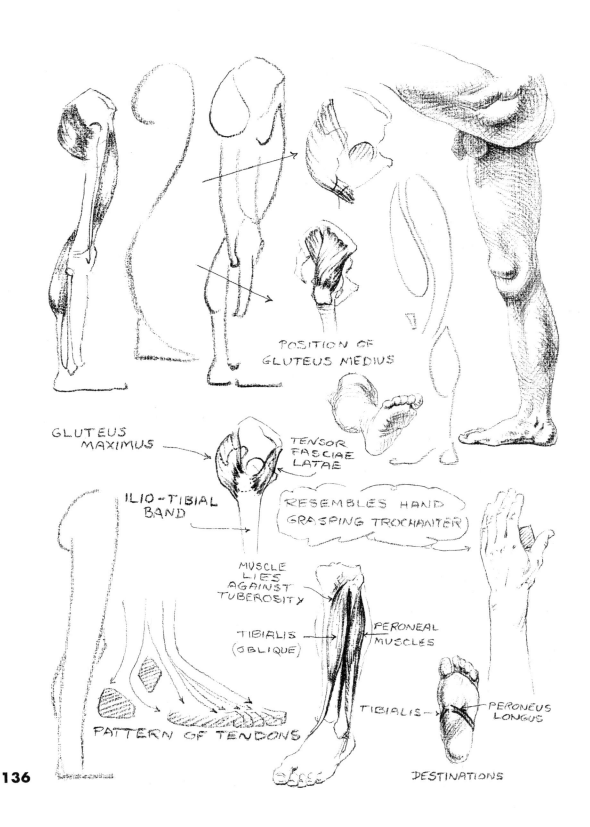

POSITION OF
GLUTEUS MEDIUS

GLUTEUS
MAXIMUS

TENSOR
FASCIAE
LATAE

ILIO-TIBIAL
BAND

RESEMBLES HAND
GRASPING TROCHANTER

MUSCLE
LIES
AGAINST
TUBEROSITY

TIBIALIS
(OBLIQUE)

PERONEAL
MUSCLES

PATTERN OF TENDONS

TIBIALIS

PERONEUS
LONGUS

DESTINATIONS

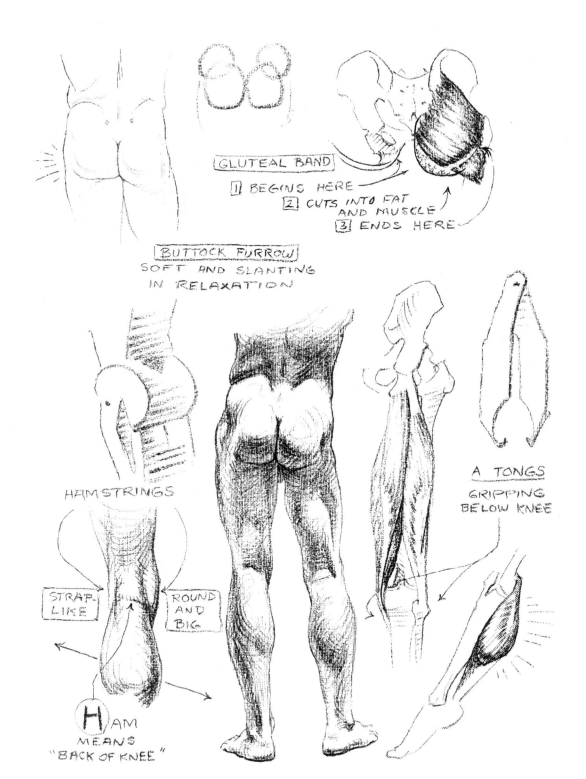

GLUTEAL BAND

1 BEGINS HERE

2 CUTS INTO FAT AND MUSCLE

3 ENDS HERE

BUTTOCK FURROW
SOFT AND SLANTING
IN RELAXATION

HAMSTRINGS

A TONGS
GRIPPING
BELOW KNEE

STRAP-LIKE

ROUND AND BIG

H AM MEANS "BACK OF KNEE"

137

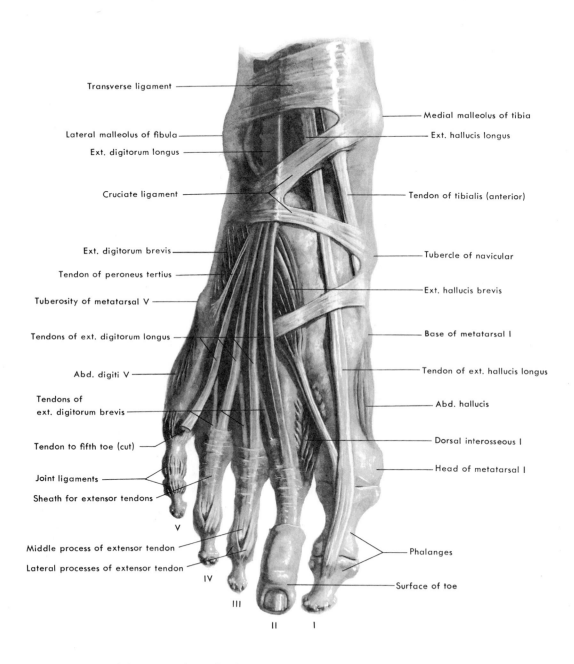

Transverse ligament

Lateral malleolus of fibula

Ext. digitorum longus

Cruciate ligament

Ext. digitorum brevis

Tendon of peroneus tertius

Tuberosity of metatarsal V

Tendons of ext. digitorum longus

Abd. digiti V

Tendons of ext. digitorum brevis

Tendon to fifth toe (cut)

Joint ligaments

Sheath for extensor tendons

Middle process of extensor tendon

Lateral processes of extensor tendon

Medial malleolus of tibia

Ext. hallucis longus

Tendon of tibialis (anterior)

Tubercle of navicular

Ext. hallucis brevis

Base of metatarsal I

Tendon of ext. hallucis longus

Abd. hallucis

Dorsal interosseous I

Head of metatarsal I

Phalanges

Surface of toe

V IV III II I

OBSERVATIONS—(1) *Axis of bony knobs at ankle:* High Inside *(HI),* Low Outside *(LO).* (2) *Retaining ligaments suggest strapping of Roman sandal, but are not evident at surface.* (3) *Tendons prominent where not lashed by ligament, fanning less than in hand.* (4) *Short extensor of toes seen as a muscular lump in front of outer knob of ankle.*

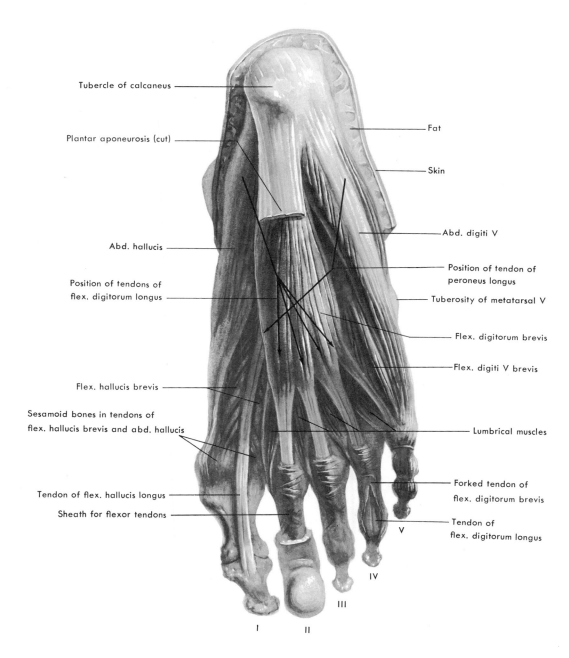

Tubercle of calcaneus

Plantar aponeurosis (cut)

Abd. hallucis

Position of tendons of
flex. digitorum longus

Flex. hallucis brevis

Sesamoid bones in tendons of
flex. hallucis brevis and abd. hallucis

Tendon of flex. hallucis longus

Sheath for flexor tendons

Fat

Skin

Abd. digiti V

Position of tendon of
peroneus longus

Tuberosity of metatarsal V

Flex. digitorum brevis

Flex. digiti V brevis

Lumbrical muscles

Forked tendon of
flex. digitorum brevis

Tendon of
flex. digitorum longus

V

IV

III

I

II

OBSERVATIONS—(1) *Abductor of little toe continuous fleshy pad from heelbone to root of toe; most other muscles obscured by sheath.* (2) *Surface of sole formed by thick pads of fat and fibrous tissue, rather than muscle.*

139

Right FOOT

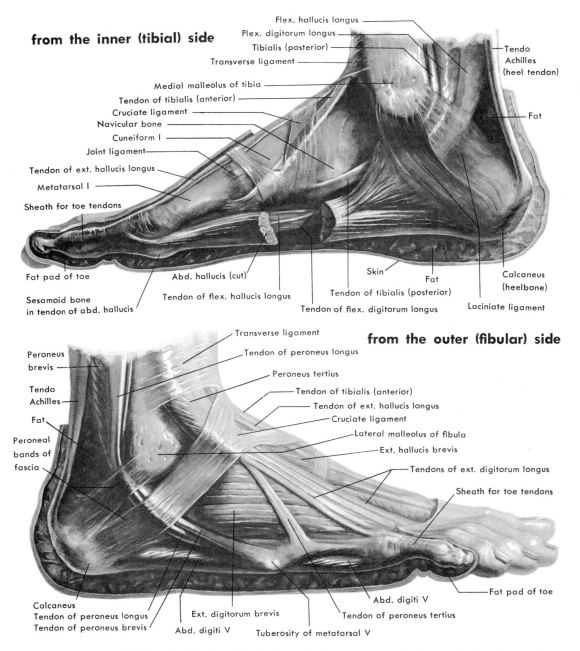

from the inner (tibial) side

Flex. hallucis longus
Flex. digitorum longus
Tibialis (posterior)
Transverse ligament
Medial malleolus of tibia
Tendon of tibialis (anterior)
Cruciate ligament
Navicular bone
Cuneiform I
Joint ligament
Tendon of ext. hallucis longus
Metatarsal I
Sheath for toe tendons
Tendo Achilles (heel tendon)
Fat
Fat pad of toe
Abd. hallucis (cut)
Skin
Fat
Calcaneus (heelbone)
Sesamoid bone in tendon of abd. hallucis
Tendon of flex. hallucis longus
Tendon of tibialis (posterior)
Tendon of flex. digitorum longus
Laciniate ligament

from the outer (fibular) side

Transverse ligament
Tendon of peroneus longus
Peroneus brevis
Peroneus tertius
Tendo Achilles
Tendon of tibialis (anterior)
Fat
Tendon of ext. hallucis longus
Peroneal bands of fascia
Cruciate ligament
Lateral malleolus of fibula
Ext. hallucis brevis
Tendons of ext. digitorum longus
Sheath for toe tendons
Fat pad of toe
Calcaneus
Tendon of peroneus longus
Tendon of peroneus brevis
Ext. digitorum brevis
Abd. digiti V
Abd. digiti V
Tuberosity of metatarsal V
Tendon of peroneus tertius

OBSERVATIONS—(1) *Bony knobs of ankle:* High Inside (*HI*), Low Outside (*LO*). (2) *Peroneal tendons turn pulley-fashion behind outer knob of ankle; tendons of tibialis posterior and long flexor of toes turn similarly behind inner knob of ankle; both groups separated from calf ten-* don by triangular hollow loaded with fat. (3) *Short extensor of toes evident as triangular lump in front of outer knob of ankle.* (4) *Tuberosity of 5th metatarsal near surface on outer border; navicular and big-toe metatarsal head prominent on inner border.*

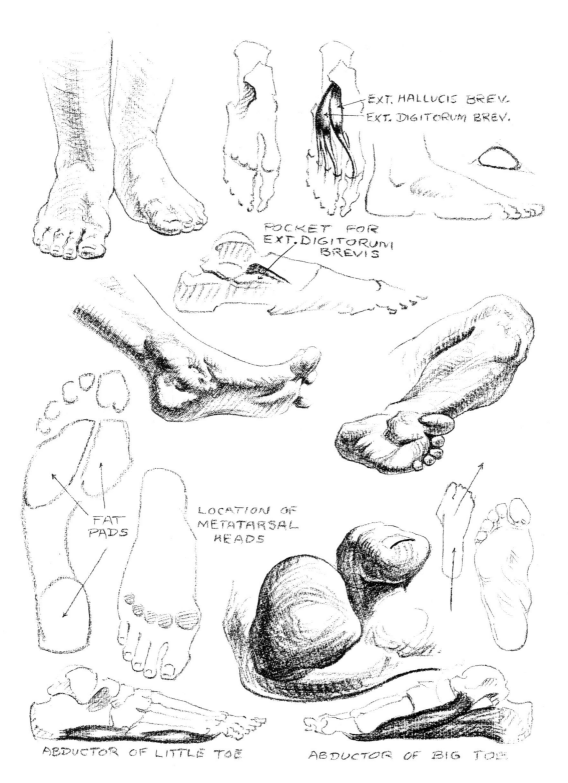

EXT. HALLUCIS BREV.
EXT. DIGITORUM BREV.

POCKET FOR
EXT. DIGITORUM
BREVIS

FAT
PADS

LOCATION OF
METATARSAL
HEADS

ABDUCTOR OF LITTLE TOE

ABDUCTOR OF BIG TOE

141

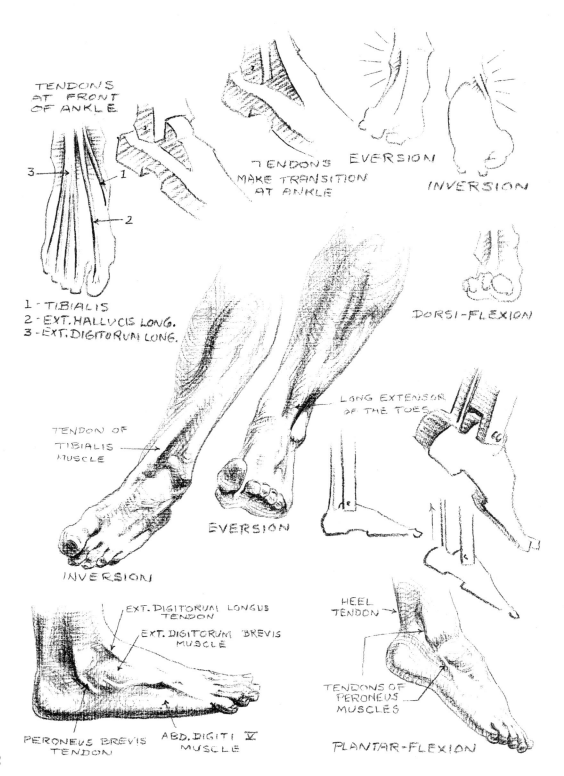

TENDONS AT FRONT OF ANKLE

3
1
2

1 - TIBIALIS
2 - EXT. HALLUCIS LONG.
3 - EXT. DIGITORUM LONG.

TENDONS MAKE TRANSITION AT ANKLE

EVERSION

INVERSION

DORSI-FLEXION

TENDON OF TIBIALIS MUSCLE

LONG EXTENSOR OF THE TOES

EVERSION

INVERSION

EXT. DIGITORUM LONGUS TENDON

EXT. DIGITORUM BREVIS MUSCLE

PERONEUS BREVIS TENDON

ABD. DIGITI V MUSCLE

HEEL TENDON

TENDONS OF PERONEUS MUSCLES

PLANTAR-FLEXION

142

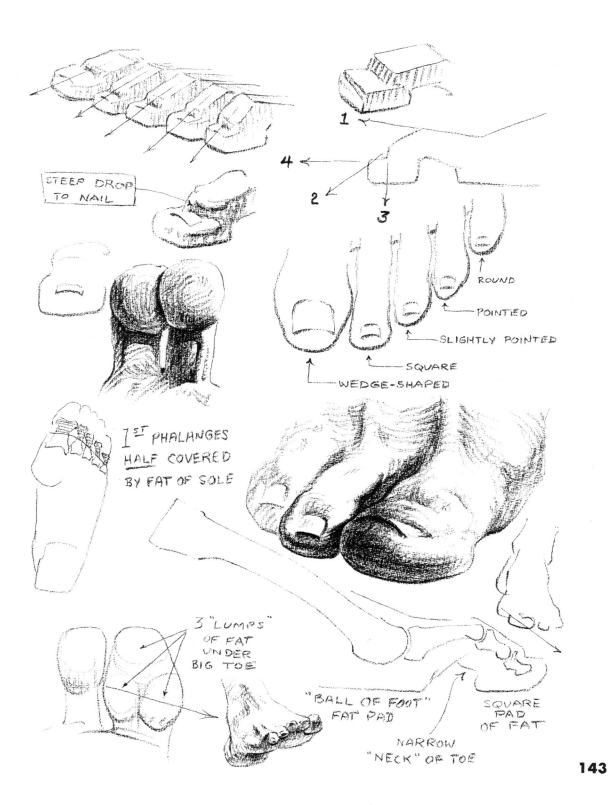

STEEP DROP
TO NAIL

1

4

2

3

ROUND

POINTED

SLIGHTLY POINTED

SQUARE

WEDGE-SHAPED

1ST PHALANGES
HALF COVERED
BY FAT OF SOLE

3 "LUMPS"
OF FAT
UNDER
BIG TOE

"BALL OF FOOT"
FAT PAD

NARROW
"NECK" OF TOE

SQUARE
PAD
OF FAT

143

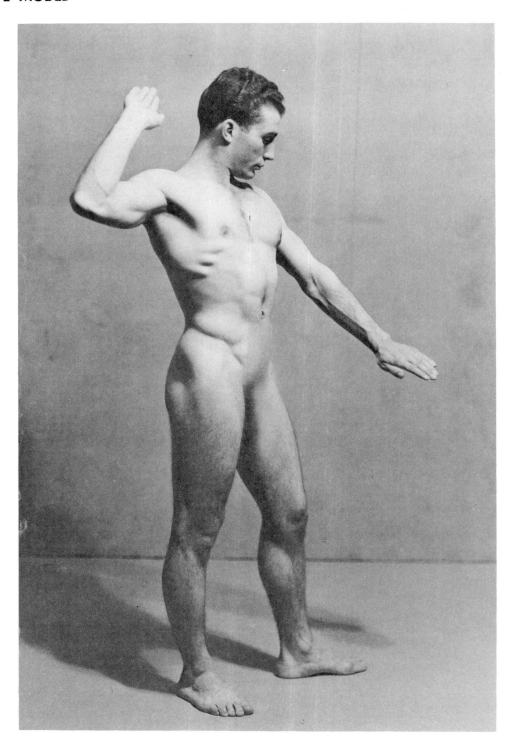

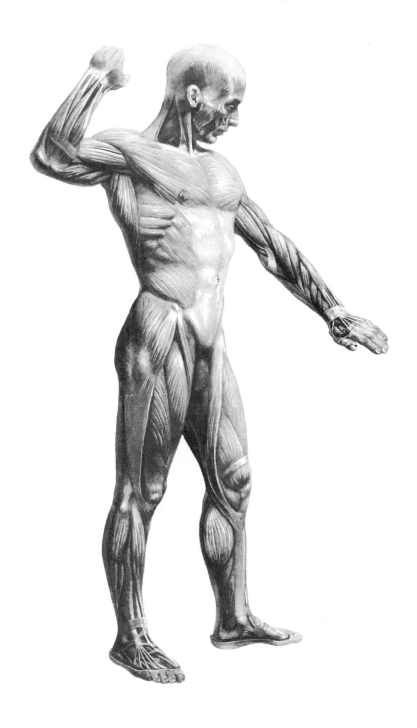

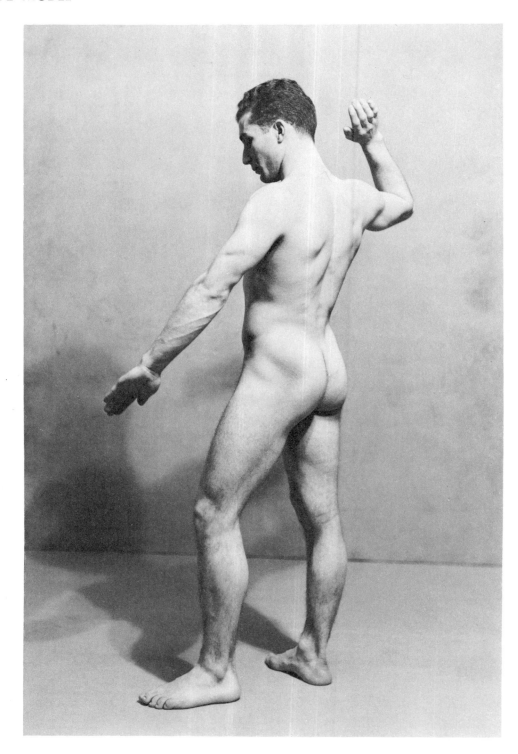

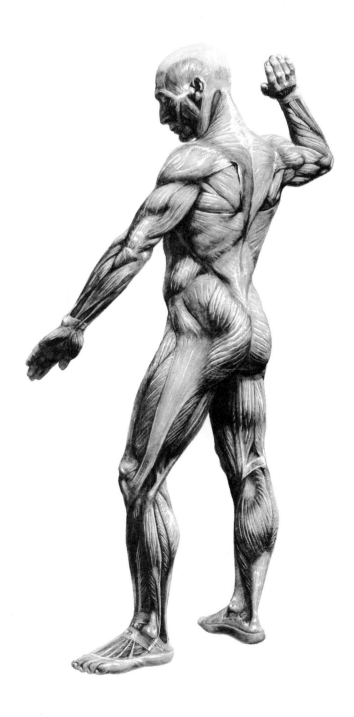

Part III

SURFACE ANATOMY

In envisaging the imitation of the surface of the human body, sculpture must not limit itself to [creating] cold resemblance such as the body of man might have had before it received the breath of life. . . Nature alive, breathing, and passionate—this is what the sculptor must express in stone or marble. . .

—FALCONET

FAT

Particles of fat underlie the skin in nearly every region of the body, and are associated with a web-like tissue called FASCIA (see cut, p. 153). This tissue is divisible into superficial and deep layers. The *deep fascia* tends to be coarse and fibrous, and may be likened to a stout rubber bandage. Its duty is to strap down the lively muscles, and so to concentrate their operations.[1] The *superficial fascia* is loosely connected to the deep fascia beneath, and, at the surface, firmly unites with the skin. This layer of fascia is more yielding, since it contains the varying quantities of fat, and it invests the entire body like thick, warm 'underwear.' The character of the fatty deposition, as it develops in puberty, is an important factor in the distinctions of male and female figures. Thickness of fat is determined largely by region, fatty tissue being more abundant on trunk than on limbs. In nearly every respect, the female figure manifests a greater quantity of fat than the male. This augmented investment amply fills the hollows and crevices of deeper structures and accounts for the smoothness and the flowing line of surface form.

MAJOR LOCAL DEPOSITS [2]

CERVICO-DORSAL FAT

Situation: trapezius muscle, surrounding Cervical VII [vertebra prominens].[3]

Character: most often limited to females and the aged.

POST-DELTOID FAT

Situation: back of upper arm, filling crevice between rear margin of deltoid and upper end of triceps muscle.[4]

Character: very pronounced in the female arm, where it increases distance from front to back at level of deltoid insertion.

AXILLARY FAT

Situation: pit of arm.

Character: disguises form of muscular structures, viz. upper reaches of coracobrachialis, serratus, latissimus dorsi, and teres major muscles.[5]

[1] For strengthening bands of fascia: see note (N.B.), pp. 113, 128, 130.
[2] Cf. p. 226.
[3] Cf. p. 105.
[4] Cf. pp. 115, 116.
[5] Cf. p. 118.

MAMMARY FAT

Situation: female breast between 3rd and 6th ribs; overlying lower fibers of pectoral muscle and its outer free border, and upper fibers of serratus and oblique muscles.[6]

Character: hemispherical promontory; rises slowly from chest and overhangs thorax; softly pointed in the young, round at early maturity, and pendulous in later years.

FLANK FAT

Situation: extending from thorax to below crest of hip, and from rectus abdominis muscle in front to latissimus dorsi muscle behind.[7]

Character: much in evidence in females, masking bony crest of hip, iliac furrow, and hollow of loin above crest; especially subject to enlargement in obesity.

ABDOMINAL FAT

Situation: front of trunk, from thoracic arch to groin.

Character: tends to obliterate outlines of rectus abdominis muscles;[8] more abundant in female than in male; greatest deposit in female below navel, in male above navel;[9] may become exceedingly prominent in obese figures of either sex.

PRE-PUBIC FAT

Situation: directly in front of symphysis pubis; bounded above by crease of abdominal furrow, laterally by furrow of thigh.

Character: provides fleshy 'bridge' from thigh to thigh; most ample in the female, an elevation called the 'mons Veneris' [mount of Venus].

GLUTEAL FAT

Situation: buttock.

Character: greatest supply at inner border (where buttock furrow is deepest); conceals form of buttock muscle; most

abundant in female, blending upward into fat of flank and forward into fat of thigh; may be excessive in obesity, but is last to disappear through starvation.

SUBTROCHANTERIC FAT

Situation: outer side of thigh, below great trochanter.

Character: especially well marked in female—blending gradually with fat of flank above to conceal iliac crest and furrow, at rear with buttock fat, and below to obliterate upper part of groove between flexor and extensor muscles; causes greatest girth of female figure to drop below trochanters.

PATELLAR FAT

Situation: deep to patellar ligament at knee joint, swelling conspicuously at either side.

Character: slightly more pronounced in female; tends to obscure form of knee-cap and patellar ligament.[10]

POPLITEAL FAT

Situation: back of knee, between hamstring (flexor) tendons.

Character: soft bulge with creases at hamstring-tendon borders; most evident in female, and in full extension of limb.

MINOR LOCAL DEPOSITS

The distribution of fat about the head is slight and more or less uniform. In the face, fat serves as a soft bed for the delicate muscles of expression. Prominent, however, is the *buccal pad of fat* in the cheek. This lies in front of the masseter muscle and sur-

[6] Cf. p. 176.
[7] Cf. p. 106.
[8] See note (N.B.), p. 102.
[9] Roundness and protrusion of the lower abdomen in males is apt to be the evidence of muscular weakness in that region.
[10] Cf. p. 70.

mounts its free border.[11] It is most apparent in children, where it largely accounts for the fullness of their cheeks. It is said to be a device for resisting the internal pressure of sucking. Although it recedes in the adult, it cannot be lost through malnutrition. A fatty-like tissue is also the chief constituent of the *ear lobes* and the *wings of the nose*. And it is common to find an accumulation in evidence below the chin, giving rise to the *jowl* or 'double chin.' *Orbital fat,* situated in the eye sockets, provides soft mattresses for the eyeballs. 'Bulging' or 'hollowness' of the living eye is thus determined by the extent of its fatty mattress, as well as by the depth of its bony socket. While extensive orbital fat is associated with Mongoloid peoples, a heavy deposit is not uncommon in the white race. The result is not a true Mongolian fold, but an overhanging of flesh above the eye and partial concealment of eyelashes. In the *neck*, the presence of fat tends to lessen the hollow known as the 'pit of the neck,' as well as depressions above the collarbones.

In the *palm* of the hand and *sole* of the foot, thick cushions act to protect these surfaces against shock and continued wear.[12] At the *ankle,* fatty tissue fills the triangular space between the shin and the heelbone tendon.

[11] For Cheek Fat: see cut, p. 100.
[12] For pads of fingers and toes: see cuts, pp. 127, 143.

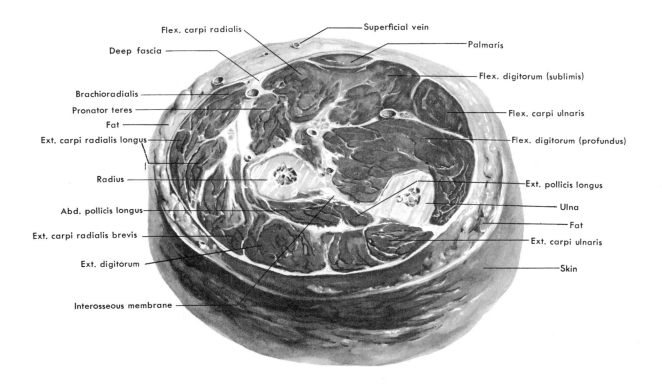

Flex. carpi radialis
Deep fascia
Brachioradialis
Pronator teres
Fat
Ext. carpi radialis longus
Radius
Abd. pollicis longus
Ext. carpi radialis brevis
Ext. digitorum
Interosseous membrane

Superficial vein
Palmaris
Flex. digitorum (sublimis)
Flex. carpi ulnaris
Flex. digitorum (profundus)
Ext. pollicis longus
Ulna
Fat
Ext. carpi ulnaris
Skin

**CROSS SECTION (Distal Surface) of Right Forearm
(close below the elbow)**

Deep fascia (white lines) is here seen infiltrating among the muscles for which it provides tough sheathing. Superficial fascia, with its fatty elements, is a thick, pliable, outer jacket. It holds the skin in place by many fibrous threads.

153

Photographs courtesy of the Constitution Laboratory, College of Physicians and Surgeons, Columbia University.

OBESITY

Normally, fat comprises about one sixth of the body weight and serves as a great reservoir of energy. As this mantle of fat is increased, it becomes a positive burden, and in extreme obesity may limit mechanical operations of the body almost to the extent of incapacity.[1] Mild obesity consists simply of an excess deposit in the normal fat regions. The upper arm and thigh are more likely to abound in fat than the forearm and leg, but fat is seldom excessive on the hands and feet. The female is more inclined toward obesity than the male, and young adults more than the elderly. When corpulence is greatly pronounced, it is marked by pendulous rolls of flesh at the back of the elbows, the flanks, abdomen, buttocks, and back of the knees. The female breasts, too, will be large and pendulous, dropping away to either side of the thorax. In depicting obesity, caution must be exercised by adhering rigidly to the same skeletal proportions as those of lean figures. The lengths and shapes of bones are not usually affected, although certain postural displacements may be seen. If upper arms and thighs are 'pneumatic,' they will be unable to close to the perpendicular position. And the very obese subject must stand, sit, or walk in something of a straddle, with elbows pushed out as if the arms were lighter than air. In some ways, a mild form of obesity is reminiscent of the figure in infancy. Of course, relative proportions of the underlying anatomy have been greatly altered in the progress toward maturity. The dimpled character of infant and obese flesh is due to the adhesion of the skin, at various points, to the deep fascia beneath.[2]

[1] Famous for his circumference was Daniel Lambert (1770-1809). It is said that he measured nearly 3 yards around the waist and weighed 739 pounds.
[2] Especially noticeable on the extensor aspect of joints, creating dimples of elbow, hand, knee, and foot.

The portrayal of emaciation is based largely on a knowledge of the skeleton. It might almost be said that the bony framework alone is the limit for reduction of soft tissues. The head and trunk, being cage-like structures, will suffer least. The neck, too, shows only moderate shrinkage. Extremities, except hands and feet, may sustain dire loss of flesh, since only their 'cores' are bony. Extreme emaciation, as seen in the victim of starvation, suggests in its dreadfulness a skeleton to which adheres very little more than skin and hair. Bony regions such as the skull, and especially joints like elbow and knee, seem disproportionately large. For a time, however, the abdomen will be distended. Wrinkles do not accompany shrinkage, except in the elderly. The degree of emaciation can be expressed by the extent to which fatty and muscular contours affect the underlying skeleton. Of all the fat deposits, last to shrink are the buccal pad of the cheek and the buttock fat. Cartilaginous regions (ear, nose, Adam's Apple, arch of ribs) do not undergo reduction through starvation.

EXTREME EMACIATION

Underwood-Strattor

This Indian family provides a grim study in the ravages of famine. Arms and legs show a high degree of reduction, with conspicuous joints. Pectoral muscles, too, are scant, but female breast (reclining adult) is still evident. Least affected are the head, hands, and feet.

155

Evidence of superficial veins is more than a pictorial feature imparting ruggedness to flesh. Frequently, veins help to clarify form by breaking a surface into clean planes. Again, certain contours of the forearm and leg may be misinterpreted unless one acknowledges the accidentals—veins that pass from front to rear upon those contours.

VEINS

The venous system resembles a river whose branches are fed by ever-diminishing tributaries. The greatest channels lie in the depths of the trunk, receiving branches from the surface at a number of hollows. Tributaries feeding this great system form a tortuous mesh about the surface of the body. They are called *superficial veins*. The presence of vessels beneath the skin may be evident because of their grayish color or their prominence; vessels are especially salient when circulation is quickened by exertion or excitement. Grotesquely conspicuous are the veins of the elderly and of those who toiled strenuously for many years. Knottiness results from the distention of weakened vein walls. Although the general pattern of veins is identical in all bodies, its finer details of arrangement are, like fingerprints, unique.

A vein is a collector. Its size increases in the direction of flow. Since the vessels are destined to enter the depths of the trunk, their diameters on the surface are greatest at the points of entry. These receiving stations are situated (1) *above the clavicle*, for veins from the head and neck; (2) *below the clavicle*, for veins from the upper limb and front of the upper trunk; (3) *below the inguinal ligament* of the pelvis, for veins from the front of the lower limb and lower trunk; and (4) *back of the knee*, for the vein of the hinder part of the leg.

VEINS OF FOREARM AND HAND distended — to show how vessels alter contours, and how they disguise some yet clarify other muscular forms.

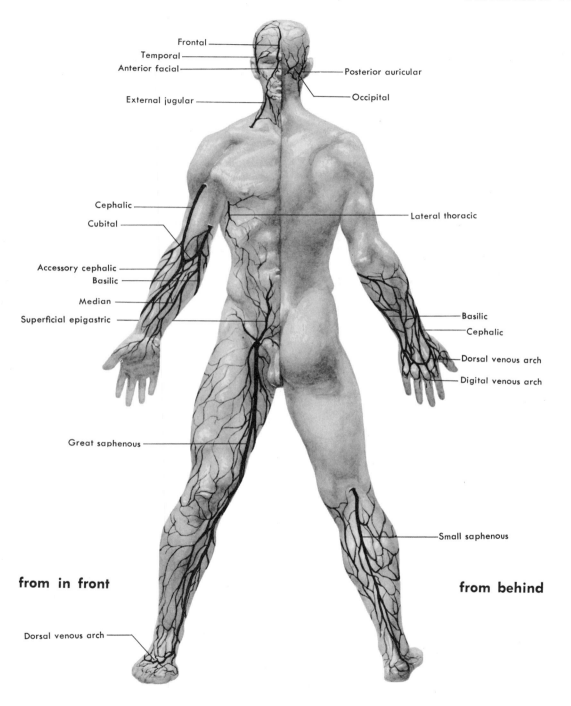

Frontal

Temporal

Anterior facial

Posterior auricular

External jugular

Occipital

Cephalic

Lateral thoracic

Cubital

Accessory cephalic

Basilic

Median

Basilic

Cephalic

Superficial epigastric

Dorsal venous arch

Digital venous arch

Great saphenous

Small saphenous

from in front

from behind

Dorsal venous arch

N.B. At the back of the hand, veins do not always form an arch; instead, they may be organized longitudinally as a venous *rete*.

SKIN

The skin is a continuous, protective sheet that envelops the entire body and is attached to deeper structures by way of connective tissue.[1] At a number of places, skin adheres closely to its underlying tissue, viz. regions of the scalp, ear, palms of the hands, soles of the feet, and the flexure lines of joints.[2] Elsewhere it glides rather freely. Over the extensor aspect of many joints it becomes checked and even puckered into wrinkles.[3] Creases in the hollow of the hand are distinct lines of flexure. They are as seams to the upholstery of the palm, and the principal creases usually describe what suggests a script letter M (see opp. page).

COLOR of skin is produced by blood and pigment particles beneath its surface. A transmitted characteristic of *race* is seen in the myriad tints from the pale-pink Nordic of Scandinavia to the jet-black Nilotic Negro on the upper Nile. With *age,* complexion varies only slightly. Most infants (white race) have a rosy color, whereas, in the elderly, decreased pigmentation leaves the skin more ivory. *Region* is another factor in skin tone. The greater part of the body is nearly uniform in color, but a number of areas show a persistent local richness of color. The lips, nose, ear, and cheek are varying tones of red, owing to their thinness of skin and a rich blood supply. Elbow, knee, and knuckles are frequently of a ruddy cast. In fact, the limbs often seem to redden toward their free ends. The nipple and its areola are pigmented—a light red or brown. In the female, their color deepens with pregnancy. General state of *health,* both physical and mental, has its concomitants in skin color. General good health in a person of fair complexion is associated with something like the color of a peach. Because skin is a semi-opaque substance, the gray color of underlying veins may be evident. Or the dispersion of hair (as in a dark, shaven beard) may seem to lend grayness to the flesh color. Nor can it be forgotten that skin is forever reflecting color from foreign sources. The satin sheen of skin, so striking in people of hot countries, has been considered to be the consequence of increased flow of blood to the surface.[4] (Such people do not perspire excessively.)

FRECKLES are small spots of pigment particles produced in the skin and aggravated by the action of light and the sun's heat. Persons having red hair and delicate skin are predisposed to this type of scattered pigment, displaying freckles on those surfaces that are usually exposed: face, neck, and forearms. In color, freckles may vary from a pale-yellow or a salmon shade to the darkest brown. Their appearance is rarely made before the seventh year, and they may or may not persist to old age. Frequently, they fade with the winter seasons.

[1] For dimples: see p. 154 (*Obesity*).
[2] Lines of flexure develop at right angles to the direction of muscle action. They may be seen about the neck, abdomen, groin, between breast and arm, at the front of the elbow, and at the back of the knee and heel.
[3] For wrinkles: see p. 222.
[4] A. de Quatrefages, French naturalist (1810-92).

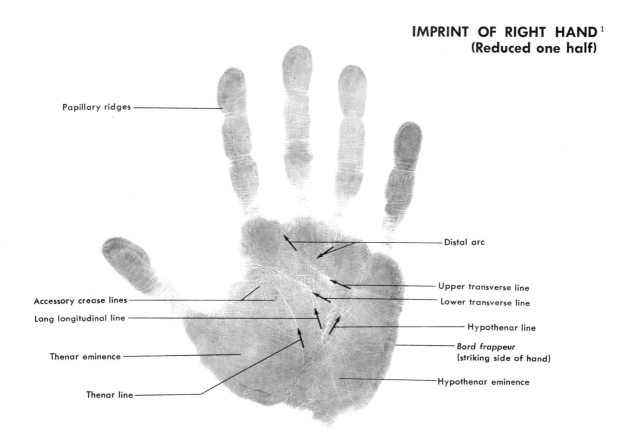

IMPRINT OF RIGHT HAND[1]
(Reduced one half)

Papillary ridges

Accessory crease lines

Long longitudinal line

Thenar eminence

Thenar line

Distal arc

Upper transverse line

Lower transverse line

Hypothenar line

Bord frappeur
(striking side of hand)

Hypothenar eminence

Because the practice of chiromancy had its roots in ancient times among superstitious people, it has fallen into disrepute with the advance of science. But the matter of hand interpretation has not in any sense been abandoned. Contemporary investigators—drawing from anatomy, neurology, endocrinology, and abnormal psychology—are cautiously compiling data from mental institutions, criminal files, colleges, etc. The findings thus far give strong support to a psychophysical theory of hand interpretation. The general shape of the hand, together with its unique pattern of papillary ridges (the lines of a fingerprint), is the consequence of hereditary factors and, in the case of the shape, the function or dysfunction of certain endocrine glands. Parts of the hand may, of course, be altered in shape by occupation. The chief crease lines are mostly of a motoric nature and therefore standard, but the details of the engraving seem to be determined more by the extent to which subconscious forces act upon the physical aspects of the hand. The theory has been formulated by Dr. Charlotte Wolff and is presented in her book, *The Human Hand.*[2] Dr. Wolff attempts to reveal the correlation of hand type with body type, physical constitution, temperament, mental capacities, and vocational aptitudes. For the expert, the accompanying print is, presumably, a psychological portrait to challenge the most honest autobiographical sketch.

[1] Compare with cut, p. 123.
[2] Published by Alfred A. Knopf, New York, 1942. **159**

HAIR

Hair is variable in type, texture, color, and quantity. The hair of the head is that part of the anatomy most subject to arrangement as dictated by vogue or whim. Such flexibility lends itself well to the artist's talents. Yet one problem can seldom be escaped—how to define the limits of a hairy region, usually called the *hairline.* The margin of hair is, of course, not a line but a zone of transition from sparseness to multiplicity. A hairline suggests the twilight perimeter of a dark forest. What may appear to be the demarcation between naked skin and hair is mostly a shade, caused by scant marginal growth. Unless the artist distinguishes between this overcast and actual hair density, he is likely to describe a badly made wig. Hairs may begin rather abruptly at the top of the forehead, but on the temple their marginal growth is more extensive. Male neck hair is naturally diffuse and wild—making the periodic barber's 'trim' inevitable. Localized growths of hair are described elsewhere (see *Eye, Ear, Distinctions of Sex,* etc.).

STRUCTURE of hair is designated as fine or coarse, and as lank, wavy, curly, or woolly. Fineness goes with wavy and curly hair. The character of a hair is determined by its *follicle* (sac containing the hair root). Thus, a straight hair grows from a straight follicle, wavy and curly hair from curved follicles. Woolly hair belongs exclusively to Negroid peoples.

PATTERN of hair on the body may evolve spiral-like from centers known as *whorls* (whirlpools), or it may lie in one direction and form *hair streams.* Whorl centers are found on the scalp, pit of the arm, and below the groin. On the forearm and back of the hand, the hair stream 'flows' to the ulnar side.

COLOR of hair is governed by the content of pigment particles. Wavy and curly hair may be found from pale ash to nearly black. Lank hair varies much less, usually black; woolliness is nearly always jet black. Red hair is an anomaly occurring in conjunction with wavy and frizzy hair. Whiteness results from loss of pigment, usually recording the progress of time. The region of its first appearance is significantly called 'temporal'!

RECESSION of hair on the scalp is common among white people, especially adult males. The hairline of the forehead, which in infancy passed almost directly from ear to ear, may draw backward in two bays just above the temporal lines of the skull. As the bays continue to recede, so will the hairs between them—until a broad path has been cleared over the crown of the head. This condition of *baldness,* if extensive, may disclose surface evidence of the various cranial sutures.[1]

160

[1] Cf. pp. 11, 17.

At the top of the head, scalp hair tends to grow forward—although it may be trained (as here) to make a turn backward. About the temple, hairs flow naturally downward and backward. Facial hairs—eyebrow, lashes, and beard—are directed outward from midline centers of radiation. The growth of the beard is not uniformly heavy. Note here the special density in a vertical path from the corner of the upper lip to the outer border of the chin. A small patch of skin below the lower lip, at either side of center, is usually hairless, or nearly so; the center portion is well tufted. The hair of the upper lip (moustache) describes an arch whose highest point is the base of the nose; skin beside the wing of the nose is hairless. Also barren is the margin of skin separating cheek hair (side whiskers) and scalp hair from the ear. Close inspection may reveal a feeble continuity from the eyebrow outward into side whiskers and upward into scalp hair. Eyelashes and eyebrow are discussed on page 163.

161

The EYE

EYEBALL

The eyeball lies nested in fat within the orbital cavity of the skull, where it occupies a position above and lateral to center. It consists of a nearly perfect sphere surmounted at the front by part of a smaller sphere, the *cornea.* The main globe is seen as the opaque 'white' of the eye (*sclera*), while the bulging cornea is clear and glassy. At the center of the cornea 'floor' is the *pupil,* a circular aperture of variable size, opening into the depths of the eyeball. Like the window of an unlighted house, the pupil appears black. If the eye is exposed to strong light, the pupil contracts; if the light is subdued, it may be greatly dilated.[1] Encompassing this opening and serving as the 'floor' of the cornea is a ring of color, the *iris.* Its minute sphincter and dilator muscles produce the pupillary changes. The iris is seen to be crowded with fine irregular lines, which radiate from the margin of the pupil.[2] *Eye color,* from hazel to black, is mostly a quantitative matter of pigment deposit (yellow or reddish-brown). Blue eyes result when the absence of such pigment allows the purplish-black rear surface of the iris to show through. Occasionally a white pigment is present and the eye color appears gray. Newborn babes usually have blue eyes, since pigment is apt to be scant at birth. Enveloping the front of the eyeball and lining the eyelids is a mucous membrane (*conjunctiva*). Washed by secretions from the tear gland, this gives the eyeball its moist and glossy appearance.[3] *Luster of the eye* (sparkle) is in proportion to the moistness of this membrane, richness of iris pigmentation, and clearness of the white part. A *highlight* on the eye is apt to be fine and pointed over the cornea, and expanded if it lies at the transition from cornea to white part (see cuts, p. 164). Distinction between 'large' and 'small' eyes is imperceptible, since variations are reckoned in fractions of millimeters.[4] *Apparent size* is accounted for by the degree of prominence given the eyeball or by the length of slit between the eyelids. The long slit is a trait common in Semitic peoples. *Focus of the eyes* requires that the imaginary axes of the eyeballs (emerging through the center of each pupil) shall not be parallel, but shall converge upon whatever point is the object of focus.

[1] The average distance between pupil centers of right and left eyes is very nearly 2¾ inches (68mm.) for the male, closer to 2½ (65mm.) for the female.

[2] The margin of the cornea, after middle age, may develop small granules of fat. These tend to produce a bluish-gray ring, which softens the outer rim of the iris.

[3] Cf. p. 245-6, *Tears.*

[4] Eyeball diameter is 17.5 mm. at birth, 24 mm. (nearly one inch) in the adult.

EYELIDS

The eyelids are two folds of skin shielding the eyeball, and their form is intimately associated with it. The upper lid, larger and more movable, regulates opening and closing. Lower-lid movement is negligible. When the eye is closed, its lids unite at the *lid-slit* in a downward curve. This line of union must correspond to the margin of the lower lid in its open position: a long, slow, double curve that turns quickly upward to the outer corner of the eye. The margin of the raised upper lid ascends swiftly from the inner corner to gain the summit of the cornea, from which it arches slowly downward to the outside. This arrangement of lid curves will show an oblique axis (medial above)—more oblique medially as the eye looks medially, yet becoming oblique laterally if the eye looks laterally. The corners of the eye are called *inner canthus* and *outer canthus;* their distinctions are best seen in the open eye. The inner canthus is a rounded, watery pit (*lacrimal lake*) containing a glistening island of pinkish color (*caruncula*), and is separated from the white of the eye by a *semilunar fold* of membrane. The outer canthus ends in a crease where the upper lid overlaps the lower lid. It is placed on the same level (or slightly higher) but more to the rear than the inner canthus, and the crease slowly disappears in the skin of the face. Characteristic of the Mongoloid eye is a fold of the upper-lid skin, above the inner canthus, called the *epicanthic fold.*[5] Both upper and lower lids are divisible into soft *orbital parts* near the orbital margins (that of the upper lid exposed only when lowered), and firm *lid plates* bordering on the lid-slit. These plates are stiffened by condensed fibrous tissue and help to preserve the curvature of the lids. Ordinarily, the more a lid's thickness is exposed, the less will be seen of its width. Under the lower lid may be seen a line, the *infrapalpebral furrow,* arising from the inner canthus and swinging across the top of the cheek.

EYELASHES

Fringing the broad, free margins of both eyelids are three series of short hairs, the eyelashes. Those of the upper lid are longer and more numerous, and they curve upward, whereas the lower lashes curve downward.[6] Transversely, the eyelashes extend on each lid from within one fourth of an inch of the inner canthus to near the outer canthus.

EYEBROW

The eyebrow is a band of short hairs that arches upward above the eye, countering the droop of the bony orbit. Along the midline of the brow is a hair crest, which 'flows' laterally and gathers hairs from above and below it. The brow is variable in the type of arch it forms, but it closely follows the bony ridge (described on page 10).

[5] Cf. p. 152.
[6] Mongoloid eyelashes tend to be straight or even to converge at their free ends, and are often partly concealed by the epicanthic fold.

Right EYE

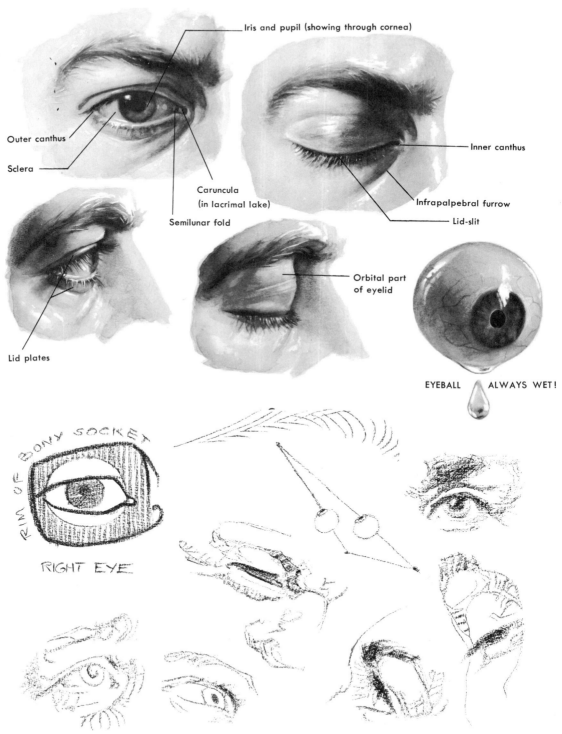

Iris and pupil (showing through cornea)

Outer canthus

Sclera

Caruncula
(in lacrimal lake)

Semilunar fold

Inner canthus

Infrapalpebral furrow

Lid-slit

Orbital part
of eyelid

Lid plates

EYEBALL ALWAYS WET!

RIM OF BONY SOCKET

RIGHT EYE

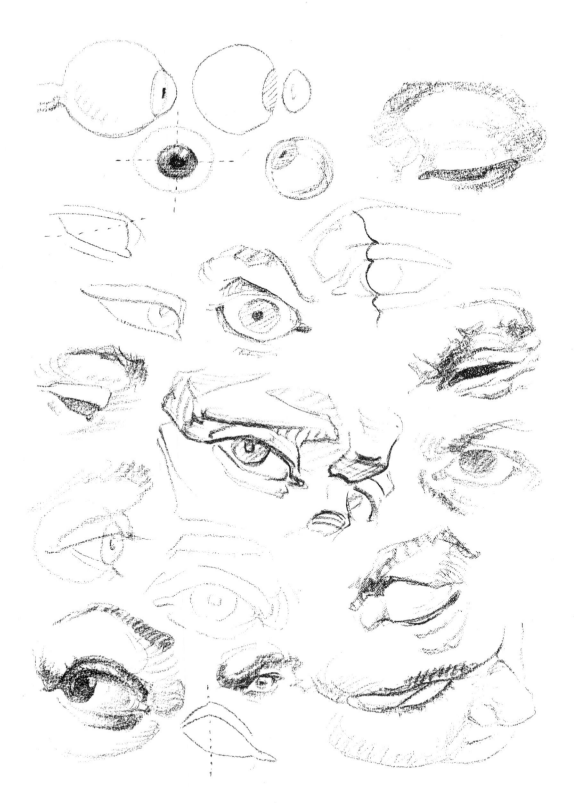

165

The EAR

Behind the joint of the jaw is the wing-shaped ear. This feature consists of a bowl, called the *concha,* and a broad double rim. It is designed to conduct sound to the partly concealed 'ear hole' (*auditory meatus*) and thence to the auditory canal. The various ridges and hollows of the ear are formed by a thin plate of crumpled cartilage; the pendant *lobe* below is soft and fleshy.

The OUTER RIM is the *helix,* so called because of its spiral line. It takes root from the concha floor as the *leg of the helix,* winds forward, then backward and downward to disappear in the lobe. Prominent in its upper rear part is a swelling called the *tubercle.*

The INNER RIM is known as the *antihelix,* and is separated from the helix only by the depression of the *scapha.* The root of the antihelix is in two low ridges, the *legs of the antihelix,* arising beneath the forward curve of the outer rim. But these 'legs' are not alike. The *upper leg* is round and full in form, while the *lower leg* is little more than a sharp edge. A pit is formed between the legs, called the *triangular fossa.* The anti-helix then swings downward beside the helix. Its forward extension below acts as a 'curtain rod' for the soft, hanging lobe. At the front of this 'rod' is the *intertragical notch,* rendered conspicuous by two flaps of the cartilage: *tragus* and *antitragus.* The one guarding the 'ear hole' from in front is called 'tragus' [G. goat] since it often begets a tuft of hair resembling the goat's beard. The antitragus is so named because of its position 'opposite the tragus.' These flaps are best understood if we imagine they are composed of lumps—a single lump in the antitragus, one or two in the tragus. Accordingly, the outline of the tragus varies from pointedness to squareness. Separating the tragus from the leg of the helix is the *anterior notch.*

The HINDER SURFACE of the ear, owing to a fairly uniform thickness of parts, shows the various elevations and depressions reversed: viz. the *eminence of the concha,* the *fossa of the antihelix,* and the *eminence of the scapha.*

Right EAR

CARTILAGE

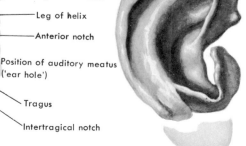

Helix — Tubercle — Scapha — Antihelix — Concha — Antitragus — Lobe — Triangular fossa — Legs of antihelix — Leg of helix — Anterior notch — Position of auditory meatus ('ear hole') — Tragus — Intertragical notch

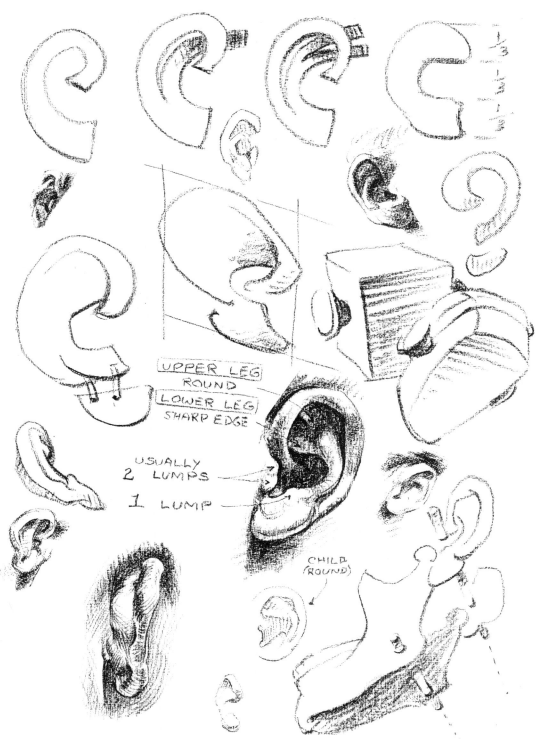

UPPER LEG
ROUND
LOWER LEG
SHARP EDGE

USUALLY
2 LUMPS

1 LUMP

CHILD
(ROUND)

167

The NOSE

Prominently situated on the face as its central feature, the nose provides a strong accent of height to oppose the horizontal direction of eyes and mouth. The stability of the nose makes for simplicity of its structural aspects. From the *root* above, at the promontory between the eyebrows, the nose mounts outward and downward to end in the *apex*, or tip. The *lateral surfaces* slope away from the center crest much as if they were a continuous piece of adhesive tape bridging the nose from cheek to cheek. The wing of the nose (*ala*) is a fleshy expansion at either side of the apex, limited above by a groove called the *alar furrow*. Undersurfaces of the wings are seen to slant downward and meet at the midline. It is in each of these planes that the opening of the *nostril* is displayed. The partition of the cavity, separating right and left nostrils, is the *septum*. And originating from the nostril lining are a few coarse hairs.

BONES[1]

The short nasal bones, together with adjacent parts of the maxillæ, project outward between the orbits as the only hard constituents of the nose. They are commonly referred to as the 'bridge.' One of the most conspicuous of facial traits is the mode of descent from this bridge, a trait that has inspired such epithets as 'hook,' 'hawk,' 'snub,' 'pug,' 'aquiline,' and 'turned up' (retroussé).

CARTILAGES

The conformation of the nose, below the bridge, is closely allied to the arrangement of its various cartilages. These semi-rigid plates of gristle are distributed so as to surround the nasal vestibule in front and prevent its closing. The *cartilage of the septum* forms the partition of the nasal cavity. Two *lateral cartilages*, triangular in shape, emerge from beneath the nasal bones to act as side walls, constricting the nose at its middle part. Two *alar cartilages* are bent like horseshoes, and lie at either side of the tip of the nose, partly encircling the nostrils. They are responsible for the enlargement called the 'bulb,' and their line of union may frequently be seen at the center of the bulb (sometimes depressed). The encirclement of a nostril is completed behind by fatty tissue, imparting a distinction to front and rear nostril rims. The cartilaginous margins in front turn sharply under to the nostril plane. Behind, the fatty margins are more rounded. The beginner should look after the structures encircling the nostril. The nostril outline will take care of itself.

[1] Cf. pp. 16, 18.

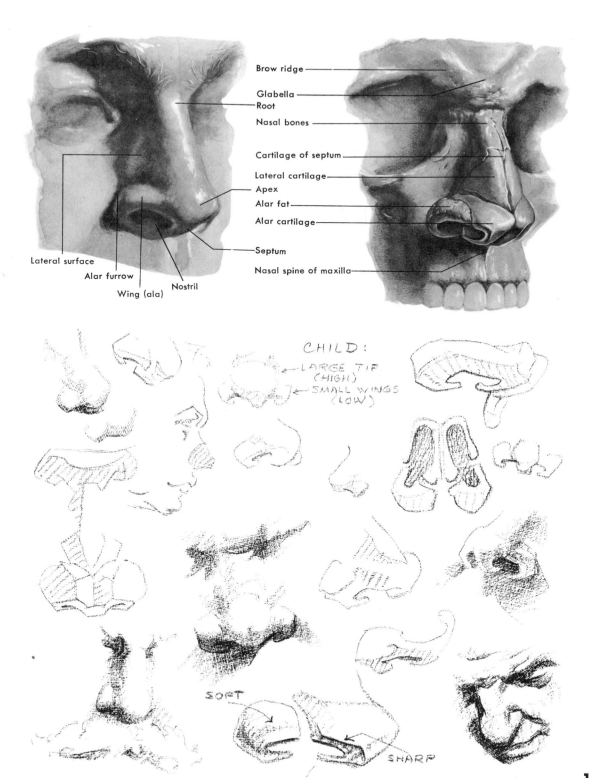

Brow ridge

Glabella

Root

Nasal bones

Cartilage of septum

Lateral cartilage

Apex

Alar fat

Alar cartilage

Septum

Nasal spine of maxilla

Lateral surface

Alar furrow

Wing (ala)

Nostril

CHILD!

←LARGE TIP (HIGH)

←SMALL WINGS (LOW)

SOFT

SHARP

169

The LIPS

The most mobile part of the face lies between nose and chin. Here the upper and lower lips bound the aperture leading into the cavity of the mouth. When at rest, this aperture appears as a curved slit, situated at the center of the upper front teeth.[1] It may, however, contract or expand into a variety of curvilinear shapes when the mouth is in action.[2] The lips arch backward from the center line and terminate at the cheek in pits, called the *corners of the mouth*. It should be observed that the lips actually bend around the cylinder of the head, much as if they were drawn back by strings and tied behind. But their arch is not so acute as that of the teeth. When the lips are parted, the rear teeth may become obscured in deep shadows at the corners of the mouth. Each lip exhibits a *red margin* whose edges are but softly indicated. High color is due to the thinness of the membrane and the rich blood supply.

The UPPER LIP hangs like a curtain from the base of the nose; it is separated from each cheek by an oblique groove in the skin, called the *nasolabial furrow*. At the center is the *philtrum*, a vertical depression accentuated by slight ridges at either side. The red margin of the upper lip consists of a swollen *tubercle* and two curled *wings*. The tubercle, shaped like a shield, overhangs a corresponding groove in the lower lip; its fullness is made more evident by the receding arches of the wings at either side.[3]

The LOWER LIP is separated from the chin by a depression called the *mentolabial furrow*. And the chin itself may show a vertical furrow where its tissue adheres to bone.[4] The red margin of the lower lip consists of a center *groove* (receiving the tubercle of the upper lip) and lateral *lobes* (complementing the upward arch of the upper-lip wings). *Eversion* of the lips, especially of the lower lip, is a typical Negroid trait. In developing the lip forms, it may prove helpful to work outward from the midline: first the tubercle of the upper lip, then away to the corners of the mouth.

[1] Ct. p. 18.
[2] For mouth in action, see pp. 252-5.
[3] Compare with the 'scrolled pediment' of architectural and furniture design.
[4] Dimple of the chin.

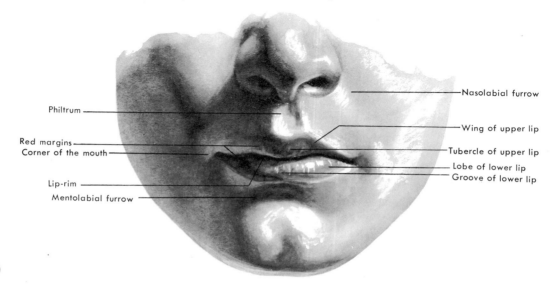

Philtrum

Red margins
Corner of the mouth

Lip-rim

Mentolabial furrow

Nasolabial furrow

Wing of upper lip

Tubercle of upper lip
Lobe of lower lip
Groove of lower lip

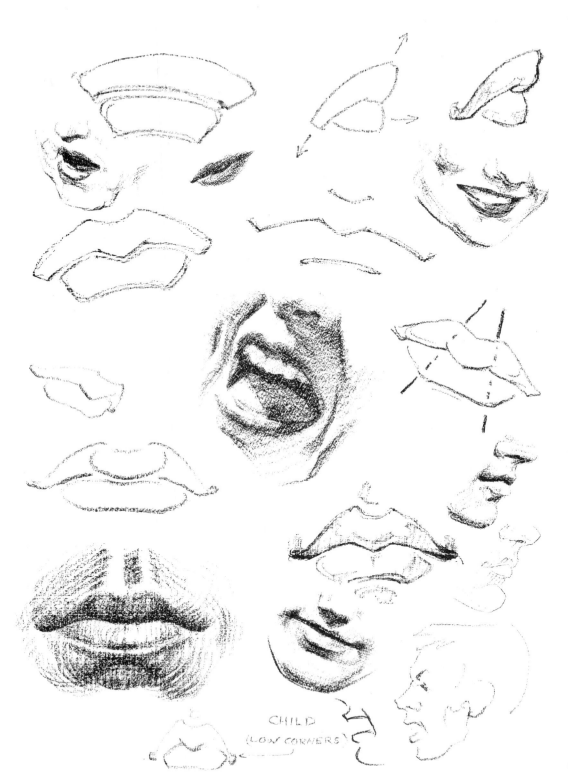

CHILD
(LOW CORNERS)

171

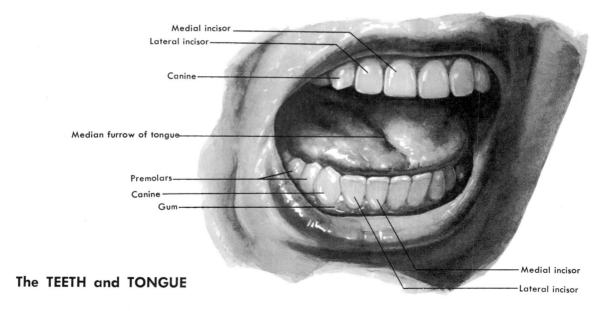

Medial incisor

Lateral incisor

Canine

Median furrow of tongue

Premolars

Canine

Gum

Medial incisor

Lateral incisor

The TEETH and TONGUE

TEETH[1]

Rooted in the dental arch of each jawbone of the adult are 16 teeth. Their *crowns* are the only visible parts, emerging from the *gum*—a reddish, fleshy membrane that surrounds the necks of the teeth. Most upper teeth are larger than lower teeth. They overbite the lower set and are nearly always the more exposed of the two.[2] Front teeth expand laterally, more above than below. This establishes a bite arrangement such that upper teeth, to the rear, are set a little behind their lower companions. The *cutters*, in front, terminate in chisel-edges. On one side of a jaw they consist of 2 flat incisors and 1 pointed canine (eyetooth). The *upper medial incisor* is far larger than the lateral, and the *lower medial incisor* is smallest of all. An *upper canine* has an angular edge—shorter in front than behind. A *lower canine* is blunt and longer than its counterpart above. The *grinders*, at the rear, consist of 2 premolars and 3 molars. *Premolars* are small, slightly pointed in the upper jaw, and more blunt in the lower jaw. The larger *molars* have an appearance of being double premolars, and they decrease to the rear in size. Molars of the lower jaw

are larger than their companions above. Deciduous or MILK TEETH are the diminutive forerunners of the larger, permanent teeth. *Incisors* and *canines* correspond to those of the permanent set; the remaining teeth are *milk molars,* two on each side of each jaw. The approximate date of eruption for each tooth in the infant and the adult is shown on the opposite page. One has only to remember that, at about six years of age, the permanent first molar erupts behind the milk molars.[3]

TONGUE

The shape of the tongue corresponds closely to that of the lower dental arch, by which it is bounded. Running from tip to root in the center of the upper surface is the *median furrow.* Generally in seclusion, the tongue may at times assist the agents of facial expression by its mobility. Among the attitudes in which it may be involved are prankishness, aversion, and apprehension.

[1] Illustrations, pp. 14-18.
[2] Black races show a tendency to large teeth, white races to small teeth, yellow races to an intermediate size.
[3] See note (N.B.), p. 214.

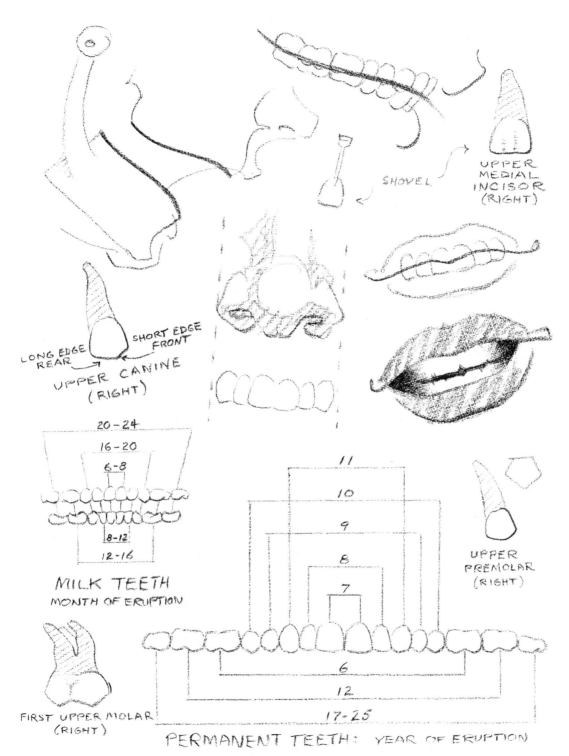

SHOVEL

UPPER
MEDIAL
INCISOR
(RIGHT)

LONG EDGE
REAR

SHORT EDGE
FRONT

UPPER CANINE
(RIGHT)

20-24
16-20
6-8
8-12
12-16

MILK TEETH
MONTH OF ERUPTION

11
10
9
8
7

6
12
17-25

UPPER
PREMOLAR
(RIGHT)

FIRST UPPER MOLAR
(RIGHT)

PERMANENT TEETH: YEAR OF ERUPTION

173

The NAILS

The horny substance of fingernails and toe-nails is semitransparent, colorless, and glossy. Visible through the nail is the pink flesh beneath, except for an opaque, crescentic area, called the *moon,* at the nail root. This moon is largest in the first digit and smallest in the fifth. If the nail is allowed to grow beyond its pinkish bed, a neutral color will be seen. Curvature of the nail gives it a saddle form and causes its lateral margins to sink into recesses of the skin, known as *nail grooves.* Each groove is flanked by a fleshy elevation, the *nail wall,* converging toward the root of the digit.

FINGERS

The nails of the fingers are usually well rounded at their free margins. Largest of all is the thumbnail. It is not so much longer than those of other fingers, but broader. The nails of index, middle, and ring fingers are approximately the same in size and shape, having about two thirds the area of the thumbnail. The area of the little fingernail is about one half that of the thumbnail.

TOES

As a general rule, the nails of the toes are square at their free margins. A comparison with fingernails shows that toenails cover a relatively smaller area of the digit and vary more in size among themselves. The nail of the big toe is by far the largest, surpassing even the area of the thumbnail. The others are smaller than their corresponding fingernails.

Right INDEX FINGER

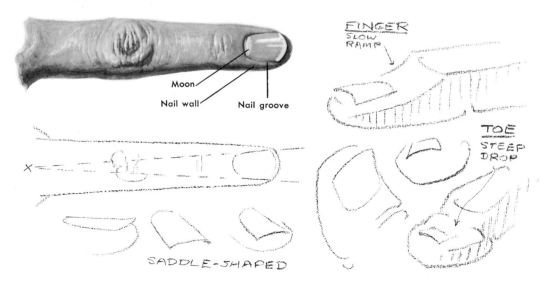

Moon
Nail wall
Nail groove

FINGER SLOW RAMP

TOE STEEP DROP

SADDLE-SHAPED

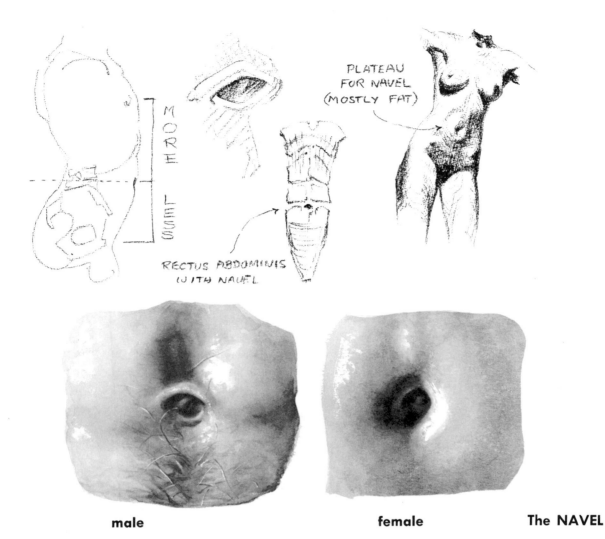

male female **The NAVEL**

The navel (*umbilicus*) lies in the tendinous midline (*linea alba*) of the abdomen, usually at the intersection of the lowest transverse line (interrupting tendon) of the rectus abdominis muscle.[1] This level corresponds to a position opposite the body of the 4th lumbar vertebra, or very little above the highest point of the iliac crest; it is nearer to the symphysis pubis than to the nipples. Although the navel is variable in appearance, its usual form is that of a crater-like pit holding the knot of excision. A sharp rim is generally produced at the upper border of the pit; below, the rim is rounded and not so well defined. In the *female* a large deposit of fat, especially below the navel, causes the pit to be deep and obscure in detail. The navel of a lean, muscular *male* is distinct and firmly rimmed. The effect may suggest an eye with upper lid overhanging lower lid. The skin of the navel itself is hairless, but the lower midline of the abdomen (male) may show a stream of hair. It emerges from the pubic growth below and usually disappears above at the lower rim of the navel.

[1] See note (N.B.), p. 102.

175

The BREASTS

The breasts overlie the muscles of the chest at either side of the midline. They reach their full development only in female adults, becoming large, glandular protrusions. Prominent on the breast is the *nipple,* surrounded by its *areola* [L. halo]. Both nipple and areola are wrinkled and of light red or brownish tint; and the latter is spotted with small buds (*areolar glands*).

The FEMALE breast is hemispherical, occupying an area between the 3rd and 6th ribs. The base of the breast is loosely connected by fascia to the chest muscles; composing the bulk of the form are glandular and fibrous tissues covered by a thick layer of fat.[1] A fatty appendix to the breast, called the *axillary tail,* extends backward along the free border of the pectoral muscle to the pit of the arm. Its effect may be to transform the breast fat into the shape of a comma. The *nipple* surmounts the main conical mass, lying somewhat lower than center at the level of the 5th rib. In general, the relative position of the female nipples on the torso corresponds to that of male nipples. With pregnancy comes enlargement of the nipple, then of the entire

breast. The rosy tint of nipple and areola gives way to deeper color, and the areola becomes more elevated. It is then not uncommon for a second areola, less distinct, to surround the first. The *axis of the breast* is such that it originates in the midline of the back, and points outward and slightly upward through the nipple. By virtue of its soft consistence, the female breast is subject to variety of form: hemispherical on an upright thorax, pendulous when the trunk is bent forward, or flattened in the reclining position. Folding-under of the breast upon the thorax is a trait developed in the matronly. *Breast form* is further subject to individual variation. It may be hemispherical, as described, or it may be distinctly conical. Again, either of these forms may be so modified as to constitute a subtype, the 'horizontal.' Here the form is extended transversely and suggests a compression from above. It is perhaps associated with the proportionately greater development of an axillary tail.

The MALE breast is vestigial. A small nipple and its flat areola lie at the 4th intercostal space (below 4th rib). Beneath is a thin disc of fat, little larger than the areola itself. Surrounding the areola is a growth of hair, usually sparse. The nipples of right and left sides are separated by nearly one head-length. However, in a subject whose chest and shoulder development is extensive, the nipples will appear to be closer than usual. And conversely, when the torso is slight, the distance between nipples will appear to be greater.[2]

[1] See *Mammary Fat,* p. 151.
[2] For alignments, see p. 194.

Right NIPPLE (Male)

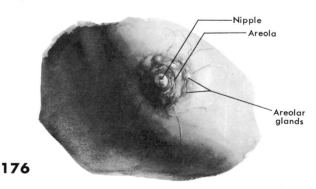

Nipple
Areola
Areolar glands

176

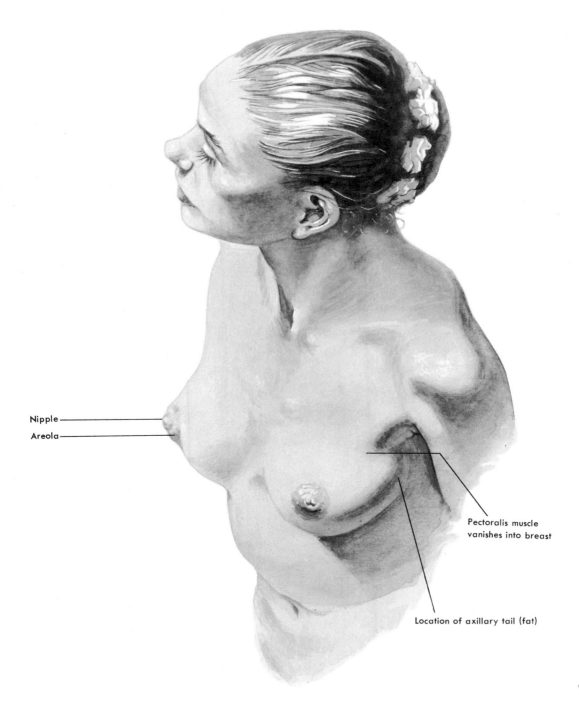

Nipple

Areola

Pectoralis muscle
vanishes into breast

Location of axillary tail (fat)

177

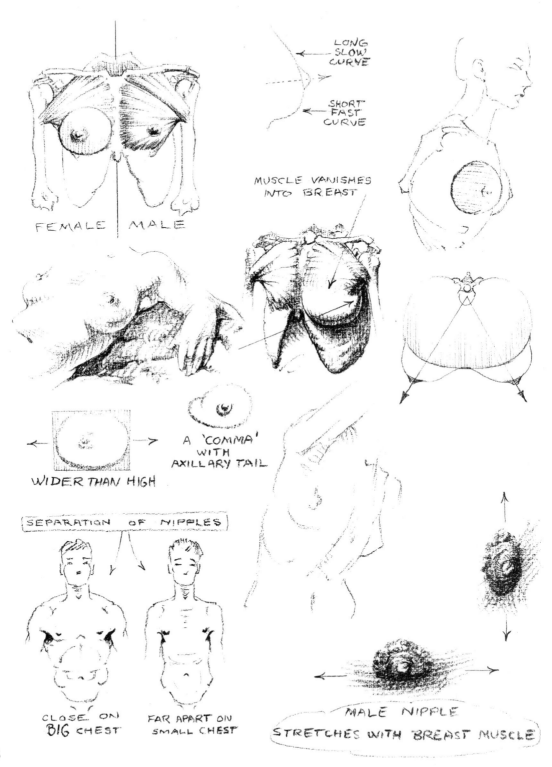

LONG
SLOW
CURVE

SHORT
FAST
CURVE

MUSCLE VANISHES
INTO BREAST

FEMALE | MALE

A 'COMMA'
WITH
AXILLARY TAIL

WIDER THAN HIGH

SEPARATION OF NIPPLES

CLOSE ON
BIG CHEST

FAR APART ON
SMALL CHEST

MALE NIPPLE
STRETCHES WITH BREAST MUSCLE

178

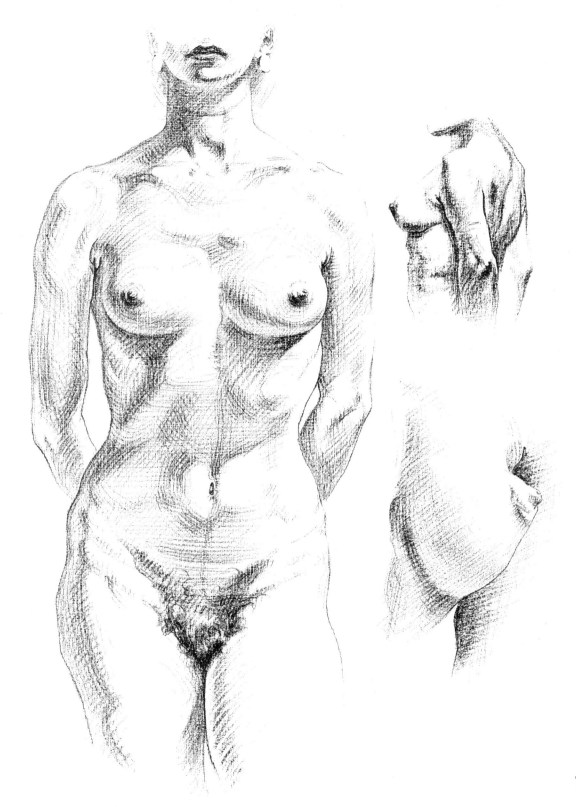

179

SURFACE LANDMARKS

Basic anatomy has been covered in the foregoing pages. At the beginning of this book, it was suggested that the human body is a sort of geographical terrain, upon which the anatomist, like a surveyor, must be prepared to take his bearings. For the figure artist, this means, in part, the ability to recognize significant features at the surface. They are the landmarks that, wisely used, guide the progress of his creative effort toward sound and harmonious construction. Such features therefore deserve special consideration. The following series of figure photographs is entered here with the hope that it may serve to test the reader's knowledge of surface modeling as revealed by light and shade. In studying these figures, the student is urged to hold relentlessly to his investigation until he has accounted for every ripple, knob, crest, dimple, and groove. The classified list below may be used as an abbreviated index. Tabular information on muscles appeared as follows: pp. 92-5, 102-3, 110-13, 128-31. Fat deposits were listed on pp. 150-52, veins p. 157. For reference to material below, page numbers are shown in parentheses.

TRIANGLES: neck (94); auscultation (105); sacral (22); lumbar (105); hollow behind ankle (152).

EMINENCES: thenar, hypothenar (112); flank pad (102); suprapatellar bulge (128); frontal (see below under Bones).

DEPRESSIONS: suprasternal space [pit of neck], supraclavicular and infraclavicular fossæ (36); axilla (118); cubital fossa (114); 'snuff box' [tabatière] (124).

FURROWS: deltoid (114); iliac (106); groin (60); linea alba (102); facial (222).

BANDS OF FASCIA: bicipital (110); wrist (113); ilio-tibial, gluteal, popliteal, Richer (128); ankle (130).

LIGAMENTS: nuchal (22); supraspinous (105); inguinal (60); patellar (70); annular (see bands of fascia of wrist and ankle).

CARTILAGES: ear (166); nose (168); thyroid, cricoid (99); thoracic arch (26).

BONES: frontal eminence, brow ridge, glabella, occipital protuberance (10); mental protuberance and tubercles (13); nasal, zygomatic, nasal spine of maxillæ (12); angle of mandibula (13); hyoid (99); spinous process of Cervical VII [prominens] (22); acromion, spine, vertebral margin, lower angle of scapula (34); clavicle (36); epicondyles of humerus (40); olecranon, crest, and head of ulna (42); styloid process of radius (43); medial and lateral spurs of wrist, heads of metacarpals (48); jugular notch and xiphoid process of sternum (26); crest and spines of ilium (56); symphysis pubis (60); sacrum (22); great trochanter and condyles of femur (68); patella (70); tuberosity, anterior crest, medial surface, and malleolus of tibia (72); head and malleolus of fibula (73); calcaneus, tuberosity of navicular, tarsal arch (78); tuberosity of 5th metatarsal, metatarsal arch (79).

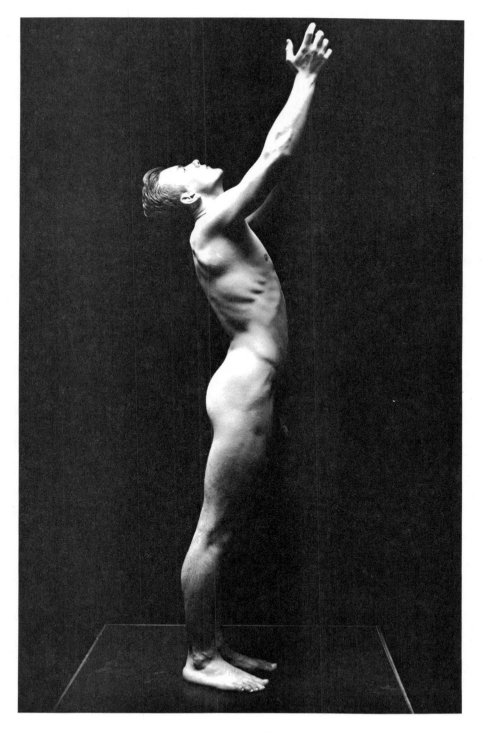

FIGURE 1

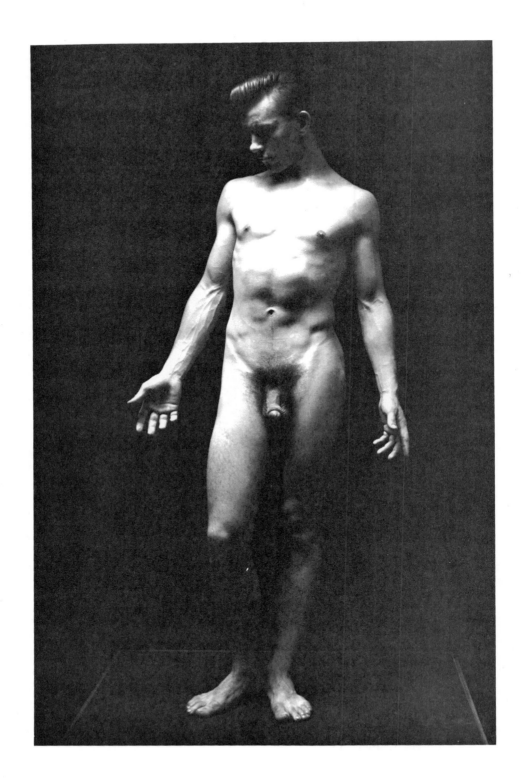

FIGURE 2

FIGURE 3

184 FIGURE 4

FIGURE 5

186 FIGURE 6

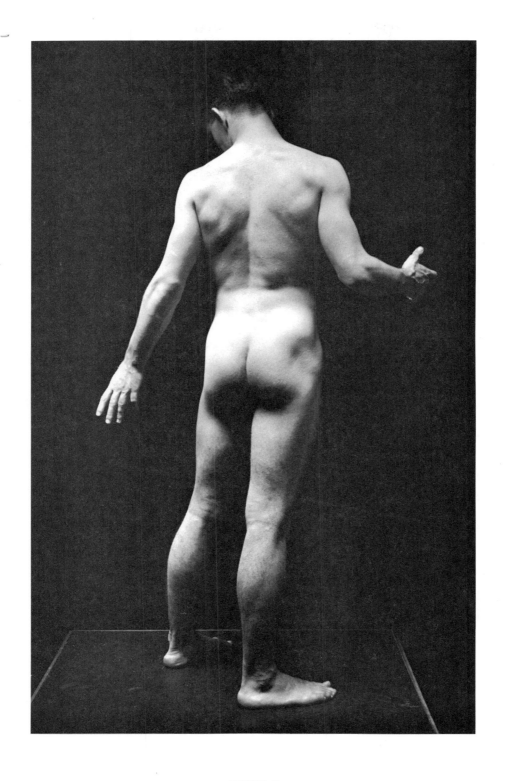

FIGURE 7

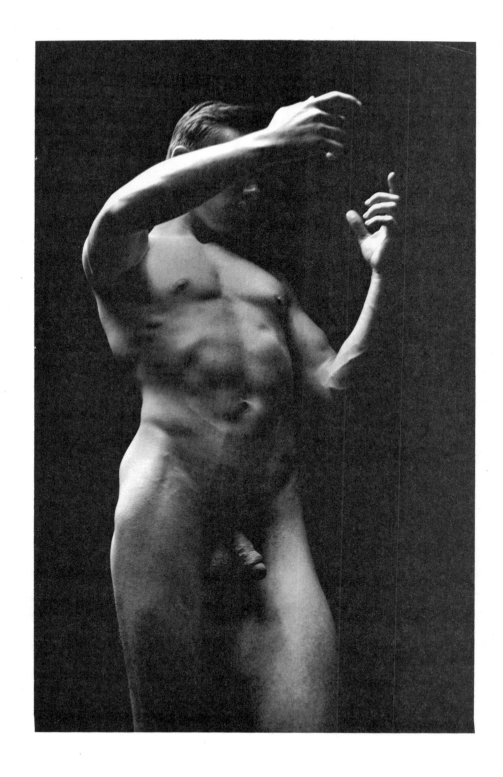

188 FIGURE 8

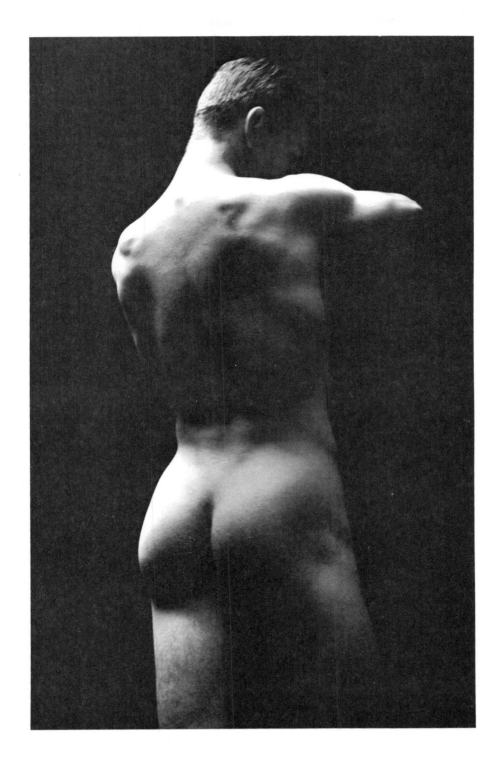

FIGURE 9

189

Part IV

PROPORTION

There is no Excellent Beauty, that hath not some Strangenesse in the Proportion.
—Bacon

PROPORTION [1]

Our study of basic anatomy has been an examination of parts. Now we must turn our attention to the integration of these parts—the organization of a full figure. Some kind of proportion system is needed. It should guide both the construction of skeletal sketches and the development of fleshy masses and surface detail. Such a system, in order to be useful, will incorporate only those relationships that may be conveniently remembered and that may ultimately become ingrained in the artist's 'second nature.' Calipers will not help. The student must observe carefully in matters of skeletal and muscular design. Proportion is more to be felt than to be plotted.

Since proportion is concerned with relativity, there must be a unit of comparison. Most widely employed is the *head-length*, from crown to tip of chin. Vasari writes of Michelangelo: 'He used to make his figures of nine, ten, or twelve heads, endeavouring to realise a harmony and grace not found in Nature, saying that it was necessary to have the compasses in the eye not in the hand. . .'[2] Certain of Raphael's figures are reported to measure only six heads. Cousin prescribed a figure of eight head-lengths, halved at the genitals and quartered at nipples and knees.[3] This division is easily committed to memory, but we should be more specific: midpoint at the root of the genitals, quarter points above nipples and below kneecaps. Richer gives seven and one-half head-lengths to the figure, with divisions that have been rather generally adopted by figure artists.[4] Yet it is said that tall people frequently measure eight head-lengths.[5] The precise number of these units is obviously variable.

Alignment is a device as useful as the 'unit of measurement,' and, in some instances, more manageable. It expresses relative direction and position, and can be especially helpful when applied to problems of perspective. An example would be the placement of the ear in horizontal line with brow and base of nose, or nipple in vertical line with anterior spine of iliac crest.

In spite of the student's need for canons of proportion, the fact remains that harmony, not anthropological ratios, is the working objective of figure artists. A concept of proportion should in time be a personal concept.

[1] See also pp. 216-19 (Age); pp. 224-5 (Sex).
[2] Translation by A. B. Hinds from Georgio Vasari's *Lives,* vol. IV, E. P. Dutton & Co., Inc., N.Y.
[3] The system of Jean Cousin (French, XVI century) is presented by Dr. J. Fau in *Anatomy of the Human Body,* Baillière, Tindall, and Cox, London.
[4] *Anatomie Artistique,* E. Plon, Nourrit, et Cie., Paris, 1890.
[5] Both dwarfism and giantism may manifest normal proportion, but in the latter there is a tendency to acromegalic features—i.e. prognathous jaw, oversized hands and feet.

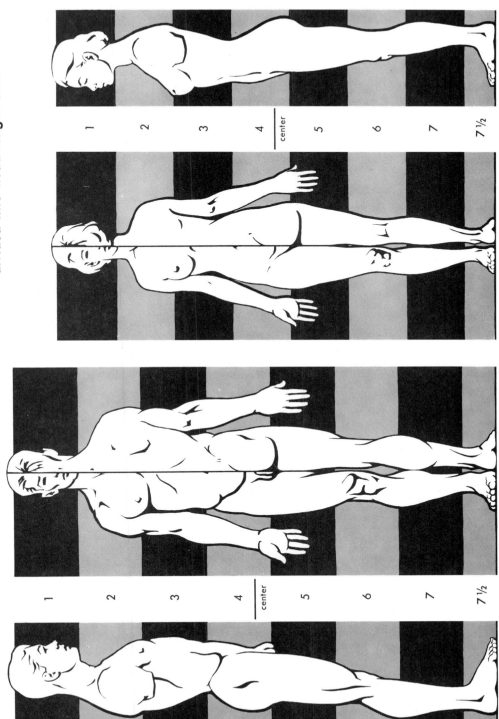

1
2
3
4
center
5
6
7
7½

NOTE: The proportion of male and female figures at selected ages from birth to old age is shown in charts on pages 216-19.

193

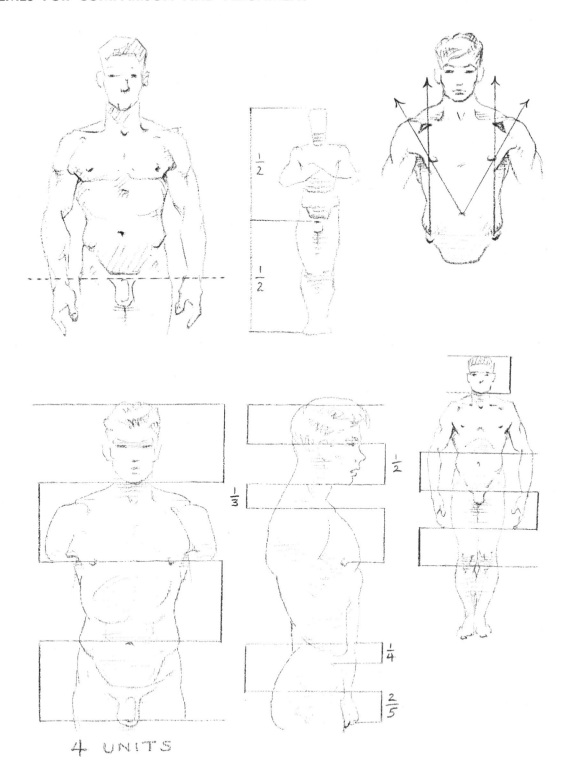

$\frac{1}{2}$

$\frac{1}{2}$

$\frac{1}{3}$

$\frac{1}{2}$

$\frac{1}{4}$

$\frac{2}{5}$

4 UNITS

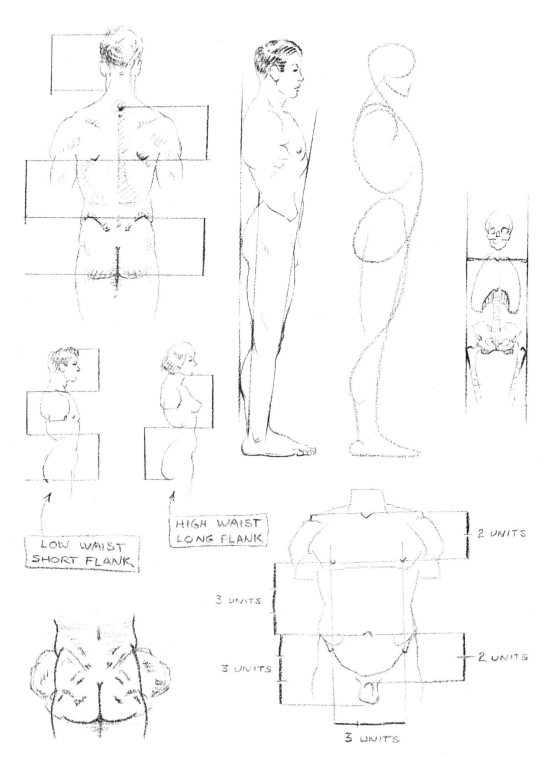

LOW WAIST
SHORT FLANK

HIGH WAIST
LONG FLANK

2 UNITS

3 UNITS

3 UNITS

2 UNITS

3 UNITS

195

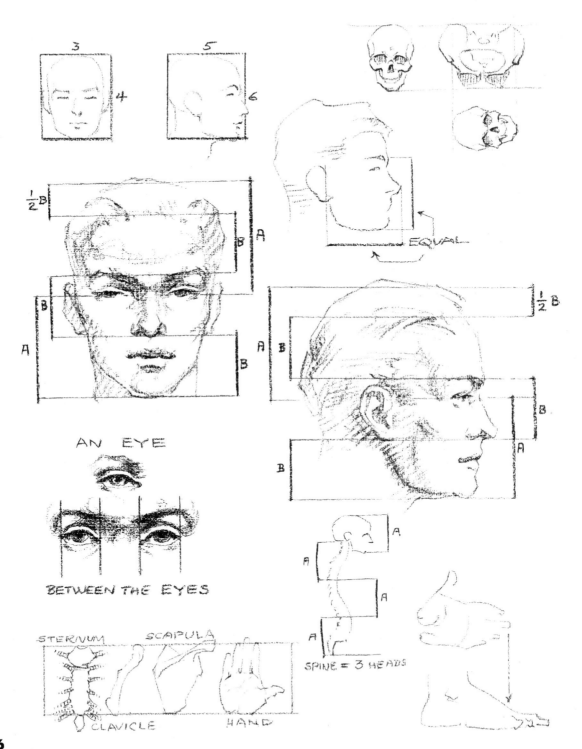

3

5

4

6

$\frac{1}{2}$B

B
A

B

A

EQUAL

$\frac{1}{2}$B

B A

B

B
A

AN EYE

BETWEEN THE EYES

A

A

A

SPINE = 3 HEADS

STERNUM SCAPULA

CLAVICLE HAND

196

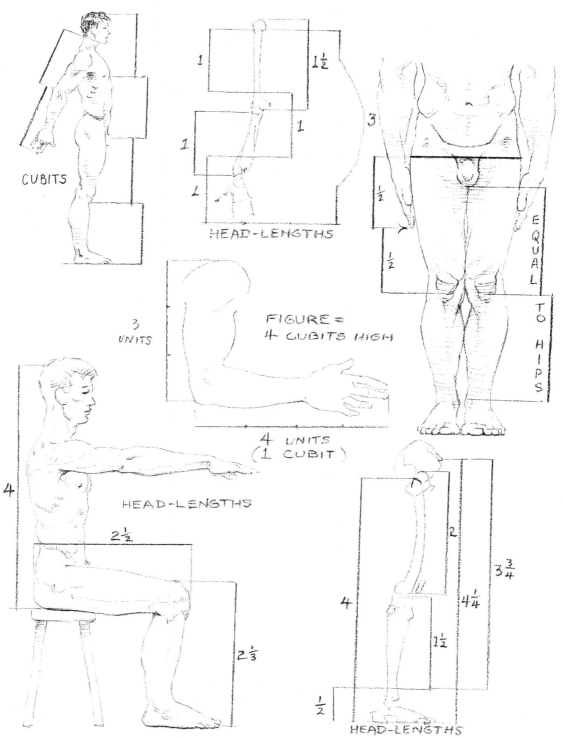

CUBITS

1

1½

1

1

1

1

3

½

½

HEAD-LENGTHS

EQUAL TO HIPS.

3
UNITS

FIGURE =
4 CUBITS HIGH

4 UNITS
(1 CUBIT)

HEAD-LENGTHS

4

2½

2⅔

2

3¾

4¼

4

1½

½

HEAD-LENGTHS

197

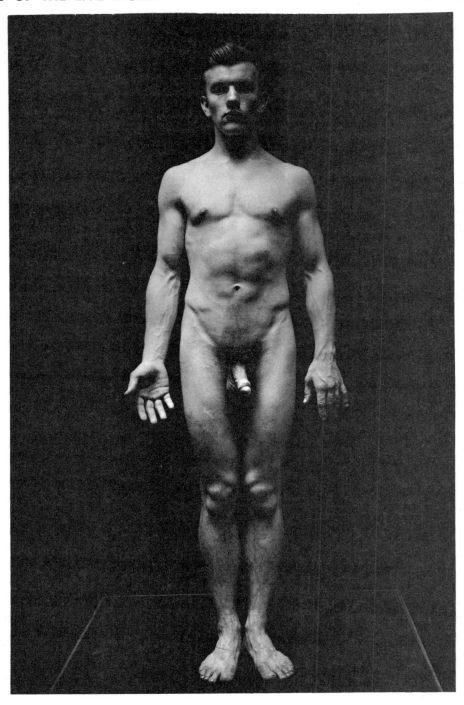

NOTE: The Proportion Scale (p. 193) indicates the anatomical levels of head-lengths in a figure of 7½ heads. Although this is rather widely adopted as the standard, the various levels should be considered as a formula to ward off incongruous proportion, rather than one to guarantee good proportion.

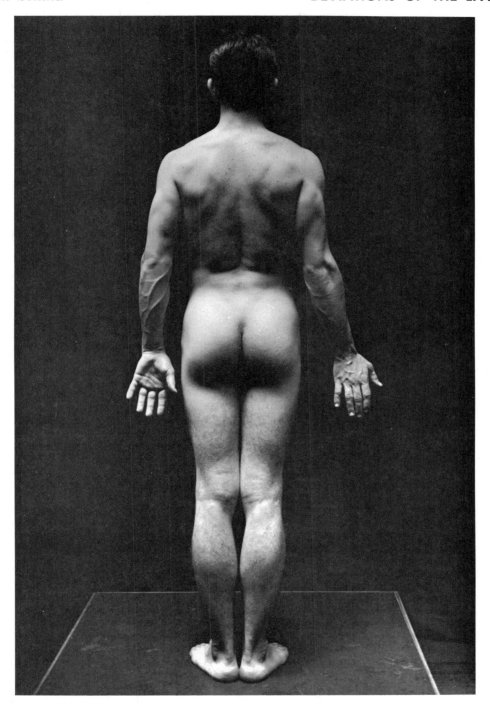

A live subject of those specifications would be not only rare but no more harmonious in general conformation than the individual shown here. Careful evaluation of intervals from one level to another will reveal the sort of variance that is almost universally encountered in the life.

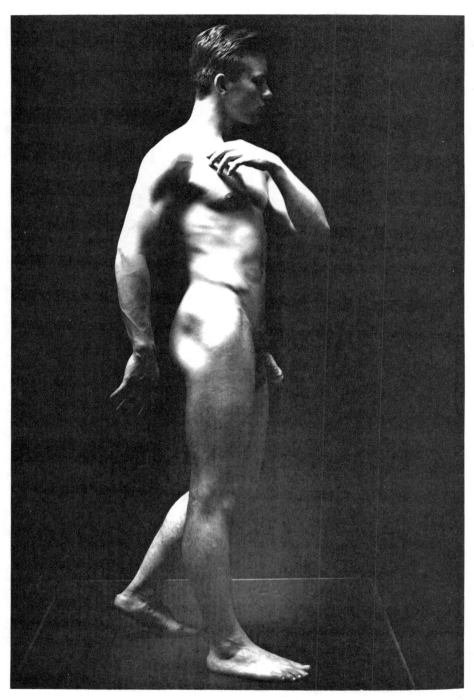

The ideal figure is one that, in bony and muscular sufficiency, declares full competence, and in poise of bone and tone of muscle, suggests an alert readiness. We expect the ideal figure to embody strength, agility, delicacy, and sleekness—all in degrees that are compatible with each other and with the sexual stereotype.

Intensive study of anatomy and figure proportion is likely to produce an archetype—the robust, well-muscled 'ideal.' And the student may discover that he is repetitiously shaping all human forms from this same generic mold. In order to cultivate a more lively awareness of human variety, it will be helpful to consider the work of the Constitution Laboratory at Columbia University. What follows is based on the studies of Dr. W. H. Sheldon, but in no sense does it presume to be an adequate summary.[1] It is hoped only that, by our bringing the subject of physique into sharp focus, the reader will at once develop his own faculties for an appreciation of its role in the total human composition.

A system of scientifically describing human physique has been devised by Dr. Sheldon and his associates. He observes that human bodies may be characterized as revealing quantitative variation in three components: (1) *endomorphic*—inclined to lay on fat; (2) *mesomorphic*—inclined to bone and muscle; and (3) *ectomorphic*—showing subordination of mass to surface, which designates linearity. Since a body may display the three components in varying degrees, a seven-point scale is used to rate the amount of each component. The least amount observed is given a 1, and the greatest amount a 7. The body pattern, called *somatotype,* is then briefly expressed as a sequence of numerals assigned to the three components in the order given above. Thus a 1-7-2, the masculine hero, is distinctly low in endomorphy, extremely well muscled, and has some of the component of linearity. The photographs that follow (pp. 202, 203) are representative examples of normal somatotypes. The population should not be regarded as a file on parade, graduated say from plump to lean. Plumpness and leanness, as we have seen, are not the only components of physique. It might rather be imagined that everybody stands somewhere within the confines of a three-dimensional structure. There each person is placed according to his position in reference to three axes of the distribution. And presiding at each pole are those who are extreme in one component. Given a point of view such as this, the reader may find himself considering physique with discrimination.

[1] *The Varieties of Human Physique* by W. H. Sheldon, Ph.D., M.D., Harper and Brothers, New York and London, 1940. This book provides photographic illustration and a clear informative analysis of body variation. Dr. Sheldon not only draws an authoritative word picture of each pattern, but also brings these individuals to life with his remarks on constitution, temperament, and forecast of what can be expected of physique in later years.

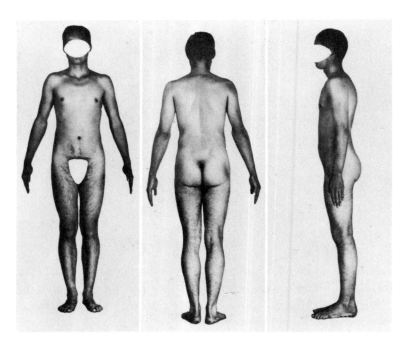

4-4-4 (average): A figure that shows equal dominance of all the components of physique. It is characterized by sleekness. Fat is well represented throughout. Musculature is well modeled but not angular. And a fair degree of linearity gives delicacy to the outlines.

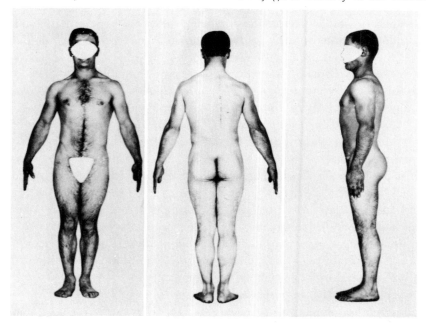

2½-7-1 (muscular): A figure that illustrates the extreme in natural muscularity. It is characterized by ruggedness. But the presence of fat somewhat relieves the surface of sharp muscular definition. Upper trunk dominates lower trunk. Note the broad, deep waist, heavy pelvic and shoulder girdles, and the powerful neck.

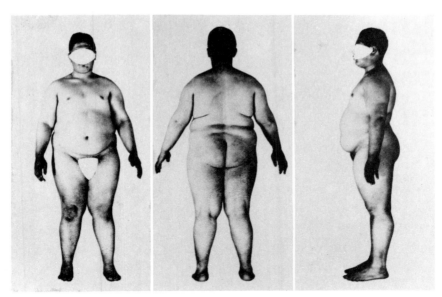

7-4-1 (fat): A figure that is unmistakably the extreme in fat. It is characterized by roundness and a pneumatic quality. Volume centers about the abdomen, diminishing into nearly average wrists and ankles. Fleshiness of thighs forces legs to straddle. Fleshiness of chest crowds upper limbs away from sides.

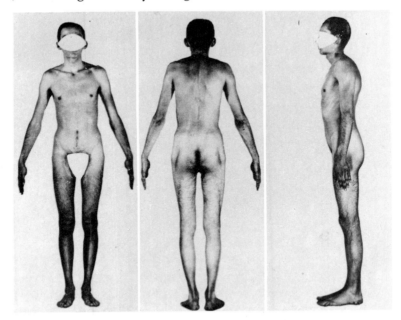

1½-2½-6½ (lean): A figure that depicts the extreme in linearity. It is characterized by fragility. The upholstery of muscle and fat is negligible, leaving skeletal framework so sharp as to seem vulnerably brittle. Note how the pelvis dominates the trunk, and how thighs fail to meet at the fork. Joints seem disproportionately large.

Photographs courtesy of the Constitution Laboratory, College of Physicians and Surgeons, Columbia University.

Part V

EQUILIBRIUM
AND
LOCOMOTION

*Let the movements of young lads be limber
and joyous, with a certain display of bold-
ness and vigor. Let mature men have stead-
ier movements, with handsome and athletic
postures. Let old men have fatigued move-
ments and attitudes and not only support
themselves on both feet but hold on to
something with their hands as well.*

— ALBERTI

At the core of the earth is the great magnetic force of GRAVITY, exerting its 'pull' on every substance. The center of weight in any object is its *center of gravity*, and a plumb line from this point to the ground would indicate the line of 'pull.' It is called the *line of gravity*. In the front view of an upright human figure, the line of gravity may be imagined as a pendulum hanging from the pit of the neck. But a bend from the hips will cause head and shoulders to counter by shifting their weight to the opposite side. A pendulum here would begin somewhere between the shoulders and hips. So long as the pendulum falls above the base of support (usually, the feet), the figure is said to be *in equilibrium*. If the line is removed to a point beyond the support, the figure will inevitably yield to gravity and fall. It is not difficult to see how much more delicate is the balance of an inverted cone (the spinning top) than that of an upright cone. The difference lies in the areas of their support. So in the figure: *decrease in the area of support requires finer balance of parts.* One of the important charges of the system of muscles and ligaments is to bring about and maintain this balance or equilibrium, whether the figure be fixed or in motion.

The SYMMETRICAL STANDING POSITION distributes the burden of body weight equally to both legs, and the line of gravity falls to a point between the feet. To be observed especially is the oblique direction of the lower limbs. Spread far from the line of gravity at the hips, they will, for the sake of lessening strain, draw together toward the ankles.

The ASYMMETRICAL STANDING POSITION denotes an unequal distribution of body weight to the legs. The area of chief support is reduced to the sole of one foot, and the line of gravity (pendulum) must swing into position over that foot. The various skeletal segments must now assume new and ingenious relationships of leverage in an attempt to preserve equilibrium. The adjustment, of course, is not a sequence of calculated movements, but rather occurs simultaneously and impulsively. (For Symmetry and Asymmetry: see figure photographs, pp. 227, 230.)

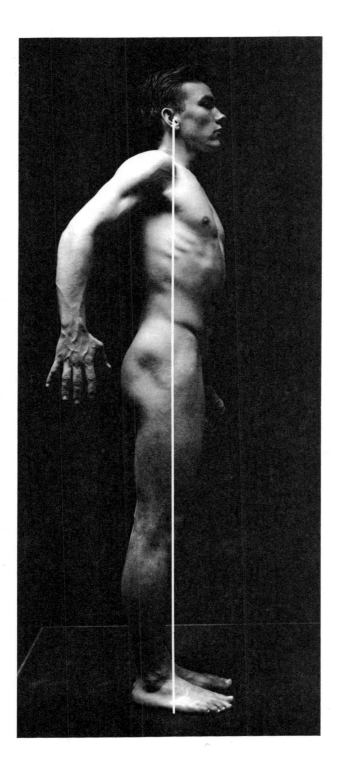

Through
ear hole

Through
lumbar
spine

Behind heads
of thighbones

Front of
cervical
spine

In front
of rotation
center of
knee joints

In front of
ankle joints

COMPENSATION OF THRUST

The effect of gravity on an upright column is static. If the column is bent sufficiently far from its base, it will fall. But balance may be recaptured by opposing one thrust with another—that is, by bending the column back upon itself. We may call this *compensation of thrust,* a principle demonstrated so patently in the human figure.

In order to ease the strain on supporting feet, body weight may be shared by props. The line of .gravity leaves the feet and swings into position, like the plumb bob for a surveyor's transit, at the weight center of all supports.

When the figure supports extra weight, the center of gravity will be the center of total weight. Unless this falls within the figure's natural line of gravity, compensation for the added load must be made to preserve balance. This is achieved by rearrangement of the skeleton in order to distribute the total weight equally over the base of support.

LOCOMOTION

Muscles are the 'engine' of the body; their contractile power generates *momentum*. The body relies on the 'coasting' of momentum and the force of gravity, as well as its own basic power (the defiance of gravity), to accomplish the acts of locomotion.

The line of gravity may be wilfully removed from the standing figure's base of support by the relaxation of those muscles that are, at the moment, preserving equilibrium. Yet it is possible to regain equilibrium by an outward step of the leg, establishing a new base of support in the new line of gravity. Locomotion is born of this deliberate loss of balance at one point and its recapture at another. Locomotion of any type is characterized by a leaning of the trunk and, except in leaping, a side-to-side oscillation. The lean is in the direction of the movement and in proportion to the interval to be gained.

WALKING requires that the line of gravity, like the familiar 'pot of gold,' shall be forever withdrawing. As it 'lures' the figure on, step by step, rythmic swinging of arms adds substantially to the body momentum and the gait acquires smoothness and co-ordination. RUNNING means that both feet must be off the ground once during each interval of the process, and the line of gravity is cast more distant. The impetus necessary to send the body aloft is provided by an alternate springing of each leg. LEAPING taxes to the limit all reserves of muscular power, summoned together in one great thrust. The legs are bent low and the body leans far out. Then follows a sudden and forceful straightening of both legs at the same instant. Momentum, thus generated, hurls the body upward and forward toward a point where gravity overtakes the motion and pulls the figure again to the ground. The fellow has quite literally 'jumped to a conclusion.' ASCENDING STEPS are the defiance of the force of gravity, and so call for greater muscular exertion than walking. The forward leg bends to surmount each step and straightens to hoist the body load aloft, while the rear leg relaxes from its supporting position and swings forward to become the next climbing leg. DESCENDING STEPS become inevitable when the line of gravity is removed to position over a lower possible base of support. Emphasis now is on checking the fall by rigidity of the descending leg. SLOPING-PLANE locomotion demands that the line of body weight be removed to toes or heel—depending on the inclination. If walking UPWARD, the figure must send its line of gravity ahead. The body is bent far forward and arms swing vigorously to increase momentum. In walking DOWNWARD, the figure must resist the precipitous force of gravity by a nearly erect posture. Arms scarcely move, since momentum is to be retarded.

N.B. The reader who desires a more detailed account of these phenomena should consult the study of Dr. Paul Richer, *Attitudes et Mouvements,* volume III of his *Nouvelle Anatomie artistique.*

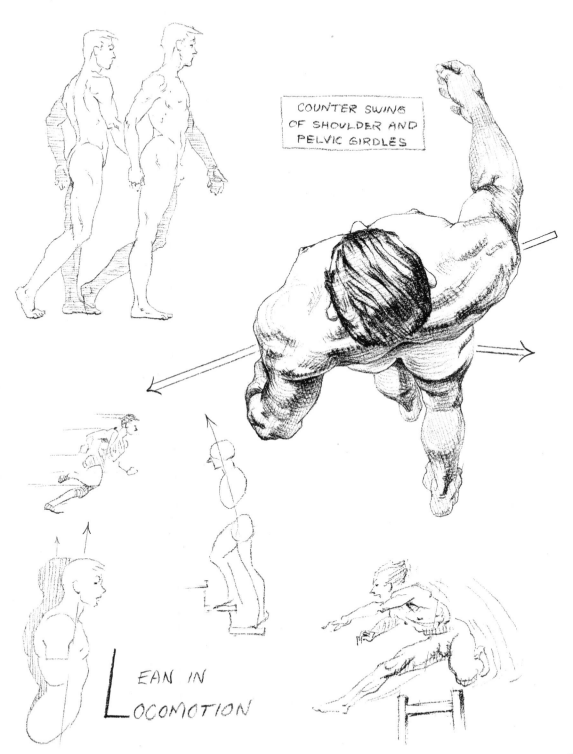

COUNTER SWING
OF SHOULDER AND
PELVIC GIRDLES

LEAN IN
LOCOMOTION

211

Part VI

DISTINCTIONS OF AGE, SEX, AND RACE

For as the race of man, after centuries of civilisation, still keeps some traits of their barbarian fathers, so man the individual is not altogether quit of youth . . .

—Stevenson

DISTINCTIONS OF AGE

The process of growth in the human body is a continuous chain of physical alterations from birth to death. Continuous, yet unlike the even ripening of fruit, these alterations are scheduled to gather more in clusters around the several life periods.

AT BIRTH

The *center of the figure,* which in the adult m le lies at the level of the pubic arch,[1] is found at birth near the navel. At intermediate stages, the center lies proportionately lower between the two points (see charts following). The newborn *head* measures about one half the height of an adult head and is nearly all cranium. The crowded face is, in effect, little more than the forward end of the cranium, with no perceptible drop of the jaw. Total *body length* is four times its head measurement. The trunk and head combined account for three head-lengths, one unit remaining for the lower limbs. Nearly equal in length are the upper arm and leg (knee to ankle). The *spine* appears to have but one curve, directed convexly backward. The *thorax* is compressed from side to side. *Buttocks* are undeveloped and diminutive. The *flesh* is comparatively plump, with rounded folds at the joints, and its dimple-like depressions indicate the presence of deeper structures.[2] The *hair* of a newborn babe is evident only on the scalp, brows, and eyelids, and is exceedingly soft. *Eye color* is usually blue, owing to lack of pigment.

INFANCY AND CHILDHOOD

With growth in stature and weight come notable changes of bodily appearance.

The *head,* large at first, grows slowly—the face faster than the cranium. And the lower jaw begets an angle. *Regions above and between the nipples* expand more rapidly than other parts of the trunk; in the *limbs,* the lengths of thighs and forearms show special progress. And the *spine* begins to form its four-arch curve.[3] *Scalp hair,* so scant at birth, increases enormously.

PUBERTY

Puberty is a period of transition from the childlike figure to that of the adult, and so displays traits of each. (Average males are pubescent at the age of 14, females at 12.)[4] The *skin* is seen to draw tightly over bones and muscles. And there appears a general manifestation of *sexual distinction*: males become angular, and females curvilinear. But there is a certain slightness and delicacy in both figures. The female hip and breast grow steadily in size. In the male, the shoulder is small and not fully extended, and there is an ungainly straightness to the trunk. Yet for both male and female, the lumbar curve of the *spine* is greatest now. With the advent of puberty, both sexes exhibit considerable *hair* under the arms and at the pubis. For the male, there is a soft downy beard and chest hair. It is now, too, that major local deposits of *fat* appear in the female.[5]

[1] Cf. p. 60. [2] Cf. p. 154, *Obesity.* [3] Cf. p. 23.
[4] Temperate climates.
[5] Cf. pp. 150-51, 226.
N.B. In young people, teeth will serve to fix the approximate age (see pp. 172-3). It is interesting that a tooth does not grow in size; on the contrary, it appears to diminish in relation to the expanding head. Milk teeth may seem 'too small' in the child of six, and the new permanent front teeth of the eight-year-old 'too large'!

YOUTH

The period of youth completes the changes begun in puberty. Both male and female acquire adult proportions, diverging still further from each other toward their sexual stereotypes. The male, inclined toward leanness, may develop a visible musculature. In the female a childlike smoothness persists, owing to the greater quantity of fat. Special fullness is given to breast, hip, and thigh. The female breast does not yet fold upon the thorax but rises gently forward. Local growths of *hair* become abundant in youth. And there is evidence of greater relative size in the neck, hands, and feet of the male.

MATURITY

At maturity the individual has completely obtained to the state of manhood or womanhood. (Average males mature at 25, females at 21.)[6] The proportion of early maturity is the so-called 'ideal' or 'perfect form' and has been presented in Part IV (Proportion). Typical of later maturity are the gradual decrease of pigment in the *hair,* a considerable gain in *weight,* and the long years of declining fitness we call 'middle age.'

SENILITY

As with any machine, the efficiency of muscles, ligaments, and other tissues must eventually become impaired. Elasticity is greatly diminished; the *skin* crumples away from the surface into 'wrinkles.'[7]

Wasting flesh reveals the knotted *veins* winding their courses beneath a dry and pallid skin. There is a general thinning of the *hair,* now pigmentless. The *head* and the bony *hands* and *feet* seem relatively large. Contours grimly hug the underlying bones and leave *joints* large and gaunt. But they are weakened, and so are their muscular supports. So the *shoulders* slouch forward with the weight of the arms. The once-sturdy *spine* can no longer remain erect; with lumbar curve reduced, it drops forward beneath its burden and produces the familiar 'stoop' of the aged. Its height is very perceptibly diminished, owing to the shrinkage of intervertebral discs. Affected too is the *hip joint,* where the pelvis, bearing down under body weight, bends the head of the thighbone upon its shaft. Indeed the whole body shrinks downward. And so we speak of a 'little old man' or a 'little old woman'! The gracious hills and valleys of maturity have given way to desiccated ridges and ravines. In the head, *loss of teeth* has caused the jawbone to rise forward.[8] *Ear* and *nose,* being of cartilage, seem large and distorted. The *eyeball* has sunk within its bony socket and lost the luster of younger days. Such is the process of human decay: the completion of the life span.

[6] Temperate climates.

[7] Described and illustrated on p. 222.

[8] Unless dentures are used, a toothless jawbone will spread its angle to about 140°. Teeth (especially front teeth) may be present in aged people.

MALE PROPORTION

SCALE OF PROPORTION DURING GROWTH

AGE	HEAD-LENGTH INTO HEIGHT (APPROXIMATE)
0	4 [¼ adult height, stands to adult knee]
3	5 [½ adult height, stands to adult pubis] (or as high as navel)
6	6 [age = head-lengths]
10	6½ [¾ adult height, stands to adult nipple] (or as high as nose)
16	7 [nearly (or entirely) adult height]
20	7½ [full stature attained]

N.B. Midpoint levels are indicated by broken lines.

*Infancy is a period of plumpness. At age 2, the figure (shown here) is ready for the elongation of childhood.

PUBERTY
AGE 14
Nearly
7 heads

CHILDHOOD
AGE 8
Nearly
6½ heads

INFANCY
AGE 2*

4½ heads

AT BIRTH
AGE 0
About
4 heads

216

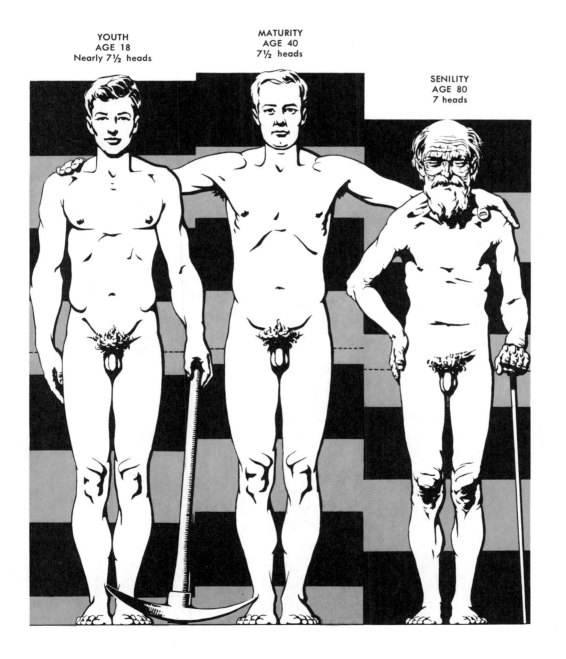

YOUTH
AGE 18
Nearly 7½ heads

MATURITY
AGE 40
7½ heads

SENILITY
AGE 80
7 heads

217

FEMALE PROPORTION

N.B. For infant development, see *How a Baby Grows* (over 800 photographs) by Dr. Arnold Gesell, Harper and Brothers, New York and London, 1945.

N.B. Midpoint levels are indicated by broken lines.

* See note (*), p. 216.

† The period of Puberty is usually completed in females at age 14.

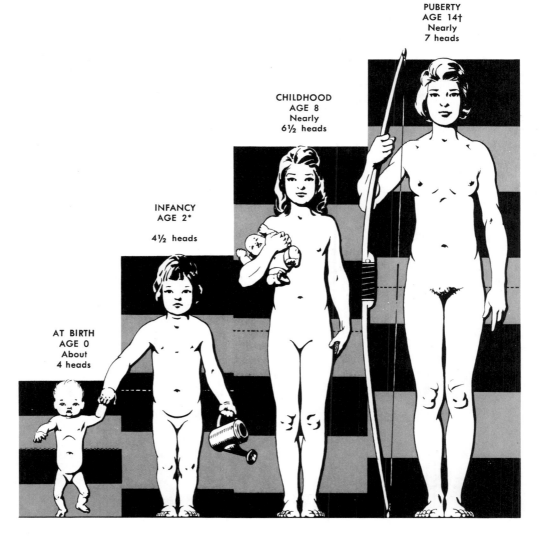

PUBERTY
AGE 14†
Nearly
7 heads

CHILDHOOD
AGE 8
Nearly
6½ heads

INFANCY
AGE 2*

4½ heads

AT BIRTH
AGE 0
About
4 heads

N.B. Until the period of youth, the average stature of females is nearly as great as that of average males of the same given age. With the arrival of youth, male stature eventually exceeds female stature by 5 or 6 inches.

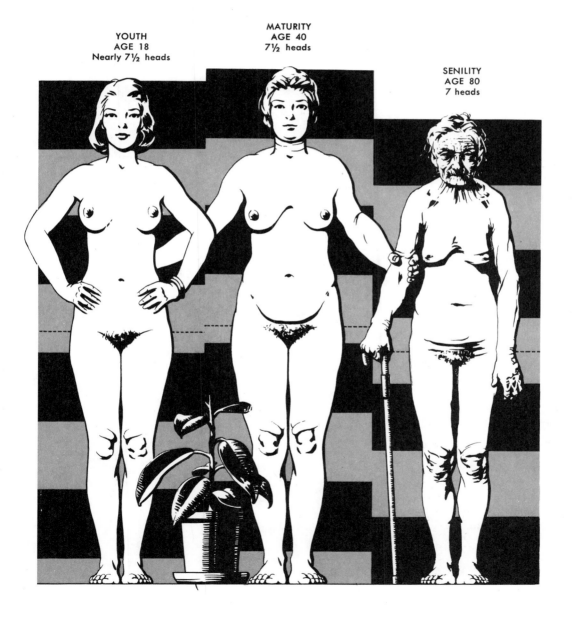

YOUTH
AGE 18
Nearly 7½ heads

MATURITY
AGE 40
7½ heads

SENILITY
AGE 80
7 heads

219

GROWTH OF THE SKULL

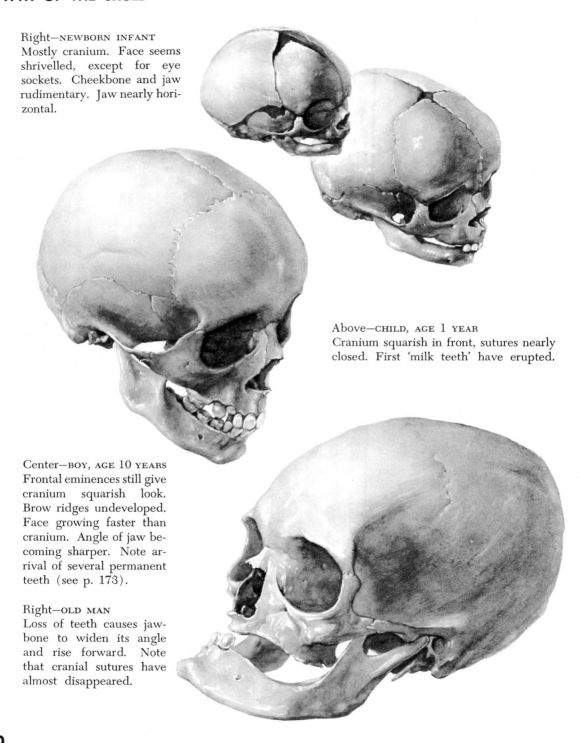

Right—NEWBORN INFANT
Mostly cranium. Face seems shrivelled, except for eye sockets. Cheekbone and jaw rudimentary. Jaw nearly horizontal.

Above—CHILD, AGE 1 YEAR
Cranium squarish in front, sutures nearly closed. First 'milk teeth' have erupted.

Center—BOY, AGE 10 YEARS
Frontal eminences still give cranium squarish look. Brow ridges undeveloped. Face growing faster than cranium. Angle of jaw becoming sharper. Note arrival of several permanent teeth (see p. 173).

Right—OLD MAN
Loss of teeth causes jawbone to widen its angle and rise forward. Note that cranial sutures have almost disappeared.

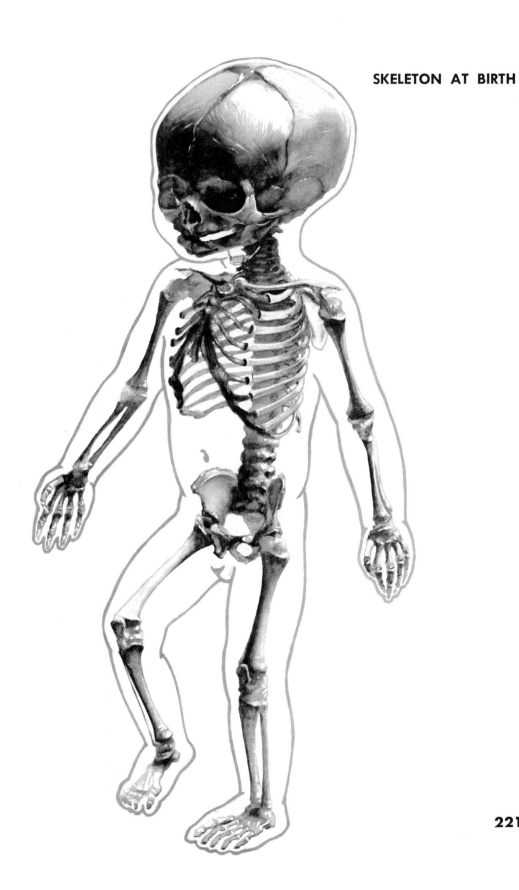

WRINKLES OF OLD AGE

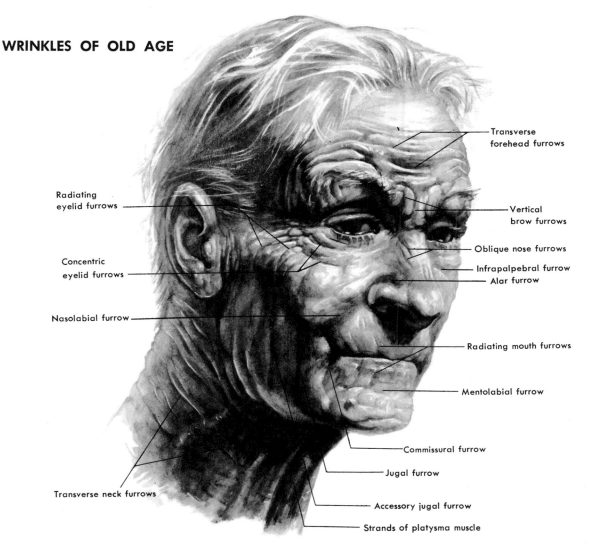

Radiating eyelid furrows

Concentric eyelid furrows

Nasolabial furrow

Transverse neck furrows

Transverse forehead furrows

Vertical brow furrows

Oblique nose furrows

Infrapalpebral furrow

Alar furrow

Radiating mouth furrows

Mentolabial furrow

Commissural furrow

Jugal furrow

Accessory jugal furrow

Strands of platysma muscle

Wrinkles of the skin appear with advanced years as the evidence of decreasing elasticity. The loosening of the skin, a result of continual distention and general wasting of flesh beneath, causes the flabby, superfluous tissue to crumple, wave-like, into folds along what were once mere lines of flexure. These lines are at right angles to the direction of muscle action—such as the vertical furrows between the eyebrows. Forehead wrinkles will take the horizontal arch of eyebrows, since muscular contraction is vertical. For the same reason, wrinkles of the eyelids will tend to repeat the eyelid contour. 'Crows' feet' wrinkles are produced by the compression of eyelid sphincters. And the swollen wrinkles below the lower eyelid will be governed by the pressure exerted by cheek muscles. Lips show an explosive pattern of creases, owing to the contraction of the elliptical sphincter of the mouth. Throughout much of the body the pattern of wrinkling resembles that for close-fitting clothes, and it is along such lines as these that the flesh will tend to 'set' as age progresses. The years must eventually leave their imprint on the very forms they helped to mold.

Nature's routine of reclaiming the lifeless body consists of a number of episodes, each of which represents submission to some force of nature. While the advances of this process may be conspicuous, the mere incidence of death itself is almost deceptive in its subtlety. The outstanding signal of the event is *immediate relaxation*. Muscular structures become flaccid; and each member of the body assumes, as best it may, the state of repose. Since both parties of an antagonist muscle group are now relaxed, it is only by virtue of their static connections that they exert any influence at all on a joint. The state of repose will therefore amount to an intermediate position between two extremes. The jaw will usually be partly open, although in the case of infants having no teeth the mouth will be closed. Elbows, wrists, fingers, ankles, and toes are prone to reach a position of semi-flexion. But any effect on shoulders, hips, and trunk in general will more likely be governed by the weight and position of those parts. Vanished is the subconscious concern for comfort of body and dignity of person that had before permeated even the slumber of life. The body is just a 'thing' utterly resigned to gravity. And so there follows a gravitation of blood that drains higher points to an ashen pallor and gorges lower regions to purple (a distinction rarely seen in cases of asphyxiation or high fever). The final beat of the heart has nearly cleared the arteries of blood, leaving veins more than ever salient and swollen. Eyelids are often closed in coma. But if instant death has been met in full consciousness (usually violent), the eyes may gaze fixedly into space (unclouded for a few hours).

Detail from *La Justice poursuivant le crime*—Pierre Prud'hon (1758-1823)

Courtesy Musée du Louvre, Paris

The fact that this body has collapsed here over the rocks, like a sack of meal, is the strongest evidence of its death. High thrust of hip and lowered head would not long be tolerable to a victim of less than mortal wounds. Note flexion of fingers and parted lips.

DISTINCTIONS OF SEX

The female is structurally homologous to the male in nearly every respect. Her distinctions are principally those of alignment, mass, and emphasis, as produced by *modification in the skeleton* and in the *deposition of fat*.[1] In a general way, the female figure displays more fluid contour. This is due largely to the greater quantity of fat, which serves to obscure muscular form.[2] In considering sexual differences, it should not be overlooked that the female figure is, as a rule, smaller absolutely than the male figure (excepting the hips), and is in some respects smaller proportionately. *Hair* is abundant in both sexes, but no appreciable growth is developed on the female face or breast—corresponding to the male beard and chest hair. The nest of pubic hair shows a distinct horizontal limit at the crest of the mons Veneris. Male pubic hair tends to converge upward into the abdominal hair stream, producing what has been called the 'masculine triangle.' General body hair (*lanugo*) of the female is more rudimentary throughout. The following summary is concerned mainly with skeletal traits. Female fat is discussed on page 226.

HEAD, NECK, AND SHOULDERS

The female *head* is proportionately small, although it is said to be relatively higher than the male. The forehead is smoother, more rounded, and is set more nearly perpendicular. *Brow ridges* are almost absent and with no special prominence at center above the nose. *Features* are a trifle smaller than in the male. The lips, while small, tend to be fuller. The *neck* appears more slender in proportion to adjacent regions, because of modifications in the shoulder development. The *collarbones* of the female are shorter and less curved than those of the male, and reduce the width of the *shoulders* in relation to trunk. While the male collarbones tend to rise laterally, the female bones are more often horizontal or even drop somewhat laterally. This increases the apparent length of the neck and departs from the squareness of male shoulders. A female neck is often seen to be encircled by creases of the skin (lines of flexure) called *rings of Venus* (see cut p. 179).[3] At the *throat*, the female shows a flattened thyroid cartilage (Adam's Apple) and a full thyroid gland. In the male throat, prominence is given rather to the sharply angled cartilage, while the gland is lean.[4]

[1] See also p. 193 (*Proportion*), pp. 218-19 (*Age*).
[2] Any slighter muscular development is a minor factor.
[3] Such lines of flexure are not uncommon on the male neck (see cut, p. 101); but they have not yet been honored with the name of Adonis!
[4] Cf. p. 101.

TRUNK

The *vertical midpoint* of the female figure is above the symphysis pubis, as contrasted to that of the male which lies at the pubic arch.[5] From this it may be deduced that the female *trunk* is longer in relation to total body height. There are also distinctions found in thorax and pelvis. The *thorax* is shorter and more conical, and displays outwardly the development of the *breasts* (male breasts are vestigial).[6] The *pelvis* is shorter but wider and deeper than the male pelvis, and its forward inclination is greater —in conjunction with a more arched *lumbar curve*.[7] The *sacrum* is broader, projects more behind, and forms a wider triangle at the surface. The triangle, however, is seldom depressed at the midline, as in most males. The dimples of the triangle are well marked, but *hollows of the loins* at the rear above iliac crests are concealed by fat. Owing to the lesser pelvic height, the iliac spines are nearer to the level of the pubic tubercles. Hence, the *inguinal ligaments* and their corresponding surface grooves, the *furrows of the groin,* do not run so steeply as the male grooves. Because of the increased pelvic diameters, hip joints and trochanters are both spread farther apart, thus giving the female *hips* their characteristic breadth. The broadest level of the lower trunk is not at the trochanter level, as found in the male, but just below the trochanters—corresponding to the *gluteal fold* of the buttocks. In consequence of the shorter female thorax and pelvis and the more extended interval between them, the *flanks* are longer. *Buttocks* reach to a lower level than in the male figure. The flesh of the *abdomen* is smoother and more rounded; and the *navel* is more deeply set.

EXTREMITIES

The *upper limb* of the female is shorter than that of the male, a circumstance due almost entirely to the relatively shorter humerus. Consequently, the level of the *elbow* is raised to a higher point at the trunk, and that of the *finger tips* to a higher point at the thigh. When the supine forearm (palm up) is extended, the angle at the elbow is seen to be more acute than that of the male elbow.[8] And hyperextension is the rule. *Wrist* and *hand* are small.

The *lower limb* is inclined to vary in proportion to the trunk, especially the leg. However, both thigh and leg in the female are shorter as related to the trunk. Owing to greater separation of thighbones at their pelvic sockets, the *thighs* take a more oblique course inward to the knees. This leads to a sharper angle between thigh and leg. *Knees* are more plump, but kneecaps and their ligaments are less conspicuous. And again, hyperextension is the rule. The *calves* are somewhat lower on the leg. The full outer contour seems to be the end of a long curve beginning at the waist. The inner calf contour is slight. *Ankles* tend to be rounder and less prominent. The *foot* is shorter and narrower.

[5] Cf. p. 60.
[6] Cf. p. 176.
[7] See also p. 64, *Distinctions of Female Pelvis.*
[8] Cf. p. 40 (*Flexion of the Elbow*).

FEMALE FAT

While a skeleton develops along certain lines that are recognizably male or female, its sexual traits are not departures in any structural sense. The most that can be observed is a shifting of emphasis in the proportional sense. In the same way, the layer of fat acquires significance. In spite of the constitutional variation of individuals, fat will seldom fail to provide a definitive emblem of sex after puberty, quite apart from the skeletal proportion. Nearly all major deposits (pp. 150-51) are especially augmented in the female.

Cervico-dorsal Fat [see p. 232: A, C]
 Transforms tendinous floor at center of trapezius muscle into low bulge disguising knobs of spine (Cervical VII, Thoracic I).

Post-deltoid Fat [see p. 232: A, B, C]
 Adds breadth to arm (front to rear) at level of deltoid insertion, increasing taper to elbow.

Mammary Fat [see p. 232: B, C, D; p. 233: A, D]
 Accounts for outer smoothness of breast; also blends (by *axillary tail,* pp. 176, 178) backward into axillary fat, seeming to anchor breast laterally on wall of chest; either hemispherical or conical form.

Flank Fat [see p. 232: C; p. 233: D]
 Will soften or conceal crest of hip, hollow of loin above crest, and iliac furrow; may leave anterior iliac spine depressed as dimple.

Abdominal Fat [see p. 232: B, C; p. 233: D]
 Envelops form of rectus abdominis muscles; gives roundness to abdominal region, especially below navel; rises to 'high tide' at navel, which is left deeply seated.

Pre-pubic Fat [see p. 233: A, D]
 Raises cushion at pubis, called *mons pubis* (also, 'mount of Venus').

Gluteal Fat [see p. 233: B, C]
 Lends special fullness to female buttock at inner border; also blends into flank fat above and thigh fat in front.

Subtrochanteric Fat [see p. 233: B, C, D]
 Establishes characteristic breadth of female hips somewhat below level of trochanters; fills upper end of groove between flexor and extensor muscles of thigh; may suggest a 'saddlebag' pocket; usually very prominent, but may be subordinated to flank fat.

Patellar Fat [see pp. 227, 230]
 Tends to confuse details of knee; may cause pronounced dimpling where skin adheres to deeper structures.

Popliteal Fat [see p. 233: B]
 Produces bulge between tendons at back of knee in full extension of leg.

NOTE: The individual shown opposite (and on pp. 228-31) demonstrates many of the typical features discussed on pages 224 and 225. The subject of female fat deposits is specifically illustrated by photographs on pages 232 and 233.

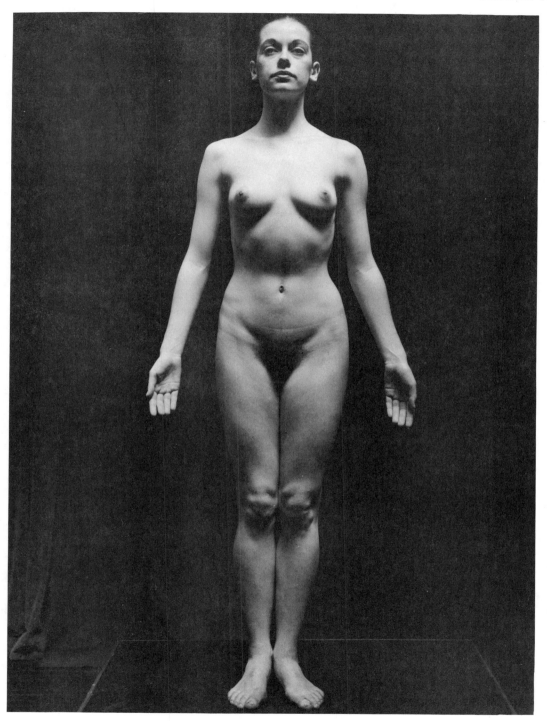

FIGURE 1

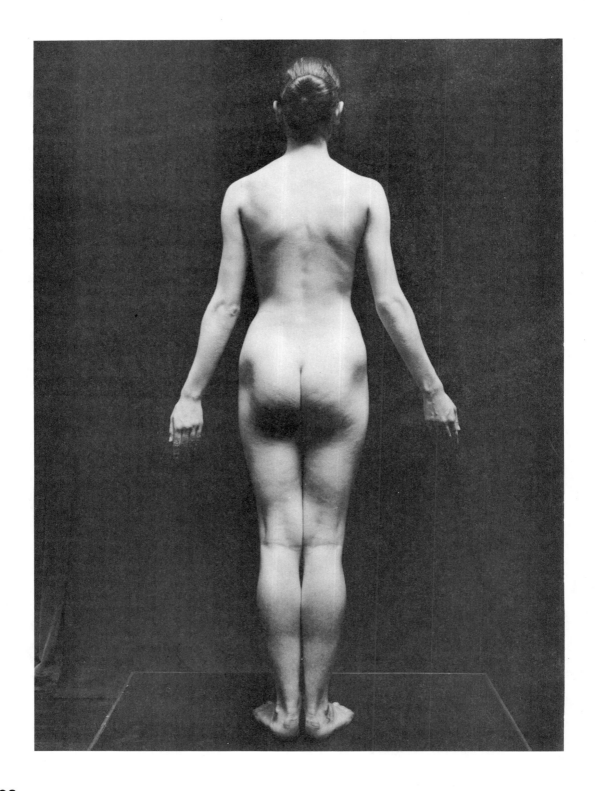

228 FIGURE 2

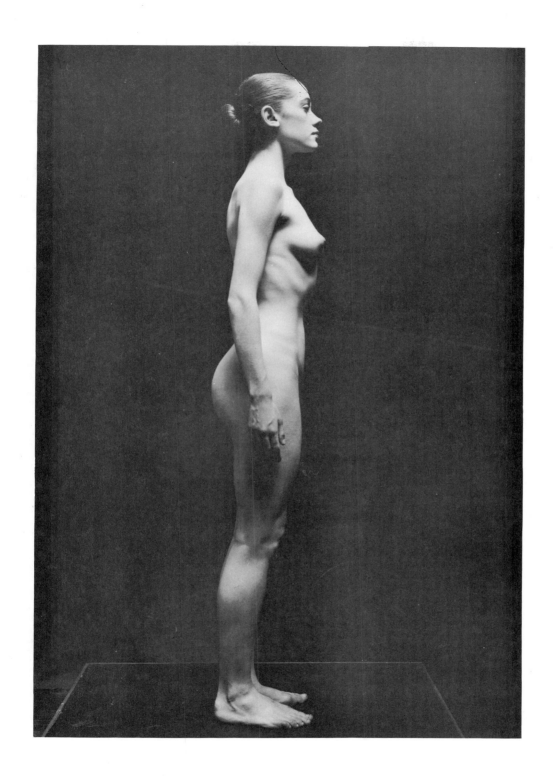

FIGURE 3

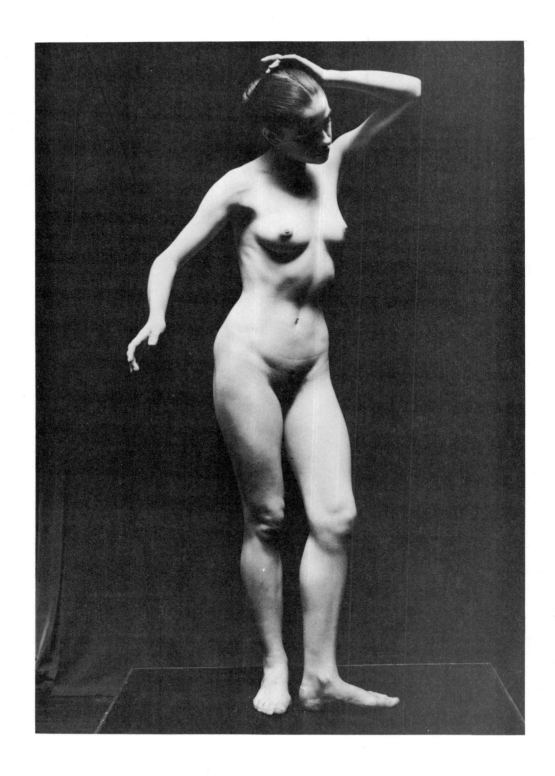

FIGURE 4

FIGURE 5

A

B

C

D

232

A

B

C

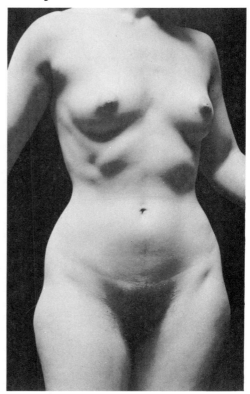

D

233

MALE FIGURE

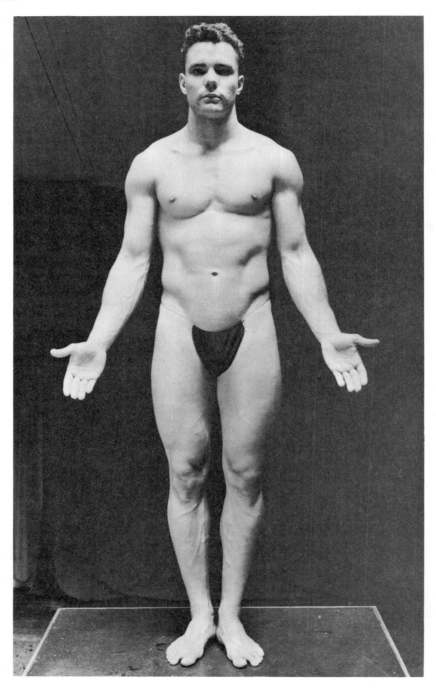

NOTE: The only important deviation of this individual from ideal male stereotypes is the general over-development of muscle, most pronounced in the upper half of the body.

234

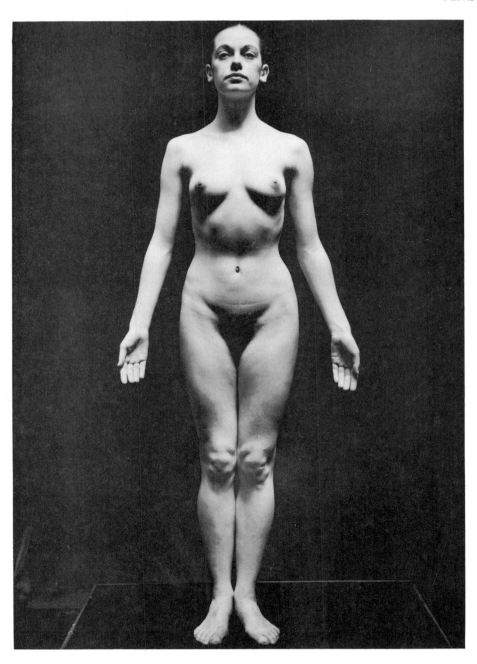

NOTE: The subject shown here might be said
to exhibit ideal female stereotypes, except for
the fragility of upper limbs, the slightness of
hips, and some want of fat.

235

DISTINCTIONS OF RACE

The external character of Man is found to be somewhat variable in respect to *color* and *conformation*. The particulars of variation are inherited and transmissible to his offspring; they tend to identify him as a member of a given human group. Collectively, they are the stamp of what we call *race*. But few human groups have remained isolated. Mixtures are far more numerous than pure types. An attempt to provide recipes for the artist, to link specific traits with specific human groups, would invite confusion in so limited a space as this. These pages intend only to present the essentials of such description as one will encounter in the literature of physical anthropology. A few generalizations concerning the *head* may well be mentioned here, to orient the student and guard against gross errors.

The races of mankind have been classified broadly according to *hair structure*. (1) *Lank hair:* nearly always black. This is a trait of most yellow-skinned and some brown-skinned peoples. (2) *Wavy or curly hair:* varies in color from pale flaxen to brown, black, and red. This type of hair is a trait of the so-called white-skinned peoples, and is shared also by some brown-skinned groups. (3) *Woolly hair:* nearly always black. This trait belongs almost exclusively to Negroid peoples. In this category, certain groups (viz. Hottentot, Bushman, and young Negroes) show a tufted 'peppercorn growth,' a variety of woolly hair that is very short and tightly spiraled. As we have seen, *skin color* is not everywhere correlated with hair structure, nor even with climate. One must look for the explanation of this in the history of Man's peregrinations about the earth.

A further basis for classification is the *shape of the cranium*. If the width is four fifths of the length, the individual is said to have a *broad head;* if it is three fourths or less, a *long head*.[1] There is little real correlation between hair structure and shape of head, since it is possible to find almost any head-shape combined with any one of the hair types. However, one observes that broadness of head tends to accompany the trait of lank hair, and length of head the trait of woolly hair. An intermediate head-shape is more often associated with wavy hair. *Protrusion of the lower face* (prognathism) is nearly always a mark of race. It is expressed in the degree of *facial angle* (Camper's angle) that is found at the intersection of a horizontal line through ear hole and base of nose, with an oblique line from forehead to upper front teeth (range: 62°-85°). As a rule, protrusion is most evident in the woolly-haired peoples, slight in lank-haired peoples, and in most cases absent in those with wavy hair. According to the degree of this muzzle protrusion, the face tends to be flatter and the nose broader and more depressed at its root; the nostrils tend to be wider and the teeth larger.

[1] The ratio is expressed numerically as the *cephalic index* by assuming length to be 100. Thus, an index of 81 would be that of a broad head (brachycephalic), one of 73 a long head (dolichocephalic), one of 78 a medium head (mesocephalic). The anthropologist logically measures length of head from front to rear. Only the initiated can know that when the artist speaks of 'head-length' he means head *height!*

Some millions of years ago, Man branched off from a stock of anthropoid primates and began his long journey into the Present. If this journey had taken place on a single highway of development, we should be tempted to explain racial differences figuratively in terms of 'distance traveled.' And this would tempt us further to chart the races of mankind as shading from apishness into non-apishness. As a matter of fact, many people do have this idea of a one-way progression upward from the primitive form. Yet it is no more possible to show a single continuity of human races than to show a single continuity for the many breeds of dogs. Let us rather consider the journey of mankind as a radiating movement on several roadways at once, as many roadways as there are breeding units. We need only to add here that breeding units are usually established as the result of geographical isolation. Indeed, the multiple-roadway idea may be taken almost literally! Thus we have concurrent but not necessarily identical differentiations from a common simian progenitor. This is the process of evolution—a process of becoming different. Man became different when he parted company with his cousins, the anthropoid apes, to specialize in the arched foot and other appointments for two-legged locomotion. The varieties of Man are, in turn, the evidence of lesser specializations that give rise to the categories of race. All races have been evolving—losing certain simian features while preserving others. But they have not been obliged to lose or preserve the *same* features. Each group seems to have a destiny of its own. It is not so much a matter of *which race* has evolved the most, as of whose *lips* or whose *brow ridges* or whose *hair* is most evolved. For example, the muzzle protrusion so common among blacks is an inheritance from simian ancestry; but this is lost in most whites—the face has sunk inward to leave nose and chin in high relief. The whites tend, instead, to preserve the bold brow ridges, the thin lips, and the hairiness of the animal prototype—traits that are less evident in most blacks.

The artist who is seriously concerned with racial portraiture should turn to anthropological description of the race in question. In addition to such comprehensive sources as the *Encyclopædia Britannica*, the following publications will go far in answering his inquiries.

REFERENCES*
Howells, W. W., *Mankind So Far* (Am. Mus. Nat. Hist. Science Series), Doubleday and Company, New York, 1944.
Coon, C. S., *The Races of Europe,* Macmillan, New York, 1939.
Seligman, C. G., *Races of Africa,* H. Holt, New York, 1930.
Buxton, L. H. D., *The Peoples of Asia,* A. Knopf, New York, 1925.
Keesing, F., *Native Peoples of the Pacific World,* Macmillan, New York, 1944.
Hodge, F. W., ed., *Handbook of the American Indians,* Bull. 30, Bur. Amer. Ethnol., Washington, D. C., 1907, 2 vols.
* List contributed by T. D. Stewart, Curator, Division of Physical Anthropology, Smithsonian Institution, U. S. National Museum.

TABLE OF RACIAL STOCKS
AND THEIR CHARACTERISTICS*

	WHITE	MONGOLOID	NEGRO	AUSTRALIAN ABORIGINES
SKIN	white	yellow, brown	dark brown	dark brown
EYES, HAIR	varied	dark brown, black	dark brown, black	dark brown, black
HAIR	straight, curly	straight	woolly	straight, curly
BODY HAIR	medium	none, slight	none, slight	medium
PROGNATHISM	none	slight	marked	marked
BROWS	medium	small	small	marked
FOREHEAD	sloping	upright	upright	very sloping
CHIN	projecting	medium	slight	receding
NOSE	high	low	flat	large, broad
LIPS	thin	medium	thick	medium

* From *Mankind So Far* by William Howells, copyright 1944 by Doubleday & Company, Inc.; reprinted herewith by permission of the publishers.

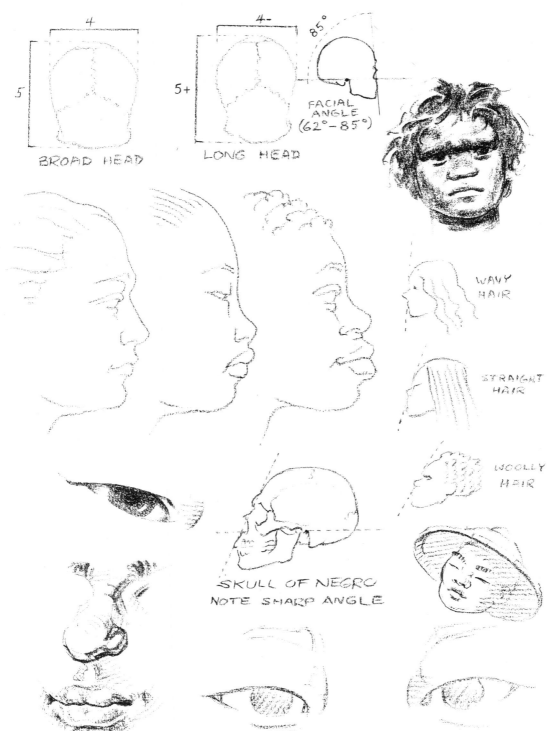

4

5

BROAD HEAD

4-

5+

85°

FACIAL ANGLE
(62° – 85°)

LONG HEAD

WAVY HAIR

STRAIGHT HAIR

WOOLLY HAIR

SKULL OF NEGRO
NOTE SHARP ANGLE

239

RACIAL TYPES

1. NORDIC FROM SWEDEN

2. MEDITERRANEAN FROM ITALY

3. DINARIC FROM SYRIA

4. SEMITIC FROM ARABIA

5. EAST INDIAN

6. GENERALIZED MONGOLOID
FROM MONGOLIA

7. SPECIALIZED MONGOLOID
FROM CHINA

8. ESKIMO

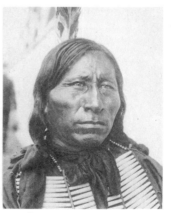

9. AMERICAN INDIAN
(BLACKFOOT TRIBE)

Photographs courtesy of (1) Swedish Travel Information Bureau, Inc.; (2, 3) C. S. Coon, *The Races of Europe*, by permission of The Macmillan Company, publishers; (4-9) American Museum of Natural History.

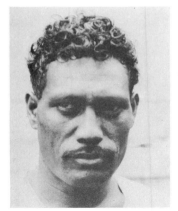

10. POLYNESIAN

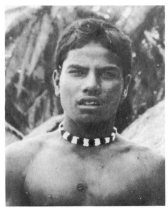

11. MICRONESIAN
FROM GILBERT ISLS.

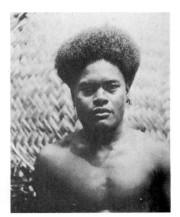

12. MELANESIAN
FROM SOLOMON ISLS.

13. AUSTRALIAN BLACK

14. NATIVE OF NEW GUINEA

15. MALAYAN FROM SUMATRA

16. BUSHMAN (front)

17. BUSHMAN (side)

18. AFRICAN NEGRO
FROM BELGIAN CONGO

Courtesy of American Museum of Natural History. Photograph no. 14 by M. J. Leahy, no. 15 by Claire Holt.

Part VII

AGENTS

OF

EXPRESSION

*To seize it only approximately is to miss it
and to represent only those false people
whose study it is to counterfeit sentiments
which they do not experience.*

—Ingres

AGENTS OF EXPRESSION[1]

Perhaps the most ambiguous and, at times, the most subtle and fleeting aspect of the human figure is its technique of communicating the various moods. Basic expressions are easily recognized, and are associated with the most fundamental feelings—pleasure, displeasure, pain, and fear. Certain others are the modifications or hybrids of basic expressions, such as eagerness and indignation. Many so-called 'expressions' exist only in the mind of the observer, and for their comprehension rely on accessories or a knowledge of circumstances. Among the imagined expressions are those of envy, longing, guilt, and jealousy. Conscious restraint and falsification are factors hindering the play of expression; but where a subject is unconcerned with appearance, the mechanisms that shape his countenance will, to a fair extent, betray his inner feelings.

For the most part, trunk and limbs behave grossly. Their stance and gesture are a chorus to the sensitive drama of the face. We must limit ourselves here to facial attitudes. These are delicate and often nebulous, and they warrant close attention. Elsewhere throughout the body, the specific form of muscles and tendons at the surface largely determines that surface. Facial muscles are indistinct. It is not shape itself so much as consequence of action that is detectable. Most of the facial muscles, taken singly, give only a mild performance. Extreme stretching and folding about the face is explained by the fact that muscular insertions are close to the skin. The slightest twitch may deepen a furrow or raise a wrinkle. Eyes, nose, and mouth, since they are functional centers, are the centers of muscular action. Not only is each center equipped for its own functions, but it may also serve as anchorage for muscular slips acting on another center. Thus, action about one center may involve action about another. To test this, the reader has only to close one eye very tightly. He will discover here the accessory movement of raising the corresponding corner of his mouth.

SYMPATHETIC FACIAL ACTIVITY

When one is intent upon his own or another's physical performance, there is a tendency to 'help the act along.' Cutting with shears may induce clenching of teeth, just as threading a needle may point the lips. Consider how the face behaves when one is wringing out a heavy wet towel, or is reaching to a high shelf. This reinforcement from the face conveys nothing of the spirit, although it accounts for innumerable contortions that accompany our work and play.

[1] For diagram of facial muscles: see p. 257; for tables of origin, insertion, and action: see pp. 92-5.

DARWIN'S THREE PRINCIPLES

Charles Darwin attacked the notion, current in his day among fellow naturalists, that expression devices had originated as such. He argued that many of these devices are actually serviceable or are the remnants of serviceable devices evolved from lower forms of life, a conclusion he supported with impressive evidence. Much of our facial behavior is based on this—Darwin's principle of *serviceable associated habits.* Another principle, *antithesis,* we may all but ignore.[2] Darwin himself could muster only a few examples, and these have little to do with facial response. He does, however, account for many aspects of expression by his principle of *direct action of the nervous system.* He refers to trembling of muscles, pounding of the heart, pallor, blush, redness, and perspiration. Even purposeless muscular activity may be included when it offers relief from tension. Here, for example, is the chief expression of pain—the agonized grin, the restless turning of eyeballs. And here is the sign of great mental distress, with wringing of hands, and so on. The entire subject of expression becomes lucid and reasonable in the light of these principles. A reading of Darwin's important discourse on the subject should give the artist a reliable grasp on what may otherwise forever elude him.[3] In the discussions that follow, I lean heavily on Darwin's work.

VIOLENT EXPIRATION

The acts of violent expiration include a cough, sneeze, yawn, scream, shout, loud laughter, and retching. Not only will the mouth have to be widely opened, but also the eyelids must be firmly and forcibly closed. This is required momentarily in order to reduce the danger of rupture in small blood vessels of the eye.[4] The serviceable attitude of 'squeezed-shut' eyes is the root of many expressions. Tears may accompany any of the acts of violent expiration.

SCREAMING

Forcible closure of the eyes begins in infancy with all the elements necessary for a scream to attract attention—the mouth squared with depressed lower lip, the upper lip raised by contraction of muscles around the eyes. Through childhood the scream becomes inhibited, but its elements linger on in the 'pout.' The center part of the forehead muscle contracts to raise the eyebrows obliquely—an effort to check contraction of muscles around the eye (thus, to check a screaming fit). Retractors for the corners of the mouth remain active even though the mouth is kept closed. The adult cannot entirely overcome the formation of this infantile facial pattern for screaming. Oblique eyebrows and depressed corners of the mouth still prevail in expressions of dejection, apprehension, vexation, and so on.

TEARS

The shedding of tears is a serviceable habit related to strain of the eyeball in violent expiration. It is acquired usually between the second and fourth month. Thereafter, tears tend to be associated with most attitudes that either are in themselves violent expiration or are derived from the scream of infancy. The adult can more or less control the shedding of tears. But he cannot so easily suppress their appearance

[2] For an example of *antithesis,* see p. 246 (*Laughing*).
[3] Charles Darwin, *The Expression of the Emotions in Man and Animals,* D. Appleton and Company, New York, 1897.
[4] Possibly explaining the familiar *Gesundheit* addressed to a sneezer!

245

('watering' of the eyes) at times of grief, despair, and tender joy. Flooding of the eye with tears will blur its detail and cause the surface to glisten. A puddle may develop on the rim of the lower eyelid, soaking lashes and drawing them into sheaves. If tears are plentiful, they will break over the rim at its lowermost level. Violent or prolonged weeping will be accompanied by congestion of the blood vessels on the white of the eye, a condition described as 'bloodshot.'

FROWNING AND SQUINTING

Since the first step toward screaming is a contraction of the brows, this frown may recur whenever something unpleasant or difficult is encountered. It may be that the difficulty is purely intellectual, as in one's effort to follow a train of thought or comprehend an idea – hence, 'knitting' of the eyebrows. However, the attitude of contracted brows, together with squinting, can be directly serviceable in shielding the eyes from a glare of light or from a pelting rain, thereby allowing eyes to remain open. The contraction of these muscles around the eyes automatically induces the accessory pattern of raised corners of the mouth. About the only thing that will prevent a sunny-day grin or a rainy-day grin is a broad-brimmed hat! Yawning involves frowning and squinting, and so exhibits a transverse crease at the top of the nose. But the required maximum lowering of the jaw impedes any raising of the corners of the mouth.

LAUGHING

Laughter intends to communicate by sound a state of feelings contrary to those of distress. Since the G-R-O-A-N of agony and the call for H-E-L-P are prolonged cries, the sound of laughter must be recognizably the opposite – a series of short, staccato cackles. Here is one of the few instances of antithesis. However, while loud laughter may convey a jovial spirit, it is still an act of violent expiration threatening the eyes. Like a scream, it requires firm closure of eyelids, but the lack of any real urgency to be heard finds inactive the depressor muscles for corners of the mouth. Instead, the corners will be retracted upward, drawn by the action of compressor muscles around the eyes. A smile is the remnant of a laugh, or a preparation for one.

RETCHING

If the reader will open his mouth part way, raise the upper lip high, and protrude the tongue, he will have combined most of the facial elements necessary for retching. Actual retching would demand that eyes be momentarily and forcibly closed, because violent expiration must help in the process of vomiting. The attitude described above will therefore be augmented by contracted brows and perhaps a squinting of eyes. It is interesting that certain feelings of disgust give rise to this same preparation for vomiting. The explanation lies in our strong association of the sight of food (perhaps any organic matter) with the prospect of eating it. Most of us will raise the upper lip in this way at the unusual appearance of decaying food. But the facial pattern occurs also as a conscious device to indicate to someone that he is as repulsive as bad food, that he cannot be 'stomached'! Children frequently 'stick out the tongue,' whereas most adults will only begin the expression by lifting the upper lip. But this

is enough to warrant the description of a countenance as bitter or sour.

SNARLING

A snarl consists of curling up one side of the upper lip, and it is instantly translated as an expression of scorn, contempt, or defiance. It is usually shown when eyes are directed straight at the object of contempt. The lip will most often be curled on the side of the offender. The pattern becomes a sardonic or half smile when the other side of the mouth is retracted. In this way, one shows that he considers his offender insignificant, that the fellow provokes only amusement. Defiance is usually accompanied by surly language. The snarl is regarded as a vestige of preparation for attack with the teeth—curling the upper lip to expose the canine tooth. Man's canine is hardly a gashing tooth; but in the dim past of animal descent, the canines of his progenitors were in all likelihood large and fiercely pointed, and therefore to be dreaded.

BARING OF TEETH

Teeth have only the purpose of tearing, snipping, and crunching. To uncover all the teeth is to threaten to use them, to indicate in a beast-like way that one is dangerously enraged and should be feared. Retraction of muscles around the mouth will bare the teeth and may approach a grin, but it is likely to be a cruel or contemptuous grin. Eversion (rolling out) of the lips suggests that retching is induced, that anger is combined with disgust. Exhibition of teeth will often be accompanied by retraction of the ears. Any animal that fights with the teeth (or whose progenitors once did so) will draw back its vulnerable ears in attack, to protect them from its foe.

CIRCULATION OF BLOOD

The circulation of blood is affected by emotions that unbalance a person and deprive him of control. Restricted breathing will impede the circulation, causing blood to stagnate and swell the vessels. *Redness* of the skin is a patent feature of rage, which is the active expression of hatred. Where the eye would be brightened by a quickened circulation, in great rage it may even become 'bloodshot' from the congestion of blood. On exposure to attention (praise, ridicule, and so on) a *blush* may accompany the feelings of embarrassment, shame, and confusion. It amounts to a heightening of color—beginning in the cheeks, then overspreading the forehead, ears, and neck. Blushing is generally accompanied by perspiration. *Pallor* of the skin is seen when blood withdraws from the surface, usually in a disagreeable situation one would sorely like to escape. Fear and horror commonly betray themselves by skin that is chill and blanched.

RESPIRATION

When one expects to fight or in any way to exert violent physical effort, the intake of air must be immediately increased. If the subject intends to appear composed prior to action, he will close the mouth firmly and breathe heavily through dilated nostrils. On the other hand, where appearance is unimportant, the mouth is apt to be moderately open. This makes for greater ease and rapidity when breathing is labored (as in terror and horror). At the same time, an open mouth allows breathing to be silent

247

when the very sound of nasal breathing might be a 'give-away' or might interfere with the accurate register of another sound.[5]

PERSPIRATION

At times of embarrassment, pain, and fear, or in any heated condition, the pores of the skin may discharge visible 'beads' of sweat that merge with each other into a streaming film. Parts of the head especially subject to sweating are the forehead and upper lip.

BRISTLING OF HAIR

An enraged dog will bristle its coat of hair in order to appear large and terrible. Birds ruffle their feathers to provide better insulation in cold weather. Probably linked to this phenomenon is Man's involuntary but utterly useless response of hair 'standing on end.' In fright or rage, or in a state of chill, the hairs of the body may be drawn upright from their sloping position, owing to contraction of minute muscles associated with the hair follicles. 'Goose flesh' refers, in general, to hairy parts of the skin when hair follicles are conspicuously raised.

RAISED EYEBROWS

We speak of 'raised eyebrows' as a synonym for real or pretended surprise. The function of this movement of brows is to remove all obstructions to the field of vision by drawing away from the eye its overhanging flesh—the upper lid as well as the brow itself. (Consider the effort in drowsiness to keep eyes open.) When one attempts to recall a forgotten name or is confronted by something he cannot immediately grasp in his mind (visualize), he is apt to make this involuntary effort to 'see better.' One who is alarmed will drop the mouth open for immediate intake of air (gasp). If only the inner ends of brows are raised, the attitude is called 'oblique eyebrows.' This derives from the countenance of screaming and suggests depressed spirits. Upper eyelids droop rather than rise. Such a pattern in the upper face may be the sole expression of pity. Combined with a trace of smile, it would be recognized as compassion.

RACE AND EXPRESSION

While facial attitudes vary markedly among individuals, they seem also to vary with habitat and racial stock. A noteworthy distinction between white and Negro stocks has been described in the racial studies of Ernst Huber.[6] This investigator has found that Negro facial muscles are more coarsely bundled, more powerful, and more extensive. He has shown further that they blend more, one with another. Such a musculature would, according to Huber, account for the sudden unmodulated expressions characteristic of the Negro—his expansive grin, his wide-eyed amazement.

•

The study of facial expression in living subjects has its problems for even the keenest observer. Remaining objective is essential, yet often impossible when an emotional situation exists. There is wisdom, if not a fearful challenge, in the counsel of

[5] The exact opposite is the case with dogs. The various Orders (and even Families) of Mammals differ, one from another, in methods of attack, defense, et cetera. We cannot expect to find universally similar attitudes.

[6] *Evolution of Facial Musculature and Facial Expression*, Baltimore, 1931.

Leonardo when he said: 'Try to be a calm spectator of how people laugh and weep, hate and love, blanch from horror and cry out in pain; look, learn, investigate, observe, in order that thou mayst come to know the expression of all human emotions.'[7]

[7] Translation by B. G. Guerney from Dmitri Merejkowski, *The Romance of Leonardo da Vinci*, Random House, Inc., New York, 1931; by permission of the publishers.

FACIAL EXPRESSIONS FROM LIFE—

(1) PLEASURE, (2) TERROR [photograph made only seconds before the man dropped dead], (3) SCREAMING, (4) SNARLING, (5) YAWNING, (6) SURPRISE, (7) PAIN complicated by ANXIETY.

Photo no. 3 by Constance Bannister. Reprinted from *The Baby*, copyright 1950 by Simon and Schuster, Inc., New York; also by permission of Hamish Hamilton, Ltd., London. All others are Acme Photos.

The EYEBROWS

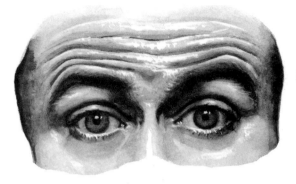

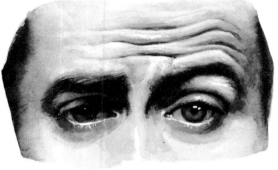

ELEVATION OF EYEBROWS
AGENT: Frontal part of epicranius.
Long, transverse folds above brows indicate desire to remove obstructions (physical or mental) to clear vision (comprehension).

ELEVATION OF ONE EYEBROW
AGENTS: Frontal part of epicranius (one side), corrugator.
One-sided wrinkling of forehead similar in motivation to raising of both brows but suggests reserve, element of doubt, or attempt to recall.

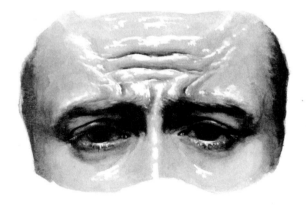

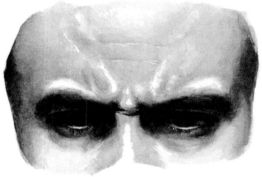

ELEVATION OF INNER ENDS OF EYEBROWS
AGENTS: Frontal part of epicranius (center fibers), corrugator.
Vestige of attempt to check crying fit is perceived in ⊓-shaped puckering at center of forehead.

OBSERVATIONS—*Brow glides freely up and down, except outer end, which seems to be fixed. Upper eyelid round and full under raised eyebrow; when brow is lowered, it may conceal center part of lid and give angular shape to eye.*

DEPRESSION AND CONTRACTION OF EYEBROWS
AGENTS: Corrugator, procerus, orbicularis oculi.
Encounter of difficulty is usually felt in 'knitting' of eyebrows over nose—effort to follow visually or mentally.

Bridge of nose long, narrow, and smooth when eyebrows are raised; widened and creased when they are lowered. Eyes pale and clear when brows rise to admit light; dark and obscure when shaded by lowered brows.

ELEVATION OF UPPER EYELID

AGENT: Levator palpebræ.

Full exposure of iris (color ring) is common response to the unexpected; endeavor to promote clear vision, usually with raised eyebrows.

DEPRESSION OF UPPER EYELID

AGENT: Orbicularis oculi.

Drooping eyelids show detachment from environment; combined with raised eyebrows when fighting off sleep.

COMPRESSION OF BOTH EYELIDS

AGENTS: Orbicularis oculi, corrugator, procerus.

Familiar 'crow's feet' wrinkles are pushed up when eyelids squeeze together to shut out bright light or to protect eyeball, as in laughing or crying.

OBSERVATIONS—*Expression about eye regulated by degree of exposure of both eyeball and upper lid, and by whatever forms (brow, cheek) may press toward eye. Brow may be drawn upward and inward across outer end of upper eyelid, or may push forcibly downward and inward across*

ELEVATION OF WINGS OF NOSE

AGENTS: Quadratus labii superioris (esp. angular head), procerus.

Nose is drawn up into thin sharp ridges, creasing between brows, when face prepares for violent expiration (see p. 245) or when raising upper lip to retch.

inner end of lid. Movement of lower eyelid negligible. When exposed to strong light, eye is pale and sharply defined, with small pupil. In subdued light, eye becomes dark and soft, with large pupil.

251

The CORNERS OF THE MOUTH

RETRACTION OF CORNERS
OF MOUTH

AGENTS: Buccinator, risorius, triangularis,
platysma.

A closed mouth drawn against teeth in-
sures holding of breath for physical effort,
often restraint of speech; suggests resolve
or firmness of mind.

ELEVATION OF CORNERS OF MOUTH
AGENTS: Zygomaticus, quadratus labii su-
perioris (esp. zygomatic head), caninus.
The V-shaped smile raises lower face, gen-
erally to signify an agreeable frame of mind;
antithesis of distressed mouth.

DEPRESSION OF CORNERS
OF MOUTH

AGENTS: Triangularis, platysma, quadratus
labii inferioris, mentalis.
A drooping mouth tells of encountering
some obstacle or unpleasantness; a vestige
of preparation for screaming.

OBSERVATIONS—*Chin puckered, resembles small
pillow. Conspicuous folds and dimples ac-
company movement of closed mouth. Pillars
arise from fullness of cheeks and join below
mouth, appearing as continuous cord. Smiling*

*mouth shows 'cord' as if caught under pillow
of chin — taut lines accentuating V pattern.
Drooping mouth has 'cord' lying above chin and
hooked under corners of mouth.*

252

OPENING OF MOUTH

AGENTS: [jaw depression] digastric (anterior belly), mylohyoid; [lip retraction] all muscles inserting into orbicularis oris (which contracts only enough to govern shape of aperture).

In astonishment or when vocalizing or yawning, mouth gapes wide—heart-shaped —to draw deep breath more quickly.

UPWARD RETRACTION OF OPEN MOUTH

AGENTS: Buccinator, risorius, zygomaticus, quadratus labii superioris, caninus.

If frame of mind is agreeable, mouth may be opened and raised into a semicircle; preparation for uttering laughter—antithesis of distress call.

OBSERVATIONS—*Lower teeth seldom conspicuous except in feelings of aversion. Nostrils tend to rise and dilate when upper lip is raised, to glide down and compress when lip is lowered.*

DOWNWARD RETRACTION OF OPEN MOUTH

AGENTS: Buccinator, risorius, triangularis, quadratus labii inferioris, platysma, mentalis.

Mouth opens downward and becomes angular, with straight, everted lips to prepare for sounds of screaming.

Upper cheek well defined only when corners of mouth are raised. Form of chin comparatively smooth when mouth is opened.

253

PARTING OF LIPS

AGENT: Orbicularis oris (relaxing).
Uncertainty or helplessness is indicated when lips are loosely parted; in contrast to firm closure of determination.

COMPRESSION OF LIPS

AGENTS: Orbicularis oris, slight use of all other muscles inserting into it.
Squeezing of lips is a sign of determined restraint.

OBSERVATIONS—*Tubercle of upper lip shrivels in compressed lips, predominates in pursed lips. Upper lip remains comparatively smooth when*

PURSING OF LIPS

AGENT: Orbicularis oris.
Apprehension, scheming, or mere disinclination to speak may be betrayed by tightly screwed lips; effort to restrain speech.

twisted about; lower lip subject to knottiness. Both lips wrinkle when contracted.

254

ELEVATION OF UPPER LIP
AGENT: Quadratus labii superioris (esp. angular head).
Raising of upper lip follows perception of something offensive, indicates that retching is induced.

CURLING OF UPPER LIP
AGENTS: Quadratus labii superioris (esp. infraorbital and zygomatic heads), zygomaticus.
A snarl presages the fight, defiantly lifting one side of upper lip to display canine tooth —dangerous weapon of Man's progenitors.

EVERSION OF LOWER LIP
AGENTS: Quadratus labii inferioris, mentalis, orbicularis oris.
Rolling out of lower lip is associated with real or pretended seriousness and with partly inhibited feelings of grief.

PROTRUSION OF BOTH LIPS
AGENTS: Orbicularis oris, mentalis.
Related to the making of appropriate sound, this shape of mouth may be cue to state of enraged rancor.

OBSERVATIONS—*Nasolabial furrow and creases below eyelid sharp when pushed up by upper lip. Mentolabial furrow sharp under pressure of lower lip; accentuates rounded pillars from jaw to lower lip. Nostrils expand with sharp naso-* *labial furrow, contract with protrusion of upper lip. Lower lip full and smooth when rolled outward, thinner and corrugated when stiffly projected outward.*

255

STRAINING OF NECK

AGENT: Platysma.

Drawn into long, fine ridges, neck signals violent strain; tension here may be regarded as sympathetic[1]—associated with physical effort—or it may, in exhaustion, insure open mouth for ease of breathing.

[1] See p. 244.

OBSERVATIONS—*Tight muscular ribbons fan from jaw to shoulder, at either side of throat. Lips often parted, drawn to the side and downward, exposing lower teeth. Skin wrinkled below jaw. Sternomastoid muscles largely obscured.*

256

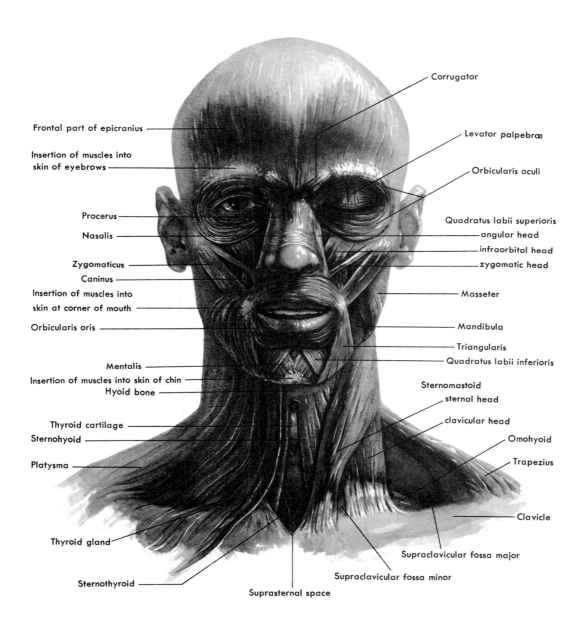

Corrugator

Frontal part of epicranius

Insertion of muscles into skin of eyebrows

Levator palpebræ

Orbicularis oculi

Procerus

Nasalis

Quadratus labii superioris

angular head

infraorbital head

zygomatic head

Zygomaticus

Caninus

Insertion of muscles into skin at corner of mouth

Orbicularis oris

Masseter

Mandibula

Triangularis

Quadratus labii inferioris

Mentalis

Insertion of muscles into skin of chin

Hyoid bone

Sternomastoid

sternal head

clavicular head

Thyroid cartilage

Sternohyoid

Omohyoid

Platysma

Trapezius

Clavicle

Thyroid gland

Supraclavicular fossa major

Supraclavicular fossa minor

Sternothyroid

Suprasternal space

N.B. For tables of origin, insertion, and action: see pp. 92-5.

257

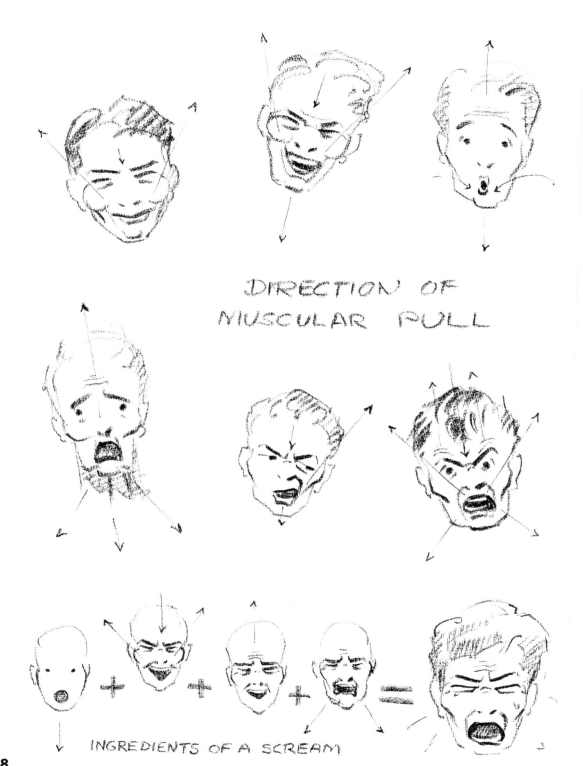

DIRECTION OF
MUSCULAR PULL

INGREDIENTS OF A SCREAM

258

259

PRONUNCIATION OF TERMS

KEY: lāte, găs, färm, sodà; bē, ĕdge, hẽr; fīve, pĭn;
cōne, stŏp, wôrn, tōol; mūte, gŭn, bûrn.
ʹ = main accent ʺ = secondary accent

N.B. Some compound terms, not listed, can be as-
sembled thus: corac(ō) — brachi(ālĭs).

a

abdomen	ăb-dō′mĕn	caruncula	kà-rŭng′kū-là
acetabulum	ăsʺĕ-tăb′ū-lŭm	cephalic	sĕ-făl′ĭk
Achilles	à-kĭl′ēz	cervical	sûr′vĭ-kăl
acromion	à-krō′mĭ-ŏn	clavicular	klă-vĭk′ū-lẽr
ala	ā′là	coccyx	kŏk′sĭks
anconeus	ăngʺkō-nē′ŭs	communis	kŏ-mū′nĭs
annular	ăn′ū-lẽr	concha	kŏng′kà
aponeurosis	ăpʺō-nū-rō′sĭs	condylar	kŏn′dĭ-lẽr
areola	à-rē′ō-là	condyle	kŏn′dĭl
aspera	ăs′pẽr-à	conjunctiva	kŏnʺjŭngk-tī′và
auscultation	ôsʺkŭl-tā′shŭn	coracoid	kŏr′à-koid
axilla	ăk-sĭl′à	cornea	kŏr′nē-à
axillary	ăk′sĭ-lẽrʺĭ	cornu	kŏr′nū

b

		coronoid	kŏr′ō-noid
basilic	bà-sĭl′ĭk	costal	kŏs′tăl
biceps	bī′sĕps	coxæ	kŏk′sē
bicipital	bī-sĭp′ĭ-tăl	cubital	kū′bĭ-tăl
brachial	brā′kĭ-ăl	cuneiform	kū-nē′ĭ-fôrm
brachycephalic	brăkʺĭ-sĕ-făl′ĭk		
brevis	brē′vĭs	**d**	
buccal	bŭk′ăl	digastric	dī-găs′trĭk
buccinator	bŭk′sĭ-nāʺtẽr	digitorum	dĭjʺĭ-tō′rŭm
		dolichocephalic	dŏlʺĭ-kō-sĕ-făl′ĭk

c

		e	
calcaneus	kăl-kā′nē-ŭs	epicranius	ĕpʺĭ-krā′nĭ-ŭs
caninus	kà-nī′nŭs	epigastric	ĕpʺĭ-găs′trĭk
capitulum	kà-pĭt′ū-lŭm		

261

f

facet	făs′ĕt
fascia	făsh′ĭ-à
femur	fē′mĕr
fibula	fĭb′ū-là
foramen	fō-rā′mĕn
fossa	fŏs′à
frontalis	frŏn-tā′lĭs

g

gastrocnemius	găs″trŏk-nē′mĭ-ŭs
glabella	glà-bĕl′à
glenoid	glē′noid
gluteus	glo͞o-tē′ŭs
gracilis	grăs′ĭ-lĭs

h

hallucis	hăl′ŭ-sĭs
helix	hē′lĭks
humerus	hū′mĕr-ŭs
hyoid	hī′oid
hypothenar	hī-pŏth′ē-nĕr

i

iliacus	ĭ-lī′ă-kŭs
ilium	ĭl′ĭ-ŭm
incisor	ĭn-sī′zĕr
indicis	ĭn′dĭ-sĭs
inguinal	ĭng′gwĭ-năl
intertragical	ĭn″tĕr-trā′jĭ-kăl
ischium	ĭs′kĭ-ŭm

j

jugular	jŭg′ū-lĕr

l

labii	lā′bĭ-ī
lacrimal	lăk′rĭ-măl
lanugo	là-nū′gō
larynx	lăr′ĭngks
lateralis	lăt″ĕ-rā′lĭs
latissimus	là-tĭs′ĭ-mŭs
levator	lē-vā′tĕr
linea	lĭn′ē-à
lunula	lū′nū-là

m

malleolus	mă-lē′ō-lŭs
mandibula	măn-dĭb′ū-là

manubrium	mà-nū′brĭ-ŭm
masseter	mă-sē′tĕr
mastoid	măs′toid
maxilla	măk-sĭl′à
meatus	mē-ā′tŭs
medialis	mē′dĭ-ā′lĭs
mentalis	mĕn-tā′lĭs
menti	mĕn′tī
mentolabial	mĕn″tō-lā′bĭ-ăl
mesocephalic	mĕs″ō-sĕ-făl′ĭk
molar	mō′lĕr
mons Veneris	mŏnz vĕn′ĕr-ĭs

n

nasalis	nā-sā′lĭs
nasolabial	nā″zō-lā′bĭ-ăl
navicular	nà-vĭk′ū-lĕr
nuchal	nū′kăl

o

obturator	ŏb′tū-rā″tĕr
occipital	ŏk-sĭp′ĭ-tăl
occipitalis	ŏk-sĭp″ĭ-tā′lĭs
oculi	ŏk′ū-lī
olecranon	ō-lĕk′rà-nŏn
omo-	ō′mō
opponens	ŏ-pō′nĕnz
orbicularis	ôr-bĭk″ū-lā′rĭs
orbital	ôr′bĭ-tăl
oris	ō′rĭs
os	ŏs
osseous	ŏs′ē-ŭs

p

palmaris	păl-mā′rĭs
palpebra	păl′pē-brà
parietal	pà-rī′ĕ-tăl
patella	pà-tĕl′à
pectineus	pĕk-tĭ′nē-ŭs
pectoralis	pĕk″tō-rā′lĭs
peroneus	pĕr″ō-nē′ŭs
phalanges	fà-lăn′jēz
phalanx	fā′lăngks
philtrum	fĭl′trŭm
pisiform	pī′sĭ-fôrm
plantaris	plăn-tā′rĭs

platysma	plà-tĭz′mà
pollicis	pŏl′ĭ-sĭs
popliteal	pŏp″lĭ-tē′ăl
procerus	prō-sē′rŭs
prognathism	prŏg′nà-thĭzm
prominens	prŏm′ĭ-nĕnz
pronator	prō-nā′tēr
proximal	prŏk′sĭ-măl
psoas	sō′ăs
pubis	pū′bĭs

q

quadratus	kwŏd-rā′tŭs
quadriceps	kwŏd′rĭ-sĕps

r

radialis	rā″dĭ-ā′lĭs
ramus	rā′mŭs
rete	rē′tē
rhomboid	rŏm′boid
risorius	rĭ-sō′rĭ-ŭs

s

sacro-	sā′krō
sacrum	sā′krŭm
saphenous	sà-fē′nŭs
sartorius	sär-tō′rĭ-ŭs
scalenus	skā-lē′nŭs
scapha	skā′fà
scapula	skăp′ū-là
sciatic	sī-ăt′ĭk
sclera	sklē′rà
semimembranosus	sĕm″ĭ-mĕm″brà-nō′sŭs
semitendinosus	sĕm″ĭ-tĕn″dĭ-nō′sŭs
serratus	sĕ-rā′tŭs
sesamoid	sĕs′à-moid
soleus	sō′lē-ŭs
sphenoid	sfē′noid
sphincter	sfĭngk′tēr
spinalis	spī-nā′lĭs
spinatus	spī-nā′tŭs

splenius	splē′nĭ-ŭs
styloid	stī′loid
subtrochanteric	sŭb″trō-kăn-tĕr′ĭk
superciliary	sū″pĕr-sĭl′ĭ-ĕr-ĭ
supinator	sū″pĭ-nā′tēr
suture	sū′tūr
symphysis	sĭm′fĭ-sĭs
synergist	sĭn′ĕr-jĭst

t

tabatière	tà-bà-tyār′
talus	tā′lŭs
temporal	tĕm′pō-răl
temporalis	tĕm″pō-rā′lĭs
teres	tē′rēz
tertius	tûr′shĭ-ŭs
thenar	thē′när
thoracic	thō-răs′ĭk
thyroid	thī′roid
tragus	trā′gŭs
trapezius	trà-pē′zĭ-ŭs
triceps	trī′sĕps
triquetrum	trī-kwē′trŭm
trochanter	trō-kăn′tēr
trochlea	trŏk′lē-à
tubercular	tū-bûr′kū-lēr

u

ulnaris	ŭl-nā′rĭs
umbilicus	ŭm-bĭl′ĭ-kŭs

v

vastus	văs′tŭs
venous	vē′nŭs
vertebra	vûr′tē-brà
vertebral	vûr′tē-brăl
vomer	vō′mēr

x

xiphoid	zĭf′oid

z

zygomatic	zī″gō-măt′ĭk

Italic numbers indicate main discussion.

Superciliary crests, 10
Superficial
 epigastric vein, 157
 veins, *156-7*, 215, 223
Supination, *43*, 114-17 illus.
Support and balance, 206-10 *passim*
Supraclavicular fossa, *36*, 152
Suprapatellar bulge, 128n., 132-3
Supraspinous fossa, *34*, 102
Supraspinous ligament, 102
Suprasternal space, 36
Surface landmarks, 180ff.
Sutures of cranium, *11*, 160, 220
Symmetry and asymmetry, 206
Sympathetic facial activity, 244
Symphysis pubis, 57, *60,* 102, 151, 175, 225

t

Tabatière, 122, 124
Tail, axillary, 176
Tail bone, *see* Coccyx
Talus, 3, *78*
Tarsal arch, 78-9
Tarsal bones, 3, *78*
Tear gland, 162
Tears, 162, 245-6
Teeth, 170, *172*, 214n. (N.B.), 247
 in facial expression, 247, *253*, 255-6
 in old age, *215 and* n.8, 220
 racial feature, 172 n.2, *236*
 sockets, *12-13*, 172
Teething, 172
Temple, 160-61
Temporal
 bone, 3, *10-13*, 94
 fossa, *11*, 92
 line, *11*, 92, 160
 vein, 157
Tendinous junctures, 122
Tendo calcaneus, 130
Tendon plate
 of quadriceps, 132
 of trapezius, 105; female, 226
 of triceps, 116
Tendons, interrupting, 89, *102n.*, 104, 175
Thenar eminence, *112*, 123-4
Thenar line of palm, 159
Thigh
 fascia lata, 128n.
 fat, *see* Subtrochanteric fat
 female, 215, *225-6*
 furrow of, 151
 muscles, 128f.
 veins, 157
Thighbone, 3, 56, 60, 68, 70, 72, 128, 130
Thoracic
 arch, *26-7*, 151
 vein, 157
 vertebræ, 3, *22-3, 26-7,* 102

Thorax, 3, 22-3, *26-7*
 at birth, 214
 female, 225
 muscles, 102f.
Throat, *99*, 224; muscles, 94f.
Thumb, 48-9; muscles and tendons, 112f.
Thumbnail, 174
Thyroid cartilage, 94-6, *99*
 female, 224
Thyroid gland, 96, *98-9*
 female, 224
Tibia, 3, 68, 70, *72-3*, 128
Toenails, 174
Toes, 79
 fat pads, 140, 143
 sheathing, 138-40
 tendons, 130
Tongue, *172*, 246
Tongue bone, *see* Hyoid bone
Torso, *see* Trunk
Trachea, 99
Tragus, 166
Transverse
 ligament of ankle, 130n.
 lines of abdominal wall, *102n.*, 175; —of hand, 159
 processes of vertebra, *23*, 27
Triangle
 of auscultation, 105
 lumbar, 105
 'masculine,' 224
 sacral, *22*, *60*, 105, 225
Triangles of neck, *94 and* n., 98
Triangular fossa of ear, 166
Triquetrum, 3, *48*
Trochanters of femur, *68*, 128 *and* n., 151; female, 225-6
Trochlea of humerus, *40*, 42; —of phalanges, 49, 79
Trunk
 muscles, 102f.
 veins, 157
Tubercle of
 calcaneus, 130
 helix, 166
 humerus, *40*, 102
 major multangular, *48*, 112
 navicular of wrist, *48*, 112
 rib, 27
 upper lip, *170*, 254
Tuberosity of
 metatarsal v, *79*, 130, 140
 navicular of ankle, 78
 tibia, *72*, 128

u

Ulna, 3, 40, *42-3*, 110, 112
Ulnar
 crest, *42*, 112, 116
 notch of radius, 43
 tuberosity, *42-3*, 110, 112
Umbilicus, 175; *see also* Navel

Upper extremity
 bones, 3
 connection with trunk, 36
 female, 225
 growth of, 214-15
 muscles, 110ff.
 veins, 157
Upper jawbone, *see* Maxilla
Upper transverse line of palm, 159

v

Varieties of physique, 201-3
Veins, superficial, *156-7*, 215
Venous arches, 157
Venous rete, 157n.
Venus, mount of, 60 n.4, 151
Venus, rings of, 224 *and* n.3
Vertebra, typical, 23
Vertebra prominens, *22*, 105, 150, 226
Vertebræ, 3, *22-3*
Vertebral
 arch, 23
 column, 22-3
 margin of scapula, *34*, 102
Violent expiration, *245*, 246, 251
Vomer, 3, *12*

w

Weeping, 245-6
Weight
 distribution to legs, 60, *206*
 gain, in middle life, 215
Weights, compensation for, 209
Whiskers, 161
White of eye, 162-3
Whorl centers of hair, 160
Wrinkles, 155, 158, *222*
 of facial expression, 250ff.
 of finger joints, *49*, 122
 of old age, 215, *222*
Wrist
 joint, 42-3, 48, 53 illus.
 ligaments, *113n.*, 122-3
 spurs of, 48
 tendons, 116
Wristbones, *see* Carpal bones

x

Xiphoid process, *26*, 102

y

Yawning, 246
Youth, 215; stature, 219n.

z

Zygomatic
 arch, *11-13*, 92, 98
 bone, 3, *10-12*, 92, 98
 process of frontal bone, *10*, 12